AQA Design and Technology

Graphic Products

GCSE

Keith Richards
John Cavill
Justin Dodd
Russel Jones

Nelson Thornes

Published in 2009 by:
Nelson Thornes Ltd
Delta Place
27 Bath Road
CHELTENHAM
GL53 7TH
United Kingdom

12 13 / 10 9 8 7 6 5 4 3

A catalogue record for this book is available from the British Library

ISBN 978 1 4085 0274 7

Cover photograph by Jim Wileman
Illustrations by Fakenham Photosetting Ltd, KJA Artists and Oxford Illustrators
Page make-up by Fakenham Photosetting Ltd

Printed in China by 1010 Printing International Ltd

Acknowledgements

The authors and publisher wish to thank the following for permission to use copyright material:

Alamy; 1.9A, 5.2c, 11.2F, 11.3A, 11.3B, 11.4B, 11.4C, 11.4D, 12.2B, 13.2B, 14.1A, 16.2A, 16.2B, 17.2A, 17.3D, 18.1A, 18.3D, 19.2D, 19.4C, 19.5C, 2.1A, 20.1C, 22.1A, 22.1B, 4.1A, 4.2B, 5.1C, 5.1D, 6.1B, 6.2C, p 86, p 90, p 106, p 148, p 24, p 32, p36, p 54; Alessi; 5.1E; Constructionphotography; 9.4D; Corbis; 11.3C; DK Images; 2.3D, 6.2B; Empics; 6.4B, p 46; Fotolia; p8, 13.2C, 14.1B, 15.3B, 17.1C, 17.1D, 19.1A, 19.2A, 19.2C, 19.2E, 19.3C, 19.4B, p 100; Getty Images; 18.2A, 22.1C; iStockphoto; 1.2B, 1.2D, 11.2B, 11.2E, 11.4A, 13.1A, 13.1B, 13.1C, 14.2A, 14.3B, 15.2A, 15.2C, 16.1A, 17.2B, 17.3A, 17.3B, 17.4A, 18.3A, 18.3B, 19.1B, 19.3B, 19.3D, 2.3C, 21.1A, 21.2D, 21.2E, 21.3C, p 94, p 110, p18, p 138; John Walmsley; p 7 (all); Nicholas Yarsley; 15.1A, 15.3A, 2.1B, 3.2B, 5.3B, 6.2D; London Transport Museum; 5.1A, Photolibrary; 11.2D; Photoshot; 18.3C, p 122; Rex Features; 11.2A, 11.3E, 15.1B, 2.3A, p 142; Samsung UK; 6.4D, Science Photo Library; 21.1B, 4.1C; www.smallp.co.uk; 4.2C; (FSC logo) Image © 1996 Forest Stewardship Council A.C, www.fsc-uk.org ; (d2W logo) Image courtesy of Symphony Environmental Technologies PLC, www.degradable.net; 14.2B (NCAP logo) Image courtesy of Euro NCAP, www.euroncap.com; 20.1A Spot varnish Image courtesy of James Thomas, www.surfacemedia.ca; 20.1B Foil blocking Image courtesy of Frewer Brothers Limited, Printers, www.frewerbrothers. co.uk; 20.2A Embossing Image courtesy of Frewer Brothers Limited, Printers, www.frewerbrothers.co.uk; Susie Slatter; 21.1A , 12.2A, 11.3D, 5.2D, 1.2A, pg 6; Transitions.com 4.1B, www.alveyandtowers.com; 5.2D, transdevplc; 11.6B, Mark Boulton/www.conservationimages.co.uk; 15.3C, Roland DG Corp; 16.1B, Gerald Higgins, motorwaymap.co.uk; 5.1B

Every effort has been made to contact the copyright holders and we apologise if any have been overlooked. Should copyright have been unwittingly infringed in this book, the owners should contact the publisher, who will make the corrections at reprint.

The controlled assessment tasks in this book are designed to help you prepare for the tasks your teacher will give you. The tasks in this book are not designed to test you formally and you cannot use them as your own controlled assessment tasks for AQA. Your teacher will not be able to give you as much help with your tasks for AQA as we have given with the tasks in this book.

Contents

Contents 4

Nelson Thornes and AQA

Nelson Thornes has worked in partnership with AQA to ensure this book and the accompanying online resources offer you the best support for your GCSE course.

All resources have been approved by senior AQA examiners so you can feel assured that they closely match the specification for this subject and provide you with everything you need to prepare successfully for your exams.

These print and online resources together **unlock blended learning**; this means that the links between the activities in the book and the activities online blend together to maximise your understanding of a topic and help you achieve your potential.

These online resources are available on **kerboodle!** which can be accessed via the internet at **www.kerboodle.com/live**, anytime, anywhere. If your school or college subscribes to **kerboodle!** you will be provided with your own personal login details. Once logged in, access your course and locate the required activity.

For more information and help on how to use **kerboodle!** visit **www.kerboodle.com**.

How to use this book

Objectives

Look for the list of **Learning Objectives** based on the requirements of this course so you can ensure you are covering everything you need to know for the exam.

AQA Examiner's tip

Don't forget to read the **AQA Examiner's Tips** throughout the book as well as practise answering **Examination-style Questions**.

Visit **www.nelsonthornes.com/aqagcse** for more information.

AQA GCSE D&T Graphic Products

A Student designing

B Student making

C Students using CAD/CAM

■ What is Graphic Products all about?

Graphic Products is a very exciting, creative and interesting subject to study. It can lead you into a wide range of interesting and worthwhile careers and is extremely relevant to the understanding of how some of these actually work. You will find there is much to learn but most of this will be through you getting involved with practical activities that hopefully you enjoy. Most of the theory elements are far easier to understand if you approach them in a practical way and you will be able to perfect many of the skills necessary as you carry out the project work. Try to remember that becoming a successful designer/maker requires a lot of practice and the grade you achieve in the exam will reflect how creative and innovative your designs are.

Graphic Products involves:

■ being creative and designing new products.

■ understanding how and why the 'design process' works.

■ learning how to research into a topic effectively and use this research to guide your designs.

■ learning how industry uses graphics and modelling skills in a wide range of products.

■ developing many skills which enable you to present and make quality products.

■ learning about graphic processes, techniques and making skills.

■ experimenting, investigating and testing products.

■ understanding how a range of products are manufactured commercially.

■ having an insight into the use of colour, shape and layout of a design.

■ understanding and using a variety of CAD/CAM techniques.

Graphic Products involves you working somewhere between how a graphic designer and a model maker would work in industry. Your classroom becomes not only a design studio, but also a place to make high-quality models in three dimensions. You will be designing and making a full range of products, showing different ways of presenting your ideas to a client, developing your 3D-making skills and, if appropriate, using CAD/CAM to get a really professional finish.

Your GCSE grade will be awarded as a result of completing two units of work:

Unit 1

A written examination worth 40 per cent of the total marks, which will require you to apply what you have learned during the course in an examination situation.

Unit 2

A coursework project called the 'Controlled Assessment', which involves answering a design brief and designing and making a graphic product; this is worth 60 per cent of the final mark.

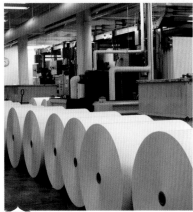

D *Large scale production: rolls of paper ready for printing*

In both your written examination and the designing and making practice, you will be assessed on how you demonstrate your knowledge skills and understanding.

Graphic Products will also help you to develop many other important and valuable skills. These include:

- communication and organisation skills
- practical skills
- problem-solving skills
- information and communication skills.

What is this book about?

You will want to achieve a good grade in your GCSE Graphic Products exam. This book has been written by experienced teachers to support your learning. You will see that it provides you with clear concise explanations, descriptions and examples to support you through the course and also helps prepare you for your Controlled assessment and the written examination. It has been written as a student book to provide you with hints and tips as you go through the GCSE course.

The book is divided into two units which match the AQA GCSE Design and Technology Graphic Products specification:

Unit 1 Written paper

- Materials and components
- Process and manufacture
- Design and market influences

Unit 2 Controlled assessment

In addition to the information it contains, the book will also provide examples of activities you can undertake and examination-style questions at the end of written paper sections.

Graphic Products and a future career

Studying Graphic Products can lead to an exciting and well-paid career in the graphics and modelling industries. These fast-moving industries are expanding all the time and are some of the largest employers in the UK. Designers and makers are much sought after and there are ample job opportunities for every graduate leaving university. Having an associated Graphic Products qualification can lead to careers in fields such as graphic design, model making, packaging design, printing, architecture, set design, product design and industrial design.

In conclusion

As you focus on different topics with your teacher, this book will help you gain the knowledge, understanding and skills you need to be successful. So learn and enjoy!

Introduction

You need to be aware of the processes and techniques which aid the manufacturing of your products in quantity. It is expected that designing and making will look at how products are made and therefore deal with materials associated with the making of quality products. When studying graphics we need to understand the properties and the functions of the materials that we use.

■ What will you study in this section?

After completing the Materials and components section you should have a good understanding of:

- The functions, properties and use of paper and board
- The functions, properties and use of thermoplastics, modelling materials and 'smart' modern materials
- How to use a wide range of graphic equipment to develop hand generated images
- How to use a range of adhesives for different materials safely
- How to use a range of hand and powered cutting and forming tools safely to produce graphic products
- Understand how graphic materials can be linked with other components and materials to produce a product designed for a specific purpose.

■ Making

One of the reasons you will have chosen Graphic Products is to use your skills in making a useful practical outcome. The best way to learn about all the materials and techniques is to be engaged in making activities. Throughout each chapter activities have been suggested to help you to learn the theoretical aspects of the unit by 'learning-by-doing'. It is important that you can explain why:

- Different papers and boards exist
- Some food packaging must use virgin board whilst other packaging can use recycled board
- Some plastics, like acetate, are more easily recycled compared to PVC
- Different coatings are applied to some boards for specific purposes
- Smart materials can be used to enhance a graphic product
- Different adhesives and fixings are required for different materials
- Different tools and methods are used when cutting or shaping.

1.1 Sketching

Sketching ideas and designs

Sketches and quick drawings record ideas on paper. These jottings can be worked up into a final idea and presentation drawing by the designer. They also help designers to visualise their thoughts and so communicate them to a fellow designer or client. A **sketch** shows shape and form, and when **annotated** helps explain how the design works; for example a design for an Easter egg box may give details explaining how the box securely holds such a fragile object as a chocolate egg.

Designers use a range of sketching and drawing techniques. They may be quick **freehand** sketches or use basic equipment. Freehand drawing is quick, informal and can simply be 'thumbnail' sketches on scrap paper. A pictorial drawing involves using rulers and straight edges, and although it takes more time, it shows size and proportion more clearly.

Freehand sketching

Straight lines

Straight lines are best drawn with a medium pencil, grade HB or H, but be bold. To draw straight lines a 'ladder technique' can be used. Draw a short line and then use this as a guide and extend it, the second part overlaying the first. Repeat this for the required length.

Freehand curves

Freehand curves are best drawn using the wrist or fingers as a natural compass. The hand is inside the curve and then the 'ladder technique' is used. As shown later in this chapter, you can use a grid 'underlay' to help produce neat sketches (see page 14).

Pictorial drawings

A straight edge or ruler can be used to help some images look neater and more accurate than freehand sketches; this is called a draw. The results are pictorial drawings which are **3-dimensional** (3D). Sketches and drawings that show the basic 'flat' shapes are known as **2-dimensional** (2D), but they lack depth or thickness. Surface developments (nets) are best drawn in 2D where the thickness of card can be ignored. Sketches and drawings in 3D show the length, width and thickness of an object, and can be drawn using different techniques.

Key terms

Sketch: a quick, informal image sufficient to communicate important features to others.

Annotated: brief notes which help explain design sketches and drawings.

Freehand: a 2D or 3D drawing completed without any aids such as rulers or straight edges.

3-dimensional: a sketch or drawing which shows all three dimensions, for example length, width and thickness.

2-dimensional: a sketch or drawing which shows only two dimensions, for example length and width.

AQA *Examiner's tip*

Do not rub out or cover up mistakes. You may be rubbing out work which can gain credit. Simply redraw on another part of the page and put a line through the original so the examiner knows which drawing to mark.

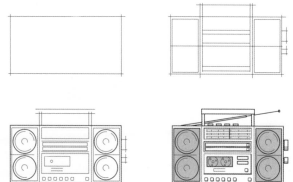

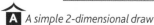

A *A simple 2-dimensional draw*

3D images from a front view

This is an easy method of drawing basic 3D objects from a familiar front view. The thickness can be reduced to make the drawing look in proportion.

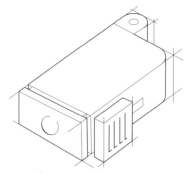

B *3D ruler drawing using crating technique*

Crating or 'wire framing'

This is a widely used method of drawing 3D objects, because many everyday items are based on cubes and rectangular boxes. Always start with a 3D 'box' or crate. Advanced skills can be developed by drawing curves inside the crate.

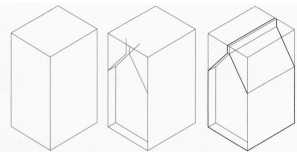

C *A 3D draw of a drinks container using the crating technique*

AQA *Examiner's tip*

- Always include the full range of annotated sketches in your project work: 2D and 3D sketches, hand-drawn and computer-generated images, and 'thumbnail' thinking sketches.

- Know the difference between a 'freehand sketch' and a 'drawing'. A freehand sketch is drawn without any aids, has no straight edges, templates or stencils. A drawing uses straight edges to improve accuracy and clarity.

- To construct an accurate, precise drawing use the appropriate drawing equipment, such as drawing boards, set squares and compasses, or computer-aided design (CAD) programs, for example 2D Designer.

Summary

Use an H or HB pencil for sketching.

Know the difference between a sketch, a drawing and a construction when answering a question.

Draw 3D images in a 'crate' for better pictures.

Equipment

Pencils

Pencils are available in a range of **grades** from very hard 7H ('H' means hard) to very soft 7B ('B' means black). For formal drawing with drawing boards or equipment, such as set squares, you should use 2H or 3H, whereas HB or B are best for sketching. All pencils should be sharp, so use a pencil sharpener or emery board. Mechanical pencils are popular; these are also available in different grades of hardness but come with a standard width 'lead' of 0.5 mm. They do not need sharpening.

Coloured pencils are available in a wide range of colours and tones that are easy to see. These are useful for enhancing design sketches and presentation quality drawings. Some types of coloured pencils are water soluble and can give an interesting 'colour wash' effect.

Paper

Cartridge paper or photocopying paper is popular in schools. The surface is good quality and will take pencils, pens and markers. Other special papers are available, such as 'bleedproof' paper and tracing paper.

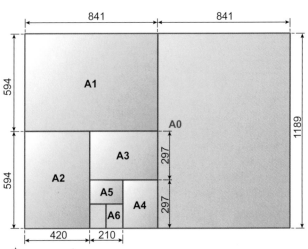

A Coloured pencils can be used to enhance sketches

B Marker pens

Paper is described by its size, weight and thickness. Weight is expressed in grams per square metre. Standard photocopying paper is A4, 80 gsm, or A3, 100 gsm. Paper sizes follow the 'A' series, where A0 has an area of 1 m². The best size for project folders is A3. Microns are the industrial standard for measuring paper thickness. There is more information on paper in Chapter 2.

Marker pens

There are two main types of marker pen:

- Water based are cheap, easy to use, and tend to be strong colours.
- Spirit based are more expensive, and have standard colours and tones.

The tip of the pen can be 'bullet' shaped (for a thinner line) or 'chisel' shaped (for a wider line of about 6 mm).

The colour pigment is in a liquid 'vehicle'. Both types can 'bleed' on normal paper, which means they spread along the fibres of the paper, so bleedproof paper is recommended.

C Paper 'A' sizes (in mm)

Graphic liner pens

Graphic liner pens (also called fine liners) are useful for general and 'lining-in' work. They are inexpensive and disposable. The fibre tip gives a line of constant width and density. They are available with line widths of 0.3, 0.5 or 0.7 mm.

Computer-aided design (CAD)

A number of different programs can be used for sketching on a computer, such as Microsoft Draw, 2D Designer, ProDesktop, SolidWorks and AutoSketch. The computer mouse is like an 'electronic pen', used for sketching and drawing on the screen. Some designers use a graphics tablet and a pen-like stylus, which are usually more precise.

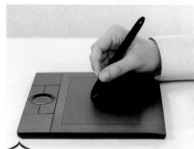

D *A graphic tablet can be used for freehand drawing*

■ Improving your sketch

Design sketches can be improved by using simple enhancements. There are some rules to follow when you enhance your sketches:

Thin/thick line

On a sketch or drawing the outline is 'lined-in' to make the shape stand out. Edges where only one surface or face is seen are in a thick or dark line, and edges where two surfaces or faces are seen are in a thin or lighter line.

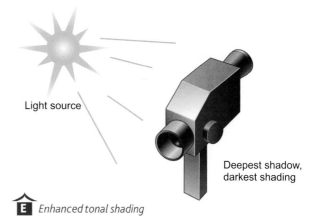

Light source

Deepest shadow, darkest shading

E *Enhanced tonal shading*

Tonal shading

By using light and dark shading the illusion of 3D can be improved. A soft lead pencil, such as B or HB, is held so that more of the lead is in contact with the paper. If a varying pressure is applied gently a wide range of the greys can be obtained. Make sure that the surface nearest the light source is lightest and the surface furthest away, in deep shadow, is darkest.

Shades of colour can be created if a coloured pencil is used in this way, and white shading on black paper can look impressive.

Colour

Colour can be used to make sketches stand out and to attract attention to important features. Pencils and pens can be used to highlight the shape by colouring its surround or by colouring the design itself. Colouring can represent the material used.

Texture

Different materials can be represented by adding effects to the sketch or drawing. This increases the illusion of the item being made from that particular material. Textures can be added with lines or colour.

Activity

Draw a shampoo bottle made of clear plastic and add texture to show the part of it that provides grip.

Key terms

Grades of pencil leads: H, HB and B.

AQA Examiner's tip

Use an enhancement technique to highlight your idea sketches and drawings. It is not necessary to use every technique you know, just the ones you can do the best.

Summary

3D sketches and drawings show a 'solid' object.

Colour and texture can improve the appearance of a drawn object and suggest the material it is made from.

Paper is graded by size (the A series) and weight (in grams per square metre, gsm) or thickness (in microns, μm).

Grids

Very few people have the skills and talent to produce outstanding freehand sketches without any form of help. We all need help sometimes, and with a little practice and patience we can all get better at producing quality drawings. Using **grids** and **underlays** will improve your drawing, and will also help you score better in an exam. There are a number of grids and underlays available, and you can even create your own. The simplest is a letter grid, as shown in Diagram **A**, which is constructed from a 3 × 5 grid. All of the letters will fit into this type of grid with the exception of M and W. The advantage of using this type of grid is that you can have text going forwards, backwards or at a different angle. All you do is just place this behind your work and trace through. The grid helps maintain the size and depth of each letter on your work.

A *Letter grid*

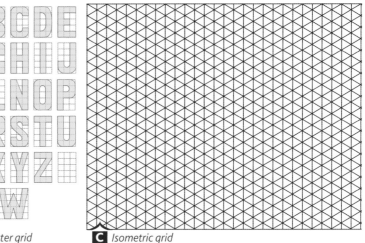

C *Isometric grid*

D

- *Try and draw these four cubes freehand using an isometric grid, the size isn't important.*
- *On the second cube add darker lines around the outside, this is called 'thick and thin line' it will enhance your work.*
- *On the third cube, still in free hand, using a pencil crayon add tone to show where the light source is coming from.*
- *The fourth cube is produced in the same way but with a white pencil crayon.*

Activity

1. Using Diagram **B**, create a number grid. You can choose any three different numbers. Number 1 is already shown.

B *Number grid*

Underlays

Underlays should be used when you are unsure how to draw in 3D. They can be used for very simple shapes, like a cube. Using underlays is a little more complex than using grids. You need to remember the orientation of the paper. There should be no horizontal lines when it is positioned behind your work.

Activities

You are going to draw a cylinder using an **isometric** grid. It is a more difficult skill to produce curves in 3D. Start with a basic isometric cube.

2 Draw a cube freehand using an isometric grid. The size is not important.

3 Divide the front face into four, then join intersection to intersection with a smooth curve.

4 Repeat the process for the back face.

5 Join the front and back faces.

Always leave construction lines on your work, so that the person marking your work understands how you have constructed it.

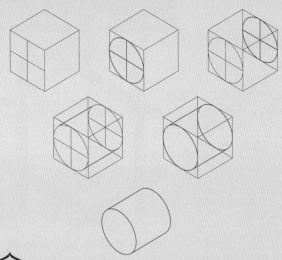

E *Drawing a cylinder using an isometric grid*

Key terms

Grid: a boxed framework to help draw shapes.

Underlay: a ruled pattern that assists when drawing 3D shapes.

Isometric: a 30 degree angular grid.

AQA *Examiner's tip*

Always try to produce freehand sketches using any grids or underlays you have. If possible start with simple feint crates, then develop them into more complex shapes using a range of techniques as your confidence and ability increases.

Activity

6 Using a perspective grid, and the letter grid in Diagram **A**, produce your initials using the grid and the vanishing point at the 'back' of the grid. Try drawing your own initials on your own perspective grid.

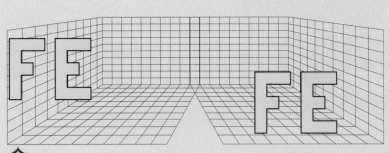

F *Drawing initials using a perspective grid*

Summary

Grids are an important and easy-to-use tool to improve your drawing.

Underlays can be used to create 3D shapes.

1.4 Enhancement of the design

■ How to enhance your ideas

Basic line drawings are an acceptable starting point during the design process. These line drawings can then be developed into more enhanced designs. To improve the overall presentation of your work, you can use a variety of media and a range of graphic techniques to add visual impact to your designs. You can draw attention to shape and form by using contrast, tone and colour. Textural representation can be used to convey different materials and surfaces. For example, if you want a design to look like different materials, such as wood, metal or plastic, then it is possible to do this using the techniques discussed later in this chapter.

Thick and thin line

Adding darker lines around the outside of a shape is called thick and thin line, and will enhance your work. Start with a simple isometric crate and remember feint construction lines. On a cube it is the outside edge that requires the lines to be made thicker. If you have double-ended markers, use the thin end for the feint lines and the thick end for the darker lines. To make your work stand out even more, try using a ruler to extend **all** outside edges until they cross over each other. The lines closer to the work need to be very dark. Further away, try to blend to a lighter depth of colour.

Colour

Colour adds vibrancy to your work, and can communicate a whole range of emotions as well as the physical properties of your design.

To produce quality work throughout your design folder you need to understand the colour wheel and how to use it in your work. Red, blue and yellow are primary colours. They cannot be made by mixing any other colours together. If we mix two of the primary colours together we get a secondary colour – green, purple and orange. If we mix a primary colour with a secondary colour then we will produce a tertiary colour.

Complementary colours are opposite each other on the colour wheel and create contrast, whereas colours that are close together on the colour wheel are said to create harmony, such as blue and green.

The depth of a colour is known as the **hue**. This can be altered by adding **tone**, such as white to lighten it or black to darken it.

Many colours have feelings connected with them, for example:

- Red – danger, love, anger, debt, strength, dominant, fear, embarrassment, warning
- Yellow – coward, weak, bright, light, sun, madness, long life, durability.

Objectives

Use pencils, pens and colours to add visual impact to designs to accentuate shape and form.

Use textural representation to convey different materials and surfaces.

Demonstrate an understanding of contrast, complementary colours, hue and tone.

Apply the language of colour.

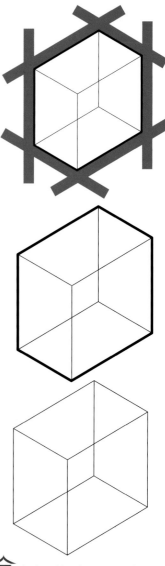

Activity

1 Can you think of any words that you feel would describe any of the other primary, secondary or tertiary colours?

A *Thick and line lines on a cube*

Tone

100% 0%

Hue

B **B** *Colour brings design to life, hue and tone bars*

Activity

2 Collect two pieces of packaging that have very different colour schemes. List the primary, secondary and tertiary colours used. Is there any evidence of complementary colours on the package? Where is the best evidence of contrasting colours? Why is it used here?

Materials

For some designs you will want to indicate the material you intend your design to be made from, such as plastic, glass or wood. Start with an isometric shape like that shown in Diagram **D**. To make it look like plastic, we have to apply thick and thin lines first, and then decide where the light is coming from. We need to show highlights where the light touches the object first and shadows on the parts of the object that are further from the light. We can use a white colouring pencil to highlight the lighter areas and lines.

D *Using textural representation to convey plastic*

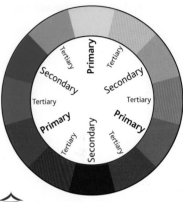

C *Colour wheel*

Key terms

Complementary: colours that are opposite each other on the colour wheel. these colours provide the greatest **contrast** to each other.

Hue: a particular gradation of colour.

Tone: a colour or shade of colour created by adding amounts of white or black.

AQA Examiner's tip

Always try to use a variety of colours in your work, some complemetary and some contrasting. You must state the obvious in your annotation – the examiner is not a mind reader!

Summary

Enhancing your drawing helps communicate your idea to others.

The colour wheel is used to inform designers about colour choices in their designs.

Textural representation is used to convey the material you plan to use for your design.

Why are there so many different types of paper?

We all use many types of paper and board in graphics. They are made from the vegetable fibres found in wood, which are carefully extracted through the process of crushing wood to make a 95 per cent water-based pulp. This looks a bit like milk. It is then refined by being passed through a series of dryers and rollers to achieve the basic quality that paper-makers need for board or paper.

A *Magnified paper showing fibres*

Perhaps without realising it, you have already used a huge range of different boards and papers. Just think about your daily routine and the boards used for cereal packets, egg boxes, juice cartons, newspapers, school books, and so on. Each has been carefully created to have certain qualities. The main factors that are taken into account when choosing a paper or board are:

- cost
- finish
- strength
- brightness (whiteness)
- thickness.

How do we get these different properties?

A really shiny paper, like the expensive photo paper you can print your pictures on, gives a very different glossy finish than the much cheaper and thinner newsprint paper used for newspapers, which is a low quality, cheap, thin, matt and absorbent paper.

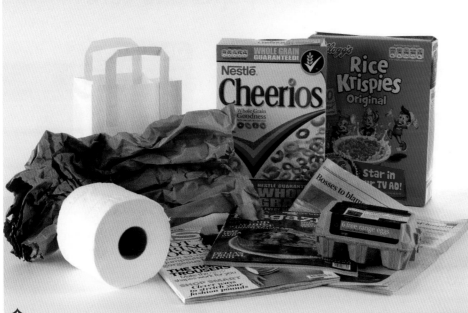

B *Everyday paper and card*

There are three main ways of achieving the different properties of paper and card:

- the addition of a *coating* to the surface, such as china clay or chalk, which is sprayed on to the surface to give a smoother finish
- the addition of a *sizing* agent which improves the ability of the paper or card to accept ink by sealing the absorbency of the paper's surface. The coating and sizing applied to the surface directly affect the brightness (whiteness) of the surface
- by *laminating* (sticking together) layers of thinner card to achieve a board. Depending on how many layers of card are stuck together, and the qualities of each card, a whole range of different boards can be made.

Weight and thickness

Paper is sold by weight in **grams per square metre (gsm)** up to 220 gsm, when it is called board. Board is sold and measured for thickness in units called **microns**, represented by the symbol μm. There are 1000 microns in 1 mm and a typical birthday card is around 300 microns thick, compared with the paper this book is printed on which is about 90 microns thick and 90 gsm in weight.

Activity

Bring in as many different papers, cards and boards as you can from home. Get into groups of four and tell each other what you think are the qualities of the examples.

Stick examples of three different types of paper and two different boards in your book. Annotate each one with their approximate weight or thickness, and whether they have a matt, satin or gloss finish.

AQA Examiner's tip

Make sure you are able to say what properties a particular paper or card has and why you think it would be suitable for a particular use.

Key terms

Grams per square metre (gsm): paper thickness is measured in gsm, which is the weight in grams of a whole square metre of paper.

Microns (μm): card thickness is measured in microns. A micron is 1/1000th of a millimetre.

Summary

Paper is made from the vegetable fibres found in wood.

Paper comes in a huge variety of weights, colours and textures.

Paper-makers change the properties using three methods: coatings, sizing agents, laminating.

Properties and uses of paper and card

Recycling

Virgin paper makes up 90 per cent of all paper, and the remaining 10 per cent of paper has some recycled content. Compared with recycled paper, virgin paper tends to be stronger and easier to make whiter. Virgin paper is used generally for food containers because it reduces the contamination risk to the food products.

It is also possible to make paper from all sorts of materials other than wood pulp, such as corn, straw, cotton and hemp, and each of these materials gives the paper different properties. It is important that we try to recycle as much as possible in order to try to save our planet from additional global warming.

- The Energy Information Administration claims that a 40 per cent reduction in energy is achieved when paper is totally recycled, compared with the energy used in making virgin paper.

- About 30 per cent of solid waste dumped in landfill is paper-based and the rotting down of this waste produces methane, which is a 'bad' greenhouse gas.

- Deforestation is also a massive environmental issue, and some of the wood is used by the paper industry. Deforestation can cause global warming because trees absorb CO_2, which is the main greenhouse gas.

Objectives

Know the difference between 'virgin' and 'recycled' paper.

Understand why it is worth recycling.

Know the properties of a range of papers and cards.

Key terms

Virgin paper: paper that is just made from wood pulp with no recycled paper added.

Activity

1 Design an image to describe the Energy Information Administration's claim.

A Advantages and disadvantages of recycling paper

Advantages	Disadvantages
Kinder to the environment – 34 per cent of trees cut down are for paper manufacturing	Harmful chemicals to the environment, such as bleach are sometimes used to achieve a white paper
Energy saving due to less raw material being processed	Not as strong as virgin paper
Companies like to be seen to be 'greener' these days and this is an easily understood message for the consumer	More expensive to make than virgin paper

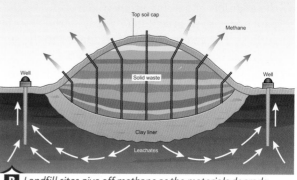

B Landfill sites give off methane as the materials degrade

Activities

2 Draw the symbol for recycled card or paper.

3 Find out where your local recycling centre is. What materials do they recycle?

Two other boards that are widely used in graphics are Corriflute and Duplex.

- Corriflute or Correx is a fluted polypropylene (plastic) board and is a light but strong weather-resistant material that is excellent for use as exterior signage, unlike paper-based boards. It can be printed on to using flexography, or vinyl stickers can be used. A good example of its use is the 'For Sale' sign of estate agents outside houses.

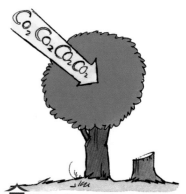

C We need trees so that they can absorb CO_2

D *Properties of paper and board*

Type	Weight or thickness	Advantages	Uses	Relative cost 10 = high cost
Newsprint	50 gsm	Cheap, lightweight, uncoated	Newspapers	1
Layout paper	60 gsm	Thin and slightly translucent	Designers often use this paper for sketches and tracing	3
Tracing paper	70 gsm	Transparent	Can be used for tracing a design onto another sheet	4
Sugar paper	90 gsm	Cheap, uncoated, variety of colours	Cheap mounting up of work. Fades in the sunlight	2
Inkjet/laser photo paper	150–230 gsm	Special high gloss or matt coating with a quick drying surface for the ink	Photos, presentations	9
Board (card)	230–750 microns	A more rigid surface that can be easily printed onto	Model-making	5
Cartonboard	230–1000 microns	Boards often made from many different layers and materials, e.g. aluminium foil is used to keep drinks cool. Many types available, each with specific packaging uses. High-quality print surface	Packaging	7–10
Mount board	750–3000 microns	Thick coloured rigid board	Model-making and high-quality picture mounting	9
Corrugated card	3000–5000 microns	Strong and lightweight	Packaging protection Point-of-sale stands	5
Foam boards	4000–7000 microns	Composite board consisting of two outer layers of high-quality card and a central layer of foam	Point-of-sale stands Presentation boards	10
Spiral wound tubing	1000–3000 microns	High strength and 3D printable surface	Packaging	9

■ Duplex – while cartonboards are mainly used for packaging, larger and more rigid multilayered display boards like Duplex have a greater variety of uses. They are made using a foam base board to which various finishes are applied. A good example are the boards often used for advertising purposes in shops and cinemas which can be coated with a 'smart' foil material with an image that reacts to light and changes (hologrammatic).

Summary

'Virgin' paper is made from 100 per cent wood pulp and does not contain any recycled paper.

Paper and boards vary in thickness and surface finish depending on their required usage.

Boards can be modified with coatings or combined with other materials to give different qualities.

AQA *Examiner's tip*

Be specific when answering questions on materials you are using, for example 'board' and 'paper' are too general.

Activity

4 Working with a classmate, find and cut out 50 mm × 50 mm squares of each paper type mentioned in Table **D**.

Stick these into your books and annotate each one with a brief explanation.

What is cartonboard?

Nearly everything we buy is packaged in some form. If you look closely at the packaging on any two different products, you will probably find that the card is slightly different for each one and that the items are over-packaged. If a card is used for the external package, then it is likely to be a type of cartonboard.

Cartonboard is mechanically strong, so it is good at protecting products. It can also easily be cut, creased, folded and glued, giving you, the designer, scope to produce functional and creative packaging. The surface is usually white and smooth and can be printed on using all the main printing processes. Cartonboard can be embossed and hot-foil stamped (see Chapter 20 for more details).

In Europe about 7 million tonnes of cartonboard are produced each year and the majority of this is then converted into cartons for packaging products like food, drink and cosmetics. Some is also used for graphical purposes, such as book covers, postcards, calendars and brochures.

Objectives

Understand the importance of cartonboard in the packaging industry.

Learn the four types of cartonboard.

Understand that extra materials can be added to cartonboard to give it different uses.

Activity

1 Collect at least four different packages, stick a part of each of them in your book and try to analyse each one using all the information on paper and card you have learnt. Try to use as many of the following key words as you can: **finish**, **strength**, **brightness**, thickness, type of cartonboard, and do not forget to include its use.

Key terms

Finish: adding a property to a board.

Strength: the resistance of a board to bending or lateral pressure.

Brightness: the level of optical whiteness.

How is cartonboard made?

Cartonboard is a multilayered or laminated material with three or more layers (plies). It usually has a white coating on one or both surfaces to make it easier to print on.

- Cartonboard types vary according to the pulp composition and the thickness in microns.
- Cartonboard can be combined with other materials such as plastic to make it waterproof.
- Most folding cartons are in the range of 350–800 μm (microns) for thickness.

There are four basic types of cartonboard manufactured: solid bleached board, solid unbleached board, folding boxboard, and white lined chipboard. They can be treated with various chemicals to improve a variety of properties such as moisture and grease barriers. Additionally, they can be coated to produce cartonboard that can be used in ovens and microwaves and other specialist packaging.

Cartonboard can be treated or laminated. Although these additions give the card unique uses, they all make the card far more difficult to recycle. Examples of treatments include:

A Cartonboard is used in a vast range of packaging

B *Types of cartonboard and coatings for cartonboard*

Material	Characteristics	Uses
Solid bleached board (SBB)	Highest quality white top printable surface	Perfumes, chocolates, cigarettes
Solid unbleached board (SUB)	Brown, very strong	Drinks
Folding boxboard (FBB)	White top layer with cream bottom layer	Toys, games
White lined chipboard (WLC)	Recycled board with a white top surface	Detergent powders

Coatings

- aluminium foil for insulation, or as a bacterial barrier for food products, for example Capri-Sun drinks containers
- plastic for waterproofing, for example Innocent smoothie drinks cartons
- greaseproof paper, for example baking cups for cup cakes
- wax coating for waterproofing, for example a takeaway coffee cup.

C *Wax-coated cartonboard*

Activity

2 Use the examples in Table **B** and draw a packaging product made from each of the four types of board. Say why you think the characteristics make them suitable for the product.

D *Greaseproof paper*

AQA *Examiner's tip*

- Make sure you understand that cartonboard varies tremendously, depending on the lamination and coating.
- You need to be able to say why a particular cartonboard is used.

Summary

There are four main types of cartonboard.

There are many ways to modify and add to the properties of cartonboard.

Cartonboard is used for a very wide range of packaging.

3.1 Plastics are all around you

■ Try looking!

We know how common the use of plastic is in the massive packaging industry. Just think about the last few products you have bought and how many used plastic in some form to package them. Look at the packaging in detail next time you go shopping and use some of the facts from this chapter to help you understand what they are made from and how they are produced.

Objectives

Understand how plastics are made and the environmental impact they can have.

Know why plastics are used in packaging.

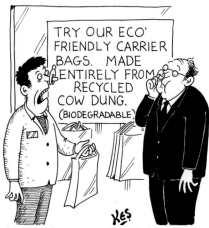

A *"They don't seem to be very popular with the customers."*

It would be much better for the environment if everything were packaged using card, as this is easy to recycle and make **biodegradable**. An even better option would be to try and avoid any packaging if possible, which is by far the most environmentally friendly method. Both individuals and industries are now becoming much more aware of their environmental responsibility and the impact of using plastics that can take a hundred years or more to degrade in landfill sites or when dumped as litter.

Activity

1 You have two minutes to make a list of five items that you think either do not need any packaging, or are over-packaged. Pick one item and explain to a classmate why you think it is a bad package design.

AQA Examiner's tip

Check that you understand the environmental impact of using plastic.

■ How plastics are changing

Of all plastics, 95 per cent are made from the limited, non-renewable and environmentally unfriendly material – oil. However, recent technological advances mean that 5 per cent of plastics can now be made from animal and vegetable matter, such as the cellulose or starch found

in plants, which can be refined to create certain **bioplastics**. Because these plastics are not based on crude oil they have the huge advantage of being biodegradable and are therefore environmentally friendly.

Why are plastics used for packaging?

Packaging often plays an important role in ensuring that the product arrives at the retailer's shop or the consumer's house in the same condition it left the factory. Plastics often play an important role in protecting a product. The top five reasons why plastic is so common in the packaging world are because it is:

- tough – so that the product is protected
- lightweight – so that the product is not made to be too heavy
- clear – so that the consumer can see the product inside
- economical – that is, easy to make and easily available
- aesthetically useful – that is, it can be made to look good and can be printed on.

Key terms

Biodegradable: this is a material, normally based on animal or vegetable matter, which can be broken down by other living organisms into harmless waste.

Bioplastics: plastics that have been made using plant or animal material. This makes them biodegradable.

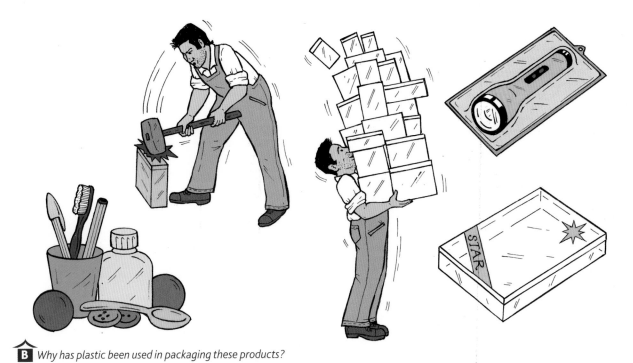

B *Why has plastic been used in packaging these products?*

Activity

2 Can you come up with a simple acronym to help you remember why plastics are used for packaging?

Summary

Most plastic packaging is bad for the environment, as it takes too long to degrade.

Different products need different packaging and plastic can answer these needs very well.

Many different plastics have been invented, each one with its own properties. We know that products need different packaging, some to protect, some to preserve and some just to promote. As a designer you need to be aware of some of these plastics and their common uses for graphic products. If you have to use a plastic in your designs, then you should always try to use a plastic that can be recycled. These are generally **thermoplastics**, which can be reused with the addition of heat.

A *Main plastics used in packaging*

Name	Properties	Uses
Bioplastic (d₂W)	Biodegradable, based on plants Clear or coloured	All sorts of food packaging
Cellulose acetate	Partially biodegradable, based on plants but with added chemicals Clear, NOT tough	Photocopiable clear film and film for cameras
Acrylic	Stiff but brittle Can shape and polish all edges to a high gloss Wide variety of colours	Point of sale stands Available as rods, tubes as well as sheets
PET Polyethylene terephthalate (1 PETE)	Tough and very good at keeping the 'fizz' in	Fizzy drinks bottles
PS Polystyrene (6 PS)	Not tough Can be vacuum formed	Shell forms for packaging CD jewel cases Yogurt pots
Expanded polystyrene Styrofoam (3 V)	Very light Impact absorbing	Protective packaging Block modelling
PVC Polyvinyl chloride (3 PVC)	Tough and resists scratching	Blister packs Games pieces
PP Polypropylene (5 PP)	Flexible	Crisp packets

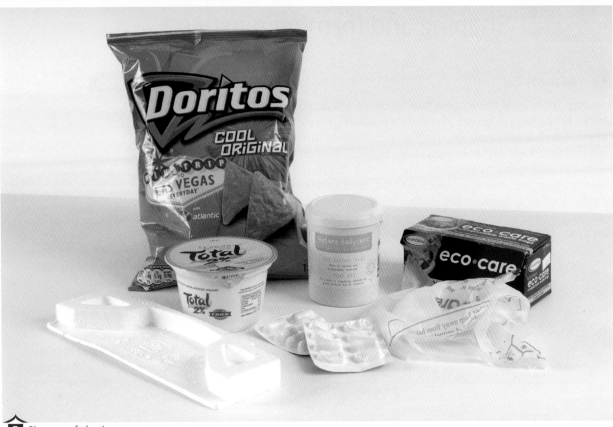

B *Six types of plastic*

Activity

Collect at least four examples of plastic packages. Try to get a range of plastics, using the symbols to help you tell the difference. Cut the symbols out and stick these in your book with a brief explanation of the packaging. Look at Table **A** to help you use the right descriptions.

Summary

Most plastics are made from oil, but some are now made from animal and vegetable matter – making some plastics not only recyclable, but also biodegradable.

Most thermoplastics are recyclable.

AQA *Examiner's tip*

- You need to know why plastics are so useful to package products and you should be able to name the most common thermoplastics and what they are used for.
- Don't just use the word 'plastic' in the examination – try to be specific.

Key terms

Thermoplastic: a plastic that can be reshaped many times when it is heated.

Vacuum forming

Vacuum forming is the process used to create uncomplicated hollow shapes by 'sucking' a heated plastic, like polystyrene or PVC, over a mould. Graphic products, like the blister packing of batteries or tablets, or the plastic trays that hold individual chocolates inside boxes, can be made easily using this method. The process can be useful when you start to make your coursework designs, such as a base for a point-of-sale stand or a domed rooflight in a building. You probably have a vacuum-forming machine in your workshop at school that your teacher can demonstrate.

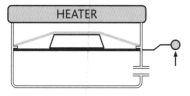

1 An accurate mould is made with draft angles and rounded edges, with appropriate 'air' holes so that the air can be sucked out.

2 The mould is placed in the bottom of the vacuum former and polystyrene is heated up until it softens. The heating elements in the vacuum former must not be touched.

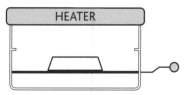

3 The mould is raised into the heated soft polystyrene and the air is sucked or vacuumed out, so that the plastic takes the shape of the mould.

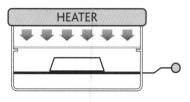

4 The polystyrene is allowed to cool so that it becomes rigid again.

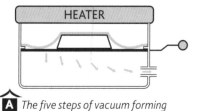

5 The mould is lowered and the polystyrene impression is removed so that the 'flashing' or excess material can be cut off.

A The five steps of vacuum forming

Key terms

Vacuum forming: a process in which simple hollow shapes are created by sucking air from underneath a heated thermoplastic plastic sheet draped over a mould.

Injection moulding: a process in which hot liquid plastic is injected by force into a mould.

Activity

1 Make a simple mould for two AA batteries, vacuum form this and then design a card surround to promote your own new range of batteries. You could call them 'N-R-G' (energy) or create your own name.

Injection moulding

Injection moulding is the most common process used to shape many different 'thermoplastics' into a the huge range of complex shapes we see all around us. For example, if you use a plastic pen to write with, then it has almost certainly used this manufacturing method to make it.

Injection moulding involves the process of heating up solid granules of a thermoplastic into a liquid form and then forcing this hot plastic into a very high quality strong metal mould, allowing it to cool and solidify. The shaped item is then ejected. Once the mould is set up on the machine, the process can be repeated many thousands of times. Nearly all thermoplastics can be injection moulded and then recycled after they have been used. This is a good process for mass or large batch production.

1 *An expensive mould is made, normally from steel.*

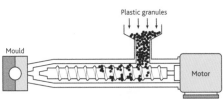

2 *Granules of plastic are placed in the hopper.*

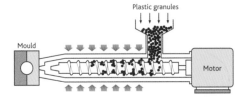

3 *Heaters melt the plastic into a thick liquid which is pushed towards the mould by an Archimedean screw.*

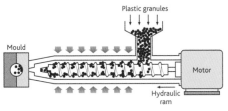

4 *A hydraulic ram forces the plastic under huge pressure into the mould.*

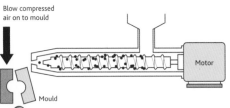

5 *The mould is cooled and the object is released.*

B *The five steps of injection moulding*

Activity

2 Use the internet to research the injection moulding process and draw and label a diagram of an injection moulding machine. Try to find two new facts about this process.

Blow moulding

Blow moulding is the process of heating up a thermoplastic which is placed in a mould. Air is then blown into the hot plastic, which quickly expands into the shape of this mould – just like blowing up a balloon. The process is used to make hollow forms such as bottles for fizzy drinks or plastic milk containers.

Objectives

Know and describe the industrial processes of blow moulding and line bending, which are used to commercially shape plastics.

Key terms

Blow moulding: a process for making hollow plastic forms by blowing air into a heated thermoplastic.

Line bending: a process used to bend straight lines in a heated thermoplastic.

Jigs and formers: these are used to accurately locate, bend or aid in the construction of a product. They often save time and make it possible to make identical items.

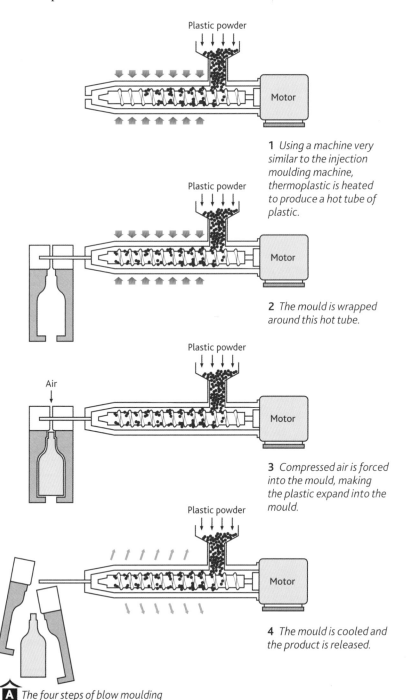

1 *Using a machine very similar to the injection moulding machine, thermoplastic is heated to produce a hot tube of plastic.*

2 *The mould is wrapped around this hot tube.*

3 *Compressed air is forced into the mould, making the plastic expand into the mould.*

4 *The mould is cooled and the product is released.*

A *The four steps of blow moulding*

Activity

1 Design your own symbol to represent each of the four industrial processes used to form and shape plastics. Name one example of a product that uses the blow moulding process.

Line bending

You are also probably familiar with the process of **line bending** when using your strip heater at school. It is used to bend straight lines in a thermoplastic. You have probably bent acrylic in this way.

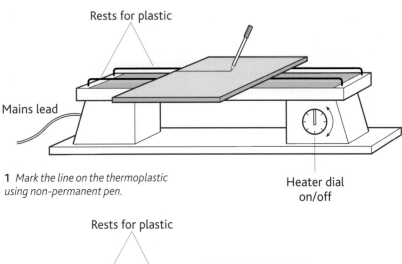

Rests for plastic

Mains lead

Heater dial
on/off

1 *Mark the line on the thermoplastic using non-permanent pen.*

Rests for plastic

Mains lead

Heater dial
on/off

2 *Heat the plastic evenly on both sides until soft. Do not touch the heating elements on the strip heater.*

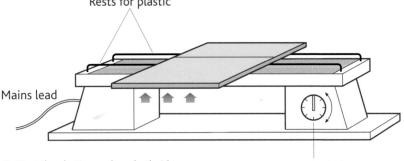

3 *Bend the plastic using a* **jig (mould)**.

B *The three steps of line bending*

Summary

Blow moulding is an industrial process used to make bottles from thermoplastics like PET. It involves heating a plastic inside a mould and then blowing compressed air into it.

Line bending is used to bend a thermoplastic, usually acrylic, into a straight line, often using a jig.

AQA Examiner's tip

These processes are often referred to in the exam, so try to make sure you not only understand each process and each step involved, but also how each process can be used for graphic products.

Activity

2 Draw your own flowchart using the symbols on page 83 for each of the four main processes used to shape thermoplastics. Try to insert some quality control measures and feedback loops into your flow chart.

4 Smart and modern materials

4.1 Smart materials

You will need to know about a range of **smart materials** that are used in the graphics industry. They are special materials as they often behave in unique ways to give some very clever effects (see below). These effects can help the function and aesthetics of a product and can help to give it a unique selling point (USP).

- *Thermochromic* materials change colour depending on their temperature. 'Thermo' means heat and 'chromic' means colour.
- *Photochromic* materials change colour in response to light, for example in light-sensitive sunglasses.
- *Electrochromic* materials change colour depending on the amount of electricity applied, for example in liquid crystal displays on clocks.
- *Hydrochromic* materials change colour depending on the amount of water applied, for example in moisture testers for plant pots.
- *Phosphorescent* materials absorb light energy during the day and then they are able to give this energy off at night, for example in watches that glow in the dark.

Thermochromic materials

Thermochromic inks are the most common smart material used for graphics because they can be used in many different ways to either attract or warn the consumer. They are also easy to print on different surfaces such as paper, plastic, ceramics or textiles.

Probably the most common use of thermochromic inks is in the thermometers we can put on our foreheads to tell whether we have a raised temperature. Thermochromic ink in a thermometer changes colour according to the temperature of the patient, and then goes back to its original black when the patient's heat is removed. The inks on this thermometer react to the temperature of the body and glow specific colours, making it very easy and safe to use.

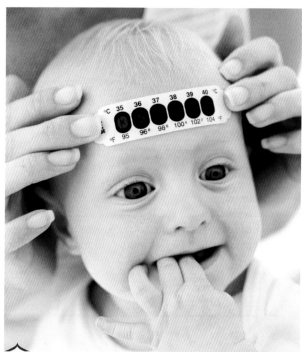

A *A thermochromic thermometer*

Photochromic materials

Photochromic inks change colour depending on the amount of light hitting the surface. By far the most common use of this is in light-sensitive glasses, such as sunglasses.

Electrochromic materials

Electrochromic inks are inks that change colour according to varying electrical inputs. The input can be incredibly small but the change in colour can be very dramatic. A common use is on car rear-view mirrors that darken when the ink detects a bright light, therefore reducing glare.

Hydrochromic materials

Hydrochromic inks change colour according to the amount of water they detect. These inks are quite accurate and a good use for them is in detectors for plant pots that tell you when to water the plant. The detector can be designed to go red when the plant is too dry and green when it is just right.

Phosphorescent materials

Phosphorescent inks are able to absorb light during the day and then glow at night. You will probably have an example of this in your classroom if you look at the Fire Exit sign. Many watches have a phosphorescent ink on the hands and numbers to help them glow at night.

B *Photochromic inks can turn prescription glasses into sunglasses*

C *Phosphorescent inks allow you to see signs in the dark*

Activity

Use the internet to research these five smart inks. Find some more examples of their uses and present them in a simple table.

Summary

Graphic designers can use smart materials to help them achieve a unique selling point (USP), often making their design better than their competitors'.

Thermochromic inks are often used to aid a graphic image by making the product actively interact with the consumer by changing colour when the temperature changes.

Know that there are five main smart materials used in graphic products.

4.2 Modern materials

A **modern material** is not 'smart' as it does not react to its surroundings, but it is a new material that has been created within the last 50 years.

Alternatives to thermoplastics

Cornstarch Polymers

These can now be used to replace some oil based thermoplastics. They are made from crops such as potatoes, corn and maize which are high in starch content. They are biodegradable and although they are not as versatile as oil based thermoplastics, they are being used in some food packaging. The latest development is attempting to replace the polyethylene film used by farmers to cover some crops with a clear polymer made from maize, which can be ploughed into the soil after use and improve the soil. At the moment these starch polymers don't have some of the hard wearing properties of oil based thermoplastics, but as research continues we should see more and more environmentally friendly thermoplastics in use.

Paperfoam

This is another alternative to some thermoplastics with a specialist use in the packaging industry. It is made from a combination of starch based polymers and simple paper fibres (even recycled paper). It produces a material that is scratch resistant and can be moulded to form inserts to protect and keep products in place. It is fully biodegradable and can be coloured with vegetable dyes. It also weighs less than the equivalent oil based plastic, which saves on transport and emissions. It is now widely used for CD and DVD case inserts and even companies such as Motorola uses it for their mobile phone packaging.

Lyocell

This is a high-strength paper fibre produced from wood pulp and is totally biodegradable within eight days if placed in damp conditions. Lyocell is therefore an environmentally friendly modern material. It is used to make special papers for tea bags, coffee filters and strong envelopes.

A A PaperFoam CD case

Objectives

Learn what:

alternatives to thermoplastics there are.

lyocell is.

polymorph is.

precious metal clays (PMCs) are.

Key terms

Modern material: a material invented within the last 50 years.

Cornstarch Polymers: alternatives to some oil based thermoplastics made from vegetable starch.

Paperfoam: a combination of cornstarch polymers and paper fibres, used to make scratch resistant inserts for packaging products.

AQA Examiner's tip

- Try to think about how modern and smart materials could be used in any of your coursework ideas.

- You are likely to be shown a graphic product that uses smart or modern materials in the exam and you may be required to name them and explain how they work.

Activity

1 Name as many products as you can that uses inserts like these. In small groups, discuss the benefits to the environment if all the products you thought of used similar biodegradable inserts.

Polymorph

This is a special plastic, often used for modelling in technology, which stays hard and white at room temperature but can be softened at 60 degrees Celsius. You can then easily mould it into any shape, using your hands, very much like Plasticine. However, polymorph, unlike Plasticine, is much harder at room temperature, making it ideal for constructing complex-shaped models or prototypes. It is so hard and strong that it can be machined with great accuracy. You could use it to create complex curved ergonomic shapes such as torches or computer games consoles. Polymorph can also be classed as 'smart' material as it returns to its hardened form when the heat is removed.

B *Polymorph*

PMC

Precious metal clays are made of 99.9 per cent metal, normally gold or silver, and 0.1 per cent clay, which give them the amazing ability to be shaped at room temperature. They are then heated carefully until the 99 per cent metal just melts. They are very expensive and mostly used by jewellery designers.

Nano technology

You need to know that nano technology is a method of changing the atomic structure of materials in order to make them better. Nano technology can make materials *less expensive, lighter, stronger and more precise*. For example if you manipulate the atomic structure of carbon you can create a diamond, or if you change the atoms of silicon you can create a computer chip.

Activity

2 Write down two facts about each of the 'modern' materials discussed above.

Summary

A 'modern' material was invented within the last 50 years.

C *Precious metal clays are used in jewellery.*

kerboodle!

5 Key designers

5.1 Harry Beck and Alberto Alessi

▇ Key designers

Design rarely takes place in isolation. Designers are influenced by people and things around them, and by designers from the past. The designers discussed in this chapter have made a big impact through their work in graphic and product design, and have changed the appearance of our environment. You need to be able to recognise their work, so that you know its main features and understand the contribution these designers have made to the way current designers think and work.

Studying other designers will inspire you so that you can adapt their designs to your work and to new situations.

▇ Harry Beck – graphic designer

Harry Beck designed the famous London Underground map in 1933. You probably take this sort of map for granted now, but in 1933 **non-geographical maps** were a completely new idea. Beck realised that the distances between stations were not important because passengers only wanted to know where they were and which station was next. Before Beck, underground maps were based on the geography above ground and on existing road maps.

Beck was an electrical draughtsman and got the idea for the tube map from looking at simple electrical wiring diagrams. On his map, different colours were used for the different lines and standard symbols represented interchanges and stations.

In fact, Beck was not a graphic designer and he designed very little else, but his tube map is a lasting example of how ideas can be adapted to suit a purpose. The map was so successful that Beck updated it on a number of occasions over the years as new lines were added. It is still used today and many countries and cities have adopted its style because it is easy to use, clear to understand and can be adapted for other networks such as road systems and air travel routes. Beck's map is now an icon of graphic design and a symbol of London.

Activity

Draw a bus route with which you are familiar in the style of Harry Beck's London Underground map. Remember the map shows a system rather than geography. The distances between the stops will not represent the distances on the ground. Colour is very important.

Objectives

Recognise the work and influence of Harry Beck's graphic style and approach.

Recognise the work of the Alessi company and the role of Alberto Alessi in creative designing.

AQA Examiner's tip

Learn why each designer's style has been successful. Do not simply learn and then repeat historical facts.

Key terms

Non-geographical map: not related to the actual landscape or topography.

Mass production: when large numbers of an item are made.

Creativity: making new designs, having new ideas, and thinking of new interpretations of older ideas and products.

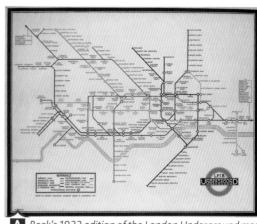

A Beck's 1933 edition of the London Underground map

Alberto Alessi – manufacturer

Albert Alessi is Italian and trained as a lawyer. He joined his family company making metal kitchenware for the hotel and catering trades as design manager. He wanted to combine **mass production** with good design, **creativity** and craftsmanship, so that well-designed products could be made available for everyone.

Alessi did not design items himself but he made it possible for others to be creative, and he produced and marketed their designs. He employed many leading designers, including Philippe Starck, Alessandro Mendini and Stefano Giovannoni. Alessi's contribution to design is not based on graphic products – instead, it was his design philosophy that started many new debates and brought about fresh ideas.

His company developed a reputation for superior designed and stylish products. He wanted his company to be an ideas factory. He said:

> Alessi's role is to mediate between the most interesting expressions of creativity of our times, and the dreams of the consumer. We like to lead where others follow. Some of our objects are so extraordinary no other manufacturer would consider making them … The possibilities of creativity are immense and we have no limit on what we can do.

Alessi designs are not simply based on function. A good example of this is the iconic lemon squeezer designed by Philippe Starck. Looking like a spaceship with legs, it is considered by many to be a brilliant design piece, and it still sells for around £50. On the other hand, you may prefer to buy a basic squeezer from a big supermarket for less than a pound. This can stay in the drawer, while the other can go on display. The Starck squeezer is actually very messy to use and functionally inferior compared with most of the basic versions on the market, but it still sells for a lot of money!

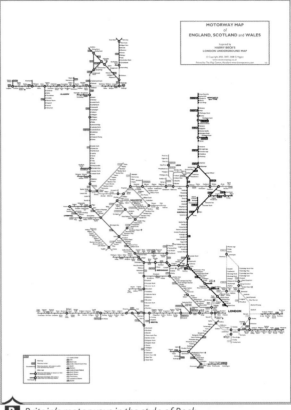

B *Britain's motorways in the style of Beck*

C *Alessandro Mendini's corkscrew*

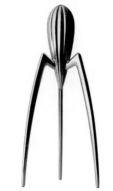

D *Philippe Starck's* Juicy Salif *lemon squeezer*

Summary

Beck's map is simple and easy to understand, and his ideas are used all over the world.

Alessi is not a great designer himself but he encourages and supports those who are.

E *Stefano Giovannoni's Girotondo motif has been used in many of his products*

Jock Kinnear and Margaret Calvert – graphic designers

In the late 1950s, road signs were not standard, and every town or county simply put up signs as they thought best. As more people started driving, and motorways started to be built, finding your way became confusing and even dangerous for motorists. New signs were needed that were the same everywhere, so that wherever you drove you understood them. It was also important that the signs could be easily seen and understood by a motorist driving at speed, but were not too distracting.

Jock Kinnear trained as a graphic designer and Margaret Calvert as an illustrator. First, they developed a **typeface** that was clear and easy to read when driving fast. The letters were *sans serif* and slightly curved, which they felt would be appealing to drivers. They called the font 'Transport'.

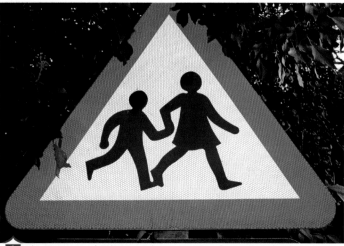

A *The Kinnear and Calvert road sign warning of a nearby school*

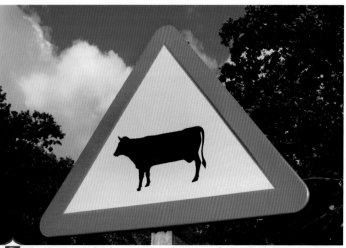

B *The Kinnear and Calvert road sign warning of a nearby farm*

They adopted the European idea of using **pictograms** instead of words to warn drivers of hazards. Calvert used her own background as the inspiration for many of the pictogram designs. The school sign of a boy and girl walking was based on a photograph of herself as a child. The farm warning sign is based on a cow called Patience that lived on a farm near to where she grew up.

Kinnear and Calvert also designed the shapes of the information boards and the colours used (white letters on blue for motorways, yellow letters on green for primary roads and black on white for secondary routes). Various fluorescent and reflective smart material coatings have since been added to road signs to improve visibility and safety.

C *Kinnear and Calvert information board design*

Kinnear and Calvert's road signs proved very popular, attractive and functional and have since been adopted by many countries. The Design Museum in London said 'Kinnear and Calvert's road signs fulfil their function so efficiently that the public tends to take them for granted and rarely acknowledges their design merit.'

> AQA *Examiner's tip*
>
> Use the correct technical terms when writing about key designers, such as 'sans serif' and 'typeface'.

Activity

Design a set of signs for departments to display in corridors in your school. Include pictograms of the subjects in the style of Kinnear and Calvert.

Summary

Kinnear and Calvert's transport and road signs are clear, uncluttered and easy to read when travelling at speed towards them.

Kinnear and Calvert created a new typeface and pictograms to give drivers information.

Wally Olins – brand consultant

Companies use graphic design to promote their products and create brands – products that are easily recognisable to customers. A brand will have a visual identity such as a logo, but **branding** is also about the relationship the customer has with the product. Companies often want to promote themselves as well as their products, so they create a **corporate image**. They might use a logo, initials or a simple phrase, or a combination of all or any of these.

Wally (Wallace) Olins is a brand consultant. After studying history at university, he worked for an advertising company. In 1965, together with Michael Wolff, he founded an advertising agency called Wolff Olins, which was to become a major influence on developing corporate images in the UK and Europe. Olins has worked with companies such as P&O and BT where the corporate image is included on every advertising campaign that they run.

Olins now works with charities, governments and even counties and regions, helping them not only to have a corporate image, but also to develop a **corporate identity**. He believes that corporate identity is the whole feeling you get when you buy something from a company. He has said:

> 66 *It seemed sensible to present the idea of the company as a whole, through its products, environment and behaviour rather than just through ... advertising.* 99

A *P&O logo*

Objectives

Understand the wider aspects of Wally Olins's approach to corporate identity.

Understand the appeal of Robert Sabuda's 'mechanical books'.

Key terms

Branding: a logo or image associated by the public with a product.

Corporate image: the branding of a company.

Corporate identity: the qualities and values an organisation wishes to be associated with and recognised by, and its signage, products and public appearances.

Pop-up: cut-out sections in a book or card that appear or flip outwards when a page is turned.

Paper engineering: precise, accurate mechanisms made from paper, and specially designed to enable the desired actions to take place.

Mechanical books: books that have movement and actions built into them.

Activity

1 Explain what Wally Olins means when he says that a product should represent the corporation that made it. You may wish to relate these ideas to Sir Richard Branson and his Virgin organisation.

AQA Examiner's tip

Try to look past the logo into the wider values of a business.

■ Robert Sabuda – author, illustrator and 'pop-up' book designer

As a child, Robert Sabuda was fascinated by **pop-up** books. He used to make them from old filing folders that his mother brought home from work. He went on to college, and while on work placement he learnt about book-making and printing. He taught himself **paper engineering**, and later used these skills to create amazing pop-up books.

After working for several publishers, Sabuda published his own books himself. The first ones were *The Christmas Alphabet, The Mummy's Tomb* and *The Knight's Tale* and they were published in 1994. He believes that adults and children enjoy **mechanical books** and that reading them together is great fun. Sabuda has won many prestigious prizes for his children's books.

He has an excellent website with many examples of pop-up book and card designs. You may think that pop-up books are not a particularly special contribution to design, but think of how many pop-up books and cards are sold each year and how much money is generated! It is the application of basic card engineering principles that allows so many images and stories to be applied to these books and cards.

AQA *Examiner's tip*

Investigate some of the mechanisms used in pop-up books.

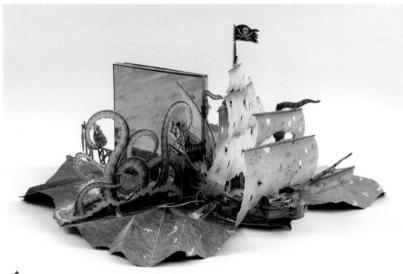

B *A pop-up book*

Activity

2 Make a simple pop-up card using information and instructions found at www.robertsabuda.com.

Summary

Wally Olins's approach to branding is that it includes an organisation's brands, values and relationship with the public.

Robert Sabuda's pop-up books use clever paper engineering for the enjoyment of children and adults.

Before spending approximately 2 hours answering the following questions you will have to do some preliminary research into MP3 players and CD packaging.

To complete these questions you will require some plain white paper, basic drawing equipment and colouring materials. You are reminded that quality of written communication is important as well as neat sketches and drawings.

1 This question is about sketching and rendering. *(total 17 marks)*

 (a) Using the 'crating' technique, sketch several 3D freehand designs for different MP3 players. *(4 marks)*

 (b) Enhance one sketch by using the 'thin/thick' line method. *(2 marks)*

 (c) Re-draw one of your MP3 designs, add a light source and render it showing shade and tonal colouring. *(6 marks)*

 (d) Give an advantage and a disadvantage of marker pens. *(2 marks)*

 (e) Marker pens on some papers can 'bleed'. Explain this term and how it can be avoided. *(3 marks)*

2 This question is about modelling and modelling tools. *(total 13 marks)*

A model MP3 player is formed from a block modelling material.

 (a) Name a block modelling material and explain why it is suitable for this task. *(4 marks)*

 (b) The surface of the shaped block is to be covered with a layer of plastic sheet by vacuum forming.

 (i) Explain the advantages of vacuum forming over the block. *(3 marks)*

 (ii) Sketch the process of vacuum forming step by step. *(6 marks)*

3 This question is about paper- and board-based products. *(total 19 marks)*

A sleeve for a CD is made from thin board.

 (a) What are the main constituents of most papers and boards? *(1 mark)*

 (i) Name four ways in which the quality of paper and thin board can be improved. *(4 marks)*

 (ii) Describe two of the ways by which the quality of paper and board can be improved. *(4 marks)*

 (b) Explain with sketches and notes the difference between 'laminated' material and an 'encapsulated' document. *(4 marks)*

 (i) Paper is usually measured by weight in 'gsm'. Explain this term. *(1 mark)*

 (ii) Board is usually measured by thickness. Explain this system. *(2 marks)*

(c) Copy the diagram below to represent size A0 in the 'A series' of paper sizes.

Show how A4 size is formed and state how many pieces of A4 can be cut from one sheet of A0. *(3 marks)*

4 This question is about smart and modern materials. *(total 29 marks)*

A CD sleeve has a symbol printed on it in a 'smart ink'. The buyer is asked to put their thumb on the ink and after a moment the symbol disappears.

(a) What is a smart material? *(2 marks)*

(b) (i) Name and explain the smart properties of the ink used in the symbol. *(3 marks)*

 (ii) Explain why such a symbol is used on AQA GCSE certificates. *(2 marks)*

(c) Given are three outline designs for children's greeting cards.

In each case name the smart material. Explain how each material enhances the greetings card. *(9 marks)*

(d) (i) Explain why polymorph and precious metal clays are good modelling materials. *(2 marks)*

 Which would you use to make the following, and why?

 (ii) A cap for a fragrance bottle. *(3 marks)*

 (iii) A figure for a board game. *(2 marks)*

(e) (i) Explain why only 'virgin' board must be used for food containers such as pizza boxes. *(3 marks)*

 (ii) Vegetable starch is used for burger boxes.

 Give two advantages of this material. *(3 marks)*

5 This question is about assembling a product and adhesives. *(total 15 marks)*

The surface development (net) of a thin board sleeve for a CD is shown.

(a) Draw a 3D picture of the assembled sleeve. *(3 marks)*

(b) The star-shaped window has a photochromatic film over it.

 (i) Why is this feature added to this product? *(2 marks)*

 (ii) With notes and sketches, show how the film can be attached to the sleeve. *(3 marks)*

(c) Which adhesive is used to assemble the thin board sleeve and why? *(3 marks)*

(d) When CDs are given away free with magazines they are often in a plastic envelope which is glued to the front cover. In this case, which type of glue is used and why? *(4 marks)*

6 This question is about modelling equipment. *(total 14 marks)*

(a) Sketch and name tools and equipment used in a school design department to make five CD sleeves. *(4 marks)*

(b) Sketch and name equipment used for multiple production of the CD sleeve. *(4 marks)*

(c) Explain the safety considerations you would observe when using the following tools and equipment.

 (i) Scalpel or craft knife *(2 marks)*

 (ii) Spray adhesive *(2 marks)*

 (iii) Bench drill *(2 marks)*

7 This question is about thermoplastics *(total 20 marks)*

(a) What is the main property of a thermoplastic? *(2 marks)*

(b) What five features make plastics suitable for packaging? *(5 marks)*

(c) (i) Why are plastics not 'bio-friendly'? *(2 marks)*

 (ii) Some modern plastics are now 'biodegradable'. Explain this term with regard to plastics. *(4 marks)*

(d) An acrylic display stand is made using a strip heater/line bender. Explain in detail, with notes and sketches, how it is formed. Consider accuracy, safety and quality in your answer. *(7 marks)*

Process and manufacture

Introduction

In this section you will cover topics that will allow you to make products using a range of materials and processes that are suitable for one-off or batch production. You will be shown an understanding of the commercial manufacture of graphic products and the increasing role CAD/CAM has in all areas.

After completing this section you should have a good understanding of:

- How production methods can change according to how many products are made.
- How and why quality checks are made during the manufacturing process.
- Why different print processes and print finishes are used for different products.
- The commercial techniques used to print and make nets.
- What is the purpose of packaging and its environmental impact.
- Why as a designer we need to protect our ideas in law.

■ Making graphic products commercially

It is great fun to learn about the processes involved with the commercial manufacturing of graphic products by carrying out a range of practical activities and investigations. These activities will help you understand some of the reasons why there is such a variety of manufacturing methods. You can carry out investigations and making activities to see:

- How quality control measures can dramatically effect the look of a final product
- How the print quality varies according to the method used
- How a forme is used to cut out a net for a package
- How a reduction in packaging can often still function effectively, but be more environmentally friendly.

How will you use this information?

Questions on some of the above points are often included in the examination. It is also important that you apply the knowledge to ensure you produce high quality graphic products in your controlled assignment. You must always consider how your design can be made in quantity and the print processes used in any promotional material for the product.

6 Techniques and processes

6.1 Mock-ups, models and prototypes

What are mock-ups, models and prototypes?

These are examples of what the final product might look like. They are usually 3D **models**, but can also be 2D drawings. In the real world, models are used to show clients or customers elements of a design because it is usually easier to understand a concept in its made-up form rather than as a drawing. For example, a car manufacturer produces **prototypes** of new cars. These are life-size working models of a design and can be used for testing, development and evaluation. The prototype would also be used to test market interest – if there was no interest in a new idea for a car then there would be little point in pursuing it.

Scale

During the design process, manufacturers will make a model, **mock-up** or prototype. However, this model may not always be made to actual size. When designing a new shop for instance, it would be difficult to show potential customers a life-size model of the new shop. Therefore, the manufacturer makes a scaled model of the shop. It is important to make sure that the chosen scale is appropriate for the design.

By now you will have designed and made many items at school, and for most you will have made a life-size or scale 1:1 model or prototype. However, it is also very common to create designs that need to be scaled up or down. For example, if you were to design a nightclub, then your drawing and model would probably be 100 times smaller than the actual building, so the scale would be 1:100. Table **A** lists common scales and gives examples of their uses.

A *Examples of scale*

Scale	Use
2:1 twice full size	A small intricate item, such as an earring
1:1 actual size	A hand-held object, such as a mobile phone
1:2 half size	A small electrical device, such as a laptop computer
1:10	A piece of furniture
1:100	A house or garden
1:500	A very large building, such as a sports stadium

B *Life-size object and scale model*

Summary

Models, mock-ups and prototypes are used by designers to refine the design process and to communicate ideas to clients.

Models and prototypes should be to scale.

Sheet and block modelling materials

Which material should you use?

As a good designer you will always want to show others what it is you are trying to achieve. To do this, you will usually start with sketches and then naturally lead on to modelling your designs into 3D versions. For modelling, it is very useful to understand how all the different **modelling materials** work and which ones are best for making certain shapes.

When making your 3D outcomes, especially in your final coursework project, it can be useful to make some models to test specific aspects of your final piece. It is important to save or take photos of these and include them in your project so that they can be assessed.

Key terms

Modelling materials: the range of materials used to produce high-quality 3D models.

A Table to show sheet and block modelling materials

Material	Uses	Tools used	Advantages	Disadvantages	Safety	Biodegradable
Expanded polystyrene, e.g. Styrofoam	Block modelling	File or rasp Abrasive paper Filler, e.g. Plaster of Paris Acrylic paint	Great for 3D models	Difficult to achieve a high-quality surface finish; filler needed	When cutting use in a well-ventilated area When shaping, use a mask to protect from dust	No
Balsa wood	Block modelling	File or rasp Abrasive paper Acrylic paint	Stronger than Styrofoam Can act as mould for vacuum former	Takes longer to shape. More expensive than Styrofoam	None	Yes
Plasticine or clay	Block modelling	Fingers and wooden shaping tools	Very quick to shape in 3D Can be vacuum formed Easily recycled	Difficult to achieve a good finish	None	Yes
Foam board – a composite rigid material consisting of a layer of foam backed on both sides with high-quality card	Point-of-sale stands	Craft knife Safety rule Complicated shapes can be laser cut or die cut	Rigid board Excellent surface for drawing onto Easy to apply a printed image using a spray adhesive, e.g. Spray Mount	Difficult to hand cut curves without 'ripping' the foam Not recyclable	Take care when cutting – always use a safety rule	No

Acrylic sheet, rod or tube	Point-of-sale stands Architectural models	Hacksaw, laser cutter Wet or dry abrasive paper Polish	Excellent finish Rigid Variety of colours Easy to cut complex shapes on a laser cutter	Expensive	Wear goggles when cutting	No
Card (230–750 microns)	Packaging, nets, cards	Craft knife Safety rule CAMM cutter Laser cutter	Quick to shape Easy to apply graphics	Easily bent	Take care when cutting – always use a safety rule	Yes
Board (750–3000 microns)	Architectural models Point-of-sale stands Hardback covers for books	Craft knife Safety rule	More rigid than thinner card Easy to apply graphics	More expensive than card	Take care when cutting – always use a safety rule	Yes
Plastazote	Card covers, medical supports (eg splints), specialised packaging	Craft knife Safety rule Scissors Laser cutter Die cutter	Flexible, colourful plastic foam sheets Can be vacuum formed over to give a slightly raised surface to any mould	Difficult to cut curves, but easier than with foamboard	Take care when cutting – always use a safety rule	No

B *Balsa wood*

C *Acrylic*

D *Plastazote*

Activities

1. Find out what a biodegradable material is.

2. Match the following materials with models of the following products. You can suggest more than one suitable material for each product.

Materials: expanded polystyrene, balsa wood, Plasticine, foam board, acrylic, card, board, Plastazote

Models of products: personal stereo, building, perfume bottle, Easter egg package, large point-of-sale stand, flexible book cover, glass building, torch, key fob, heart-shaped chocolate, board game

Summary

Each material requires different skills to shape it.

It is important that you choose the right material and scale for any model you build to represent your graphic product.

6.3 The designer's role in the manufacturing process

Initial ideas

When you start the design process for your GCSE coursework, you will produce lots of ideas that need to be narrowed down – some will need to be eliminated while others will be developed. One way of choosing which to eliminate is to produce quick mock-ups of some of your ideas. The focus is on 'quick', so your materials may include paper, masking tape or adhesive tape. You can then get some feedback or refer to your own design specification to see if the models meet with your original ideas. You may also want to do a survey of your target market using ICT. This can be recorded as a graph and included in your testing. Once you have selected your final ideas, you will need to develop a small number of them, for example consider names, typefaces, logos, packaging or points of sale.

Objectives

Understand when to use mock-ups, models and prototypes and the difference between each.

Understand how to develop ideas into a final product.

Incorporate ICT into the design process.

Development

A **CAD** package can save time, because you can use it to easily produce a number of views and options, and make changes quickly and easily. Diagram **B** shows computer-generated models of a point-of-sale display drawn using a CAD package such as ProDesktop. Remember that all of these are still only on a computer and have not actually been made yet. Some of the benefits of using a CAD package in this way are as follows.

- It is very easy to produce a whole range of views, colours and textures using this type of software.
- At this stage you can get feedback and then have a conversation about any changes required, or refer back to your own design specification.
- It can help to ensure that you are making a product that is really needed and avoid spending unnecessary time and money.
- It is very easy to change aspects of the design without having to change the entire thing.

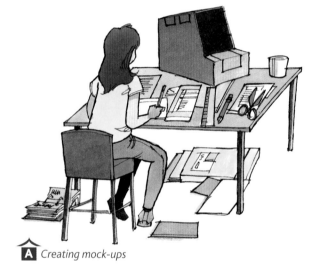

A Creating mock-ups

Key terms

Computer-aided design (CAD): producing a design using a computer.

a Basic point of sale design using CAD

b See-through of the product

c Colour change

d Foreground and background change

B

Modelling

Materials used for modelling ideas must be quick and easy to use. The choice of material will depend on the type of project or the part of the project being modelled. Models can be in the form of a 2D sketch. These will be based on initial ideas and will lack some detail, but they may clear up any basic confusion. You should be able to develop your simple 2D sketch using 3D sketching and modelling.

It is often helpful to make 3D models in the early stages of the design process, because a visual 3D product can be very powerful. The advantage of a 3D model is that it can be viewed from all sides, and you can judge whether or not it looks as you intended. Later on in the process you can show people a variety of different 3D models. Discussion at this early stage can stimulate a range of new ideas, such as the use of different materials. It is far more cost effective to make mistakes with a paper or card model early on than in your final product.



AQA *Examiner's tip*

Try to keep any mock-ups you produce no matter what quality they are. They can help to show the development of your idea and provide evidence of your thought processes to gain extra marks.

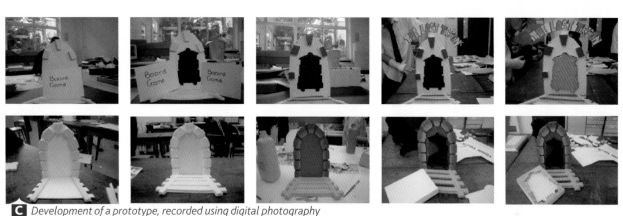

C *Development of a prototype, recorded using digital photography*

Prototype manufacture

Why make a prototype?

A major part of the GCSE course is to produce a 3D outcome. You are expected to produce a prototype of your design idea(s), just as manufacturers would in industry. Diagram **C** shows the production of a point-of-sale display from the initial idea to a final 3D prototype. Digital photos like these are an excellent way of recording lots of information, and will show your teacher how your work has progressed. You should include some notes with your photos to explain your choices, such as the materials used, the colours selected and tried, and any feedback.

Summary

CAD is an excellent way of developing an idea.

Modelling your ideas should be very quick, using materials available in your school.

6.4 Target marketing

Target markets

Whilst researching, you will be thinking about a potential **target market** for your designs. Remember that products are designed to be a commercial success. How do you find out who is part of your target market? One way of finding out is to ask lots of questions aimed at a possible target market. This will be based on factors such as age, gender, occupation, interests, attitudes and values, and socio-economic group.

You may have experienced questions like these from someone with a clipboard, who approached you and asked if you had five minutes to spare. Their questions, and your answers, may have helped a company to find out what their customers want. If enough of their customers want a certain thing, then the company may change its product or launch new ones.

Objectives

Understand what target marketing is.

Learn how 'gap in the market' identification is used to promote a product.

Key terms

Target market: the group of people your design is aimed at.

Market Segmentation

1. Identify all the different types of people in the market
2. Develop profiles for the resulting segments of the market.

Market Targeting

3. Evaluate each segment
4. Select the target segments

Product Positioning

5. Decide on how your product can be aimed at this target segment
6. Select, develop and communicate the chosen concept

A *Market research*

B *Professional cyclists have a common interest and form a target market for specialist equipment companies*

Activity

Apple first started making computers, they then developed the iPod, with a range of different shapes, sizes and functions. They then developed the iPod touch and the iPhone. Put yourself in the position of an Apple designer and try to imagine what might be the next range of products to be produced. Where is there a gap in the market?

C *Apple iPhone*

Target marketing in practice

Netbooks are the latest range of laptops to come onto the market and are specifically designed for web browsing and mobile communication. They are half the size of a traditional laptop and much lighter and therefore easier to carry around. At present they are not as powerful as the bigger laptops but advances in technology are likely to solve this issue. What do you think is the future?

This new generation of laptops has been designed for the target market of people on the move, who use wireless mobile internet technology. Most of the major manufacturers in this market are now introducing this type of new technology. You may have them in your own school.

D *A netbook*

This is an example of how manufacturers saw a gap in the market, especially as students were becoming increasingly dependent on ICT and needed a more affordable and robust product to use at school, at home and on the move.

Summary

A target market is the group of people which your design idea is aimed at.

You need to gain feedback on your designs from a sample of your target market.

AQA Examiner's tip

- Always try to give your GCSE work a sense of reality.
- If possible, try to find a gap or niche in the market. For example, it is better to create and promote a new rock band rather than an existing one, since the existing band and all its products will have been promoted already.

7.1 Typography

■ Fonts

Typography has long been a vital part of promotional material and advertising. Designers often use typography to set a theme and mood in an advertisement, for example using bold, large text to convey a particular message to the reader. Today, typography in advertising often reflects a company's brand. **Fonts** used in adverts convey different messages to the reader: classical fonts for a strong personality, while more modern fonts for a cleaner, neutral look. Bold fonts are used for making statements and attracting attention.

A font consists of:

- CAPITAL LETTERS – also known as 'upper case'
- small letters – also known as 'lower case'.

Companies and brands use fonts to say something about their values. The font Times New Roman is taken from the newspaper of the same name. Who reads this? This **typeface** is known as 'serif', and the serifs come from the use of brushes and chisels in the past. Generally speaking, we can think of serif typefaces as conveying values such as quality, seriousness and tradition.

Letters without these extra strokes are know as 'sans serif'. Sans serif fonts, such as those used in the Sun newspaper for example, suggest better value for money, an element of fun and modern values.

'*Virgin*' is known as script. This looks handwritten and therefore seems trustworthy and friendly. A disadvantage is that script can be hard to read. Decorative fonts such as the one used in the Coca-Cola logo are designed to attract attention. They can be any style.

Letters have basic part-names as shown below.

STEM	SERIFS	BAR	CURVE	CONTINUOUS CURVE
P	T	H	G	O
The vertical stroke of a letter	A short line added to the ends of letters	An arm joining two parts together	Any curved shape	A line which shows no join

A *The parts of a letter*

Changing the way text looks

We can change text in a variety of ways. Type size is measured in points. One point is 1/72nd of an inch, about 0.25 mm. So a

72pt

letter would be about this size (25 mm high).

Type can also be made narrower or wider, or finer or darker, such as Arial, Arial Narrow and **Arial Black**.

The text we produce can be justified left, right or centred depending on what we are doing, as shown in Table **B**.

B *Different text positioning*

Left	Right	Centre	Justified
This book has been written to help with GCSE Graphic Products controlled assessment and examination.	This book has been written to help with GCSE Graphic Products coursework and examination.	This book has been written to help with GCSE Graphic Products coursework and examination.	This book has been written to help with GCSE Graphic Products coursework and examination.

Letter spacing (or **kerning**) is the space between letters, and it has a big impact on the presentation of your work. It can make the text harder to read if the letters are too far apart or too close together. For word spacing, too little space between words causes the words to merge together and it becomes difficult to read. Too much space between words can also make it difficult to read, and can be distracting and so make reading less fluent.

Line spacing is the space between two consecutive lines, or rows, of letters. The amount of space needed will depend on the typeface used.

Activity

1 Using software on a computer, generate your own initials with a variety of typefaces, including serif, sans serif and script.

AQA *Examiner's tip*

You may be asked in an exam to design and develop the name of a product. You must understand some of the basic typefaces available and what sort of significance or impact they can have.

Activity

2 Collect a variety of magazines, then produce and annotate a mood board on the different typefaces used in the magazines. Include comments on the typeface, colour, size, justification and spacing used.

Summary

Typography is a technique used to enhance the style and design of lettering.

A variety of different typefaces and fonts can be used to enhance the presentation of your work.

7.2　Use of ICT and encapsulation

■ Use of ICT

DTP

You may be aware of such programs as CorelDRAW or Photoshop. These are some of the more popular **desktop publishing** (DTP) packages available in schools. These programs are often used in the design of magazines, newspapers, leaflets and flyers as they give more control over the layout of a page. Microsoft Publisher is another similar package in which text and images can be imported and manipulated.

A Using DTP to develop ideas

Objectives

Understand and demonstrate a knowledge of computer graphic manipulation.

Be able to use ICT to present a final idea to the client.

Understand and demonstrate a knowledge of encapsulation.

Key terms

Desktop publishing: using a computer program that combines text and images.

Import: bring an image from one application into another application.

CAD: the process of developing an idea using a computer.

Encapsulation: the inclusion of a printed item within a transparent outer casing, for example a thin layer of plastic bonded over a printed surface.

Activity

1 Using the software you have in school, copy the name of your favourite magazine, then develop/change it as many times as you can. Diagram **A** is a very simple example, using a fictional magazine title 'Football'. Each time you do this type of copying and pasting activity, add some annotation to explain what you are trying to do, or what you have done. Try to include typeface, font, colour (complementary and contrasting), tone, shadows, background, orientation of text, mirror images, manipulation and resizing.

Use of a scanner

A very simple way of using a scanner in your design folder is to produce a line drawing of a design, usually with a fine liner. Using software such as CorelTRACE, scan your design, then convert it to black and white, then trace around it. You can now **import** it into a CorelDRAW file where you can then develop your own work in a variety of colours and textures, in a similar way to how you developed your text.

CAD

Once you have completed any sketching, you can start to design on the computer. Computer-aided design (**CAD**) is the process of developing an idea and then changing it by using a computer. Some CAD programs, such as Google SketchUp, are free in school. Other CAD packages you may be familiar with are ProDesktop and 2D Design.

CAD has many advantages: it saves time and money; it gives the designer and the client far more opportunities to produce an ideal product; and it gives everybody concerned an exact representation of the final product without anything being made. Designs can always be modified, reworked and developed. If they have been done on a computer then the process can be quick and economical. A design can be viewed in 360 degrees, and textures and colours can be changed at the press of a button. Once you have designed a product it is very easy to produce a working drawing with lots of views. When presenting work to a client it is important that you show them as much detail and information as possible.

There are some disadvantages of the CAD process:

- Initial set up costs can be high.
- Whoever is going to use this technology needs training, which takes time and is expensive.
- Other equipment may be required to manufacture your design.

> **AQA Examiner's tip**
>
> Try to produce evidence in the form of a series of screen captures, which can then be mounted and annotated at a later stage. Examiners and moderators are trying to see how your work was developed and what from.

> **AQA Examiner's tip**
>
> When using a graphics package always save your original name or logo, copying and pasting it every time you change or develop it. This will provide strong evidence of good ICT skills, which the examiners are looking for.

Activity

2 List three advantages and disadvantages of using CAD.

Encapsulation

Encapsulation helps to protect a printed product that will be handled many times. The products are encased on both sides by a thin layer of plastic which is bonded to the surface normally by the addition of heat. This provides a high gloss finish that can be wiped clean which, although expensive, has the benefit of increased durability. Menus are a good example of an encapsulated product.

Activity

3 Ask your teacher whether they can demonstrate encapsulation on a machine at school.

Summary

DTP and CAD can develop and enhance your work.

Objects can be imported from one application into another.

Images can be manipulated in a variety of ways.

8 Pictorial drawings

8.1 Isometric drawing

Basic rules of isometric drawing

You will at some point need to draw in 3D, which is called **pictorial drawing**. **Isometric drawing** is a really good way of presenting a design in 3D. Isometric means 'equal measure', because the angles used are 30 degrees to the horizontal. Drawing on the computer in isometric is a very useful skill, easily practised if your school has a CAD package. If it has, you can set your page with an isometric grid, and set to 'lock on grid'. This means that it is only possible to click on the isometric grid at the intersection of the lines – and this makes drawing much easier!

A good example of how isometric drawing can be used is the soma cube puzzle. This puzzle is made up of seven basic pieces, based on cubes, as shown in Diagram **A**. The pieces have been drawn using TechSoft 2D Design in isometric, with tone added.

It is possible to then use this same program to produce a sequential diagram of the assembly process. This has lots of advantages. Can you think of any? Diagram **A** is a sequential diagram produced by a student. There are no words on this – it is purely a pictorial image and it is not language specific.

Objectives

Understand the basic rules of isometric drawing.

Be able to draw in isometric, using crates.

Be able to construct more complex shapes in isometric.

Key terms

Pictorial drawing: a 3D drawing.

Isometric drawing: a pictorial drawing without horizontal lines, which shows objects in three dimensions. Lines are vertical or at 30 degrees to the horizontal.

A The seven pieces of the soma cube puzzle

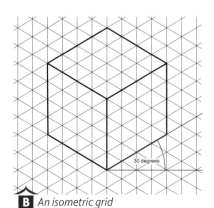

30 degrees

B An isometric grid

Activity

1 Produce an isometric cube of any size, then construct ellipses on all three sides. See Diagram **D** for guidance.

AQA Examiner's tip

Practise converting your 2D designs into 3D and then put ideas in 3D back into 2D.

C *How to solve the soma cube puzzle!*

Making more complex shapes

Isometric drawing is also used to construct round objects and more complex products and shapes. This can appear to be a very difficult technique but using the following basic methods it is very straightforward. A basic principle is to draw everything from a feint isometric crate. This is a square drawn at 30 degrees. To construct an ellipse divide this 'square' into four. See Diagram **D** for further guidance.

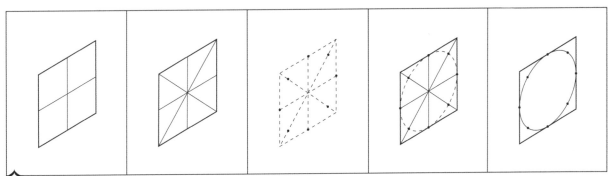

D *Producing an ellipse*

Once you have tried a design in one direction, try it in the other. This will improve your drawing skills. Drawing ellipses is a good starting point, because you can join two together to form a cylinder. Remember to use thick and thin lines to enhance the outline of the shape.

Summary

Isometric drawings have no horizontal lines.

They are used to produce 3D drawings.

More complex shapes can be produced using a simple crating technique.

Activity

2 Sketch a common everyday product in isometric, using an underlay. Construct crate lines, add thick and thin lines, and then colour. Use a different media or photocopy your idea three or four times and produce the same idea but in a variety of media.

One-point perspective sketching

Perspective drawing is based on the fact that all lines appear to converge and meet at a **vanishing point**. An excellent example of this is when you look down a railway line or a very straight road and all the lines appear to meet or converge at one point. This is called the vanishing point, and it usually sits on a **horizon**.

One-point perspective is a form of 3D drawing created with a single vanishing point. All horizontal lines converge and meet at one common vanishing point.

Both one-point and two-point are excellent techniques for producing 3D drawings of point-of-sale displays and assembled packages. It is important that you understand how to construct ideas using both techniques.

The technique for one-point perspective sketching is shown in Diagram **A**.

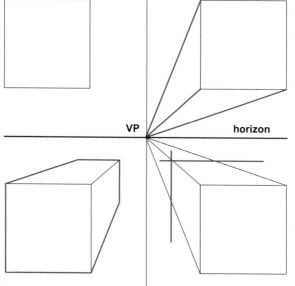

1 Draw a basic shape using construction lines.

2 From each intersection take lines to the vanishing point.

VP horizon

4 Add thick and thin lines, erase construction lines.

3 Set the depth of the cube, draw horizontal and vertical parallel lines.

A *Drawing a one-point perspective object*

Activity

1 Using the technique shown in Diagram **A**, produce a one-point perspective version of each image in Diagram **B**. Try to include thick and thin lines, and then tone.

B *Can you turn these 2D shapes into 3D one-point perspectives?*

Key terms

Vanishing point: the point or points at which all lines in a perspective drawing appear to meet.

Horizon: the line on which most vanishing points sit - usually where the sky meets the land.

One-point perspective: a drawing created with only one vanishing point.

Two-point perspective: a drawing created using two vanishing points.

Two-point perspective

The **two-point perspective** method, although a little more complicated, produces the most realistic views of an object or product. Here, there are two vanishing points sitting on the horizon. There are no horizontal lines and all non-vertical lines should go back to either of the vanishing points, as in the example in Diagram **C**.

It is possible to draw shapes above, below and on the horizon, like the ones in Diagram **C**.

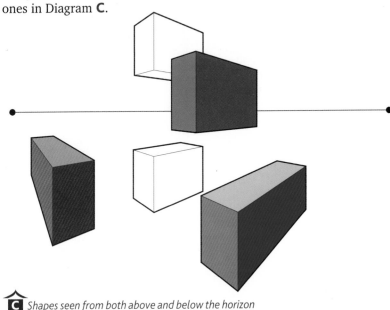

C *Shapes seen from both above and below the horizon*

The technique for two-point perspective sketching is shown in Diagram **D**.

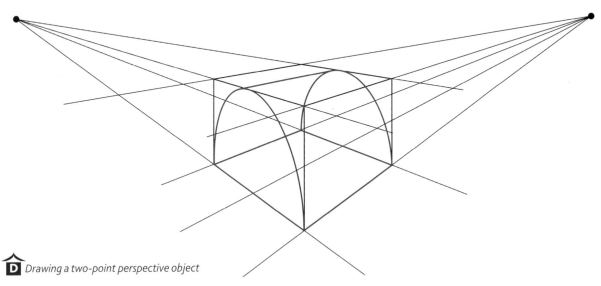

D *Drawing a two-point perspective object*

AQA *Examiner's tip*

Always try to use construction or guide lines in this type of work, especially in the exam.

Activity

2 Using the technique shown above, can you produce a two-point perspective drawing of your graphics classroom and/or some basic furniture? Now try to draw it above the horizon and then on the horizon.

Summary

One- and two-point perspective are types of 3D drawings.

The vanishing point is a point where all lines meet or converge.

The horizon is a horizontal line on which the vanishing point sits.

9.1 Third angle orthographic projection drawing

What is third angle orthographic?

Orthographic means 'drawing at right angles' and it is a 2D method of drawing items or products. It is used to show sizes and details of a design and it usually requires three views (front, side and plan) with sizes or **dimensions**, usually in millimetres. Drawings are produced to a British Standard BS8888, 2006, so that anyone can understand and interpret the information on the drawing.

Third angle orthographic projection is the most common method of producing a working drawing, made by using the following 2D views:

- **front view** produced by looking at the front of a product
- **plan view** drawn directly above the front view
- **end/side view** drawn by looking at the side or end of a product.

A *The symbol for third angle orthographic projection*

These types of drawings are used for manufacturing purposes, so the drawing should have enough detail in the form of dimensions to enable a third party to make the item. You will need to produce a working drawing for your major 3D item which you are designing for your GCSE coursework. You will use it to help manufacture your product, so it will need to be drawn to scale.

Producing a third angle orthographic drawing

We are going to make a third angle orthographic drawing of a simple 3D image, the letter C in Diagram **B**. Start with the largest side first, which is usually the front view. Draw construction lines for the front view, making sure you are using a scale you are familiar with (1 & 2). Project these lines up, to enable you to produce your plan view (3). Project lines across so that you can construct your side or end view (4), and use dotted lines to show any **hidden detail** (5). Add the outside lines in bold (6), and the sizes or dimensions of your work (7). State the scale and dimensions you have used. Remember the golden rule:

> *Look on top then draw on top, look from the right then draw from the right.*

Objectives

Understand the basics of formal drawing.

Be able to produce a simple third angle orthographic drawing to British Standards (BS).

Key terms

Dimensions: sizes, usually in millimetres (mm).

Third angle orthographic projection: a standard technique for producing detail and working drawings that everyone can understand.

Front view: a view looking towards the front of your product.

Plan view: a view looking down at the top of your product.

End/side view: a view looking at the side or end of your product.

Hidden detail: lines which you know exist but you cannot see.

B *A 3D drawing of the letter C*

FRONT VIEW

1 Start by drawing construction lines for the size of your front view.
2 Make sure you use a scale you are familiar with.

PLAN VIEW

3 Project these lines UP to enable you to produce your plan view.

END VIEW

4 Project lines ACROSS so you can construct your side or end view.

5 Hidden detail is shown by dotted lines.
6 Add the outside lines to your product in bold.

Activity

Imagine a pyramid (a square base rising to a point) and produce a detailed orthographic drawing of it. Start with the largest side first, which is usually the front view. Add sizes to see if another student can make it from the information on the drawing. How many views will you need to draw?

Summary

Orthographic drawing is a 2D method of drawing products, used so that anyone can interpret the drawing and make the product.

An orthographic drawing is usually drawn showing three views: front view, plan view and end view.

The golden rule is to look on top then draw on top, look to the right then draw from the right.

PLAN VIEW

Follow this simple rule

Look on top then draw on top look from the right then draw from the right.

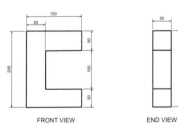

FRONT VIEW END VIEW

7 Add sizes or dimensions to your work.

 How to construct a third angle orthographic drawing of the letter C

9.2 British Standard conventions

British Standard conventions are standards set by the British Standards Institute (BSI). They are standards used for working drawings that are recognised throughout the manufacturing industry. This means that any working drawing produced can be understood anywhere in the world. For example, a product can be designed in one part of the country and then manufactured in another. All computer-aided design packages (CAD) have the facility to draw using British Standard conventions already set up within them.

Activity

1 Can you think of any other advantages in using a standard to produce drawings?

Using British Standard conventions

In almost every controlled assessment, there is a question about British Standard conventions. These are easy marks to gain, yet very few candidates get them! Follow these few simple rules when attempting this type of question:

- Dimensions should read from the front or from the right.
- **The leader line** should not touch the object.
- The leader line should extend past the dimension line a little, but reach to the edge of the object to be measured.
- The dimension should be in the middle of the line but not touching it.
- Arrowheads should be solid and to a point.

Key terms

Leader line: the line that defines the outer limits of an object to be measured. It does not touch the object and extends past the arrowhead.

Outline: the outside line of an object.

Centre line: the line that defines the centre of a circle or an arc.

A *How to label an object using British Standard conventions*

Other conventions you should use in your work:

- **Outlines** are the outside edges of the object, shown as a continuous thick line.
- Dimension is a specific length; it can be a whole or a part of an object and is usually measured in mm. These are shown as continuous thin lines.

- Projection lines are taken from one view of an object and used to create another view. For example, when looking at the front view of an object you can project lines from the object above to create the plan view (see Diagram **C** on page 63).

- Hatch lines are usually at 45 degrees, and are used to fill an area in (see page 66).

- Hidden details are the parts of the object which you cannot see but that you know are there. These are shown as short dashed lines.

- **Centre lines** define the centre of a circle or an arc, and are usually represented by long dash, short dash (long chain) lines shown in red.

- Section lines define where an object will be cut, and are shown as long chain, usually with a letter at either end (see page 66).

- Short break lines are represented by wavy lines and are used when an object is very long or has the same cross-section. These are used so that you do not have to draw the whole shape.

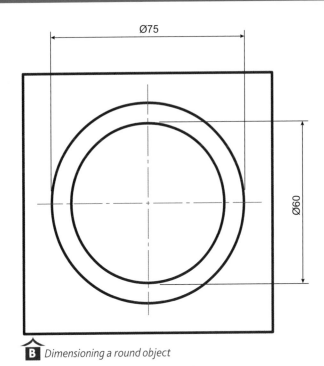

B *Dimensioning a round object*

———————————	continuous thick line – **outlines**
———————————	continuous thin line – **dimension, projection, hatch line**
- - - - - - - - - - - - - - -	short dashes – **hidden detail**
—— - —— - —— - ——	long chain – **centre lines**
A↓ —— - —— - —— A↓	long chain, thick end lines, arrows – **section lines**
～～～～	wavy lines – **short break lines**

 Line types

Activity

2 Try adding some dimensions and other conventions to the objects in Diagram **D**. Use British Standard conventions to label these drawings.

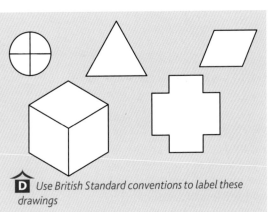

D *Use British Standard conventions to label these drawings*

AQA Examiner's tip

You may be asked during a controlled assessment to add dimensions or other conventions to an incomplete drawing. Knowledge and understanding of these techniques are important for a successful response.

Summary

British Standard conventions are an important element of a controlled assessment.

A number of different types of lines are used to produce a successful drawing.

9.3　Sectional and exploded drawings

■ Sectional drawings

What are sectional drawings?

Sectional drawings are drawings that show the inside of an object as if it was cut in half. For example, sectional drawings could be used to represent what a standard HB pencil may look like inside if it was cut open. You could cut it in half one of two ways. You could cut it along its length, and this would produce a sectional drawing which would include an outline of the pencil showing the lead inside. But, if you cut the pencil across its diameter, the drawing would show the cross-section of the pencil.

The technique of cutting objects open is called sectioning. The areas where the object is cut are shown by **hatching**, which is made up of lines usually drawn at 45 degrees. Different parts of an object are hatched differently (see Diagram **B**). Sectional drawing can be a very complex technique but an understanding of the technique is important.

Making a sectional drawing

Imagine cutting through a pencil sharpener with an axe. What would you see? Why would you want to see inside an object?

Objectives

Develop an understanding of sectional and exploded drawings.

Understand when to use these techniques.

Key terms

Sectional drawing: a drawing produced by cutting through an object.

Hatching: equally spaced lines, usually drawn at 45 degrees, which represent where an object has been sectioned.

Exploded drawings: the production of a 3D drawing showing construction methods and components, which are all drawn separately but in relation to one another.

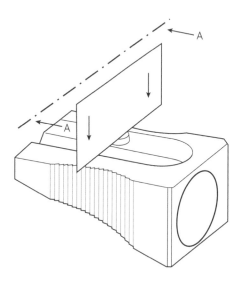

A *Cutting through a pencil sharpener*

A line is drawn across the view you want to section, and arrows are then added in the direction of the view you want to produce. These arrows are labelled, starting with the first section line labelled as A–A. In a complex assembly drawing you may have lots of sectional views, so the first section line is called A–A, then the next section line is labelled B–B, and so on.

When the axe cuts through the surface of the pencil sharpener, where it makes contact with the object a hatch line is produced on the sectional drawing. The hatch lines are usually at 45 degrees, and equally spaced. Where the axe does not touch the surface of the object (for instance the area where the pencil is inserted) the area is left blank.

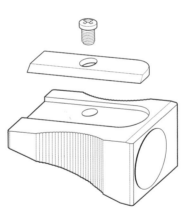

A – A

B *A–A cut through the pencil sharpener, showing hatch lines*

Exploded drawings

What are exploded drawings?

Exploded drawings are 3D drawings used to show how an object has been constructed. Sections of the object are drawn separately from one another but remain in relation to each other. If you were to buy a flat-pack product, exploded drawings would be included in the instructional booklet to show you how to construct the product. Exploded drawings would also include the joining methods you would need to use in order to be successful. This technique has been used in successful GCSE coursework.

Summary

Sectional drawings show how an object would look if cut through.

Exploded drawings are 3D drawings used to show how a product is assembled.

C *An exploded isometric sketch of a pencil sharpener, together with an assembled drawing*

9.4 Self-assembly, scale drawings, site plans and maps

Self-assembly

Self-assembly products are produced by a company in pieces and sold as 'flat packs', with detailed plans for the customer so that they can put the item together at home. Customers would not be able to assemble the products without good quality, easy-to-read assembly instructions. Self-assembly products are drawn in 3D because most people find such drawings easier to visualise. Remember that a picture saves a thousand words! If you have ever seen any self-assembly instructions you will know that they have very few words, if any. They also vary in their usefulness!

Self-assembly has lots of benefits:

■ The company can store many more products in a certain space, and then make more money.

■ The customer pays less for the item because the company has not had to pay for professional assembly, and this saving is passed to the customer.

■ 3D-drawn instructions are simpler and cheaper to produce than instructions using words because they require less paper, and they are generally printed on recycled low-quality paper, which is also better for the environment.

Scale drawings

A **scale** drawing is produced when it is impossible to draw the product at its actual size because it is far too big to fit on a single sheet of paper. To enable it to fit on paper, a scale is used (see Chapter 6). Scale is a ratio and therefore has no units. The convention is that the scale of a drawing is the ratio between the drawing and the object, not the other way round. For example a scale of 1:2 indicates that the drawing is half the size of the object. It is very important to remember that the *actual* size/dimension still needs to be on the scaled drawing; you *do not* put the size as the length of the line on the paper. As a check, the person reading your drawing should be able to measure your line and then multiply it by the scale to get the actual size.

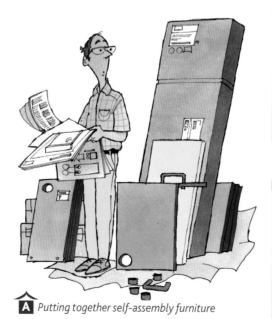

A *Putting together self-assembly furniture*

Activity

1 Can you think of any disadvantages of self-assembly drawings?

Key terms

Self-assembly: independently constructing an item from a kit using instructions supplied.

Scale: the ratio between the drawing and the object.

Site plan: a drawing showing a piece of land from above with existing and/or new buildings and features.

Schematic drawing: a drawing of an electrical or mechanical system.

Floor plan: a scaled down drawing to represent how the floor space in a building is to be laid out.

Activity

2 Draw your route to school on a scaled map, then give it to a friend to see if they could find their way to school. Include a key of some of the major landmarks you pass.

Scale - 1:1

B *Life size-scale drawing*

Scale - 1:2000

C *Small-scale drawing*

Site plans and maps

Site plans are drawings which show a project site from above. For example, when a builder is building a new street, site plans are used to represent where each of the houses will be built. They are used at public meetings before building begins, by local councils to judge planning permission, and by sales people to show potential buyers where their house will be and what it will look like.

Let's say for example that a student has chosen a computer game promotion as a GCSE project. As part of this they can produce some 2D making outcomes. The game will be promoted at a convention and they want to produce a plan of the convention centre to show the location of the stall on that day. This would be a site plan. They could also produce a 'sat-nav' style map that gives directions to the centre from the nearest motorway junctions. The map could even be in the style of Harry Beck (see Chapter 5, page 37)!

Floor plans are scaled down drawings used by architects and designers to show exactly how the inside of a building is laid out. Details of where doors, windows and positions are shown allows everyone to understand how the space inside a building is to be used.

Schematic drawings are drawings produced for a specific practical function, usually electrical or mechanical. For example, an electrician will use a schematic drawing to illustrate the power lines and where the electricity cables enter a building. A plumber may use a different schematic drawing showing the location of the water supply and sewerage pipes to the building.

Activity

3 Construct a net for a cube 60 mm × 60 mm × 60 mm, including tabs. Now produce similar nets using a scale of 1:2 and 1:4.

D *Site plan for a building site manager*

Summary

Scale helps other people to understand the real dimensions of an object from a drawing.

Site plans are drawings of a site and are usually produced in the construction of buildings.

Schematic drawings are produced for a specific purpose in the building process.

10.1 3D containers and surface developments

What are surface developments?

Surface developments are the 2D, or flat, versions of an item that will eventually be assembled into a 3D object. They can be produced in a range of different materials.

Each surface development is a flat shape that is **scored**, creased, and sometimes glued, before being folded into a 3D shape. Surface developments are used for a variety of products, such as Easter egg packaging or fast-food meal packaging.

They are designed using CAD. The benefits of using CAD designed surface developments or nets means that less waste is produced. A variety of sizes can be produced using the same design.

You may need to produce a surface development for a product that needs to be packaged. So you need to understand about fold lines, cut lines and tabs.

Surface development manufacture

Paper and card with straight edges are cut to shape and size on large guillotines. For irregular shapes, such as the surface developments of packages, a machine process called **die cutting** is used.

Die cutting is an expensive option that is used when large numbers of unusually shaped objects are required. Narrow blades are shaped to the outline of the surface development and fixed to a board. When this is pressed down onto the printed package it cuts around the outline of the surface development like a pastry cutter.

The surface development would then have any further finishes such as varnish or embossing applied before being die cut to its final shape.

Surface developments for a package are printed in multiples on a sheet of card.

Tessellation is a method of alignment that reduces waste to an absolute minimum (see Diagram **A**).

Round-edged steel strips, called creasing bars or creasing edges, are then used to squash the fibres of the board where a fold is needed. Once the surface development has been cut out, creased and folded it may be glued, often with hot melt glue, ready for the product.

AQA Examiner's tip

Several CD-ROMs have lots of examples of surface developments on them. Ask your teacher to show you some of the more complex ones; print and try to assemble them.

Key terms

Surface development: a 2D version of an item that will eventually be assembled into a 3D object.

Score: indent along a fold line to help reduce the risk of the paper or card cracking.

Die cutting: an industrial process used to produce large quantities of the same surface development.

Tessellation: the arrangement of a surface development that reduces waste to an absolute minimum.

A Tessellation reduces waste

Activity

1 Trace the surface development, or net, in Diagram **B** and then decide which lines should be fold lines and which lines should be cut lines. Which product packaging do you think it will make?

B *Sample surface development: which lines are folded and which are cut?*

Joining and locking card

Card can be glued together using a variety of glues or designed in such a way that it becomes self-locking. Diagram **D** shows a container with a crash bottom, a similar design used in children's fast-food meal containers. The containers arrive 'flat' but are very quickly constructed into a 3D box. Diagram **E** shows a container with an interlocking fastening mechanism, which is not permanent. This type of container is often used for confectionery.

C *Can you sketch a surface development for both shapes?*

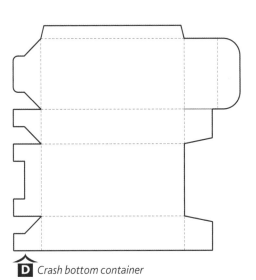

D *Crash bottom container*

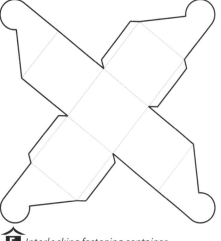

E *Interlocking fastening container*

Summary

Surface developments are the 2D, or flat, versions of an item that will eventually be assembled into a 3D object. They are used by most of us in our everyday life.

Designers have to consider a range of commercial and environmental constraints during the design process.

Surface developments are tesselated to reduce waste.

What is CAD and CAM?

Computer-aided design (CAD) is about using computers to assist you, the designer, during the design process. It can help in a number of ways, for example you can produce a design in a variety of materials and you can rotate a design through 360 degrees on any axis. Designs can be **manipulated** and **mirrored** with a simple click of the mouse. Any area of a design can be viewed at a range of magnifications.

Computer-aided manufacture (CAM) is about the manufacturing process linked to a computer system. There are lots of advantages when using CAM, for example it ensures that each product is produced exactly the same as the previous one. CAD and CAM can be linked together by converting the numerical data of a design into machine data that can be used to drive the machine. These sets of data are normally referred to as G- and M-codes. Most systems will offer a simulation of the cutter path, so that you can ensure it is as expected.

How to use CAD software

We are going to draw a surface development for a cube (60 mm × 60 mm × 60 mm), including all the tabs. The easiest way to do this is to follow these steps (also explained in more detail below):

1 Set your grid up to 10 mm units.
2 Lock to grid.
3 Draw a 60 mm × 60 mm square.
4 Copy and paste five times.
5 Add tabs.
6 Convert the fold lines into dotted lines.

The first step is to set the grid to 10 mm units in 2D Design: click on *setup, drawing, grid/coordinates*. Select the grid spacing to *10 mm in x and y*, and select *grid lock*. To copy and paste (which is similar on most CAD packages), use ctrl c to copy and ctrl v to paste (press these two keys together to make it work).

Objectives

Understand how CAD/CAM is used in the design of surface developments.

Key terms

Manipulation: reducing or enlarging a design. This can be done to shrink or enlarge an image whilst keeping its dimensions relative.

Mirroring: selecting an axis on which to produce a mirror image of a line, shape or design of a picture. This can save time in the long run.

AQA *Examiner's tip*

The use of a CAD package makes life much easier when designing your own surface development. Try and develop your skills with a variety of CAD packages and machines, checking you understand the basic principles.

A Setting the grid

B *60 mm x 60 mm square*

Now we can add the tabs: 10 mm wide ends cut at 45 degrees. On most CAD packages, you select multiple lines by holding *shift* down and then selecting as many lines as you want using the mouse. Convert the fold lines into dotted lines. Remember that if a tab has been added, the inside line of the tab now changes from a solid cut line to a dotted fold line.

C *Tabs added with dotted fold lines*

The same net is shown in CorelDRAW in Diagram **D**. Here, you can reduce the net by 50 per cent for a scale 1:2 (or less) and use *copy*, *paste* and *mirror* to tessellate the surface development.

D *A cube in CorelDRAW, scaled down by 50 per cent*

Nine surface developments are the minimum number that can fit on an A3 sheet. However, if you rotate and move your surface development, you can fit even more on a sheet. What is the maximum number that will fit?

E *A tessellated net*

AQA *Examiner's tip*

If you use this technique, photograph (or screen dump) every stage to help the examiner visualise your design process.

Activity

Once you are confident in making a cube, try adding the dots to make your cube a die. Remember that opposite sides should add up to seven.

Summary

Surface developments are easy to design with simple CAD software, using a few simple guidelines and a process of trial and error.

11 Information drawings

11.1 Representing data in graphical form

■ How can data be presented?

When data is collected it needs to be **collated** and **analysed**. Putting the numbers into a table can make it very hard to interpret. In order to display the data in a more understandable way it is usually converted into a graphical form, either by drawing graphs by hand or using a spreadsheet application such as Microsoft Excel.

Data can be presented in a variety of ways:

- bar charts
- pie charts
- line graphs
- pictographs.

Bar charts

Bar charts are great for showing *comparisons* between different data. They show the relative size of each category of data in a visual way, which is especially useful when you are trying to show the results from a questionnaire where the data shows preferences for a particular product or colour.

Bar charts can be drawn with the bars vertically or horizontally. It is up to you how you draw the chart but make sure that you label the axes!

Computers are good at creating charts and you should be able to design your chart to suit your needs.

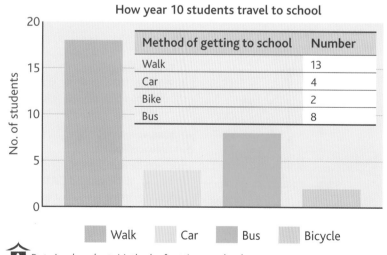

How year 10 students travel to school

Method of getting to school	Number
Walk	13
Car	4
Bike	2
Bus	8

A *Data in a bar chart: Methods of getting to school*

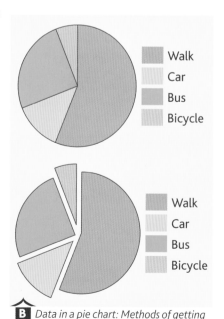

B *Data in a pie chart: Methods of getting to school above in 2D and below in 2D exploded*

Pie charts

Pie charts are great when you need to show *proportions* within the data. This means that if you want to show, for example, how many people used different types of transport to get to school in your class, you may want to show that as a percentage of the whole class.

In this way, the data are converted into a percentage of the total to show segments of the circle that look like slices of a pie. This is calculated by using the following formula:

$$\frac{\text{actual}}{\text{possible}} \times 360°$$

Remember that the total number of degrees should add up to 360 and also do not forget to label the segments (and to use a key) or it will not be clear what each of the 'slices' represents. Colouring each segment with a different contrasting colour will add to the impact of the pie chart.

Line graphs

Line graphs are used to show *changes* in particular data. If you visit someone in hospital you will see that changes in their temperature every hour are recorded using a line graph.

When you draw a line graph you need to make sure that the 'constant' data, such as months, are displayed along the bottom, while the 'variable' data, such as sales figures, are displayed on the vertical axis.

Pictographs

Pictographs are similar to bar charts but use symbols to represent the data. This makes it easier to understand because the symbols show what the data refer to. In pictographs you can use different symbols for different things but you must remember that the overall value of each symbol must be the same.

Houses sold in 2008

C *Data in a line graph: Sales of houses from an estate agent*

D *Data in a pictograph: The number of students who walk to school each day of the week (key ♦ = 10 students)*

Activity

Undertake a small survey in your class using the following questions to gather data. Then design appropriate graphs to display the data.

How do you get to school in the mornings?

What is your favourite colour?

How many pets do you have?

Summary

Bar charts are used to show comparisons between data.

Pie charts are used to show proportions within the data.

Line graphs are used to show changes in data.

Pictographs are similar to bar charts (and also shows comparisons) but are easier to understand because they use symbols.

AQA **Examiner's tip**

Marks are awarded for accuracy and colour quality.

AQA **Examiner's tip**

Understanding and drawing graphs will probably form part of the examination. Make sure you know when and how to use them. DO NOT include every diagram and chart you know of in the controlled assessment. One will probably be enough!

11.2 Signs and labels

Signs

Signs are there to give **instructions** or warnings. The best examples of these are road signs warning of such things as a bend ahead or how to get to a local attraction. Signs may include a symbol to help you to understand what the sign is about, although this also acts as a method of communicating to people who are not able to fully understand the written language, such as visitors from abroad.

It is important that the signs are clear and **eye-catching** so that they can easily be seen. The symbols that are used on these are called pictograms (see pages 38 and 81) and many of these have become known, and are instantly recognisable, all over the world. A good example of this is the sign that warns of men working in the road.

A *A roadworks road sign*

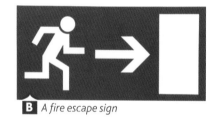

B *A fire escape sign*

Labels

Labels are attached to everything that we buy. They explain a lot about the product and will also tell you how to use it or how to care for it. They may be attached directly to the product or be given to you as part of the packaging or as a leaflet. They may also give information on the materials used in the product and packaging, so that they can be recycled if possible.

The most common labels that we see are on packaged food. It is now a legal requirement to label all food (except fresh meats and vegetables) with the following information:

- the name of the food
- the name and address of the manufacturer or seller
- the storage instructions including the 'use by' and 'best before' dates
- preparation and cooking instructions
- the weight or volume of the product, sometimes represented as 'e' which means 'estimated'
- a list of the ingredients, starting with the largest or main ingredient
- a list of any special claims and warnings, for example contents linked to food allergies

- nutritional information, such as the amount of sugar and fat per 100 g.

Many of these instructions also include symbols to make them easier to understand, such as symbols for freezing and cooking.

Another common type of label is the one found on clothes. This helps the purchaser look after them by giving washing instructions, usually as a series of symbols and often with written instructions.

Other labels that are important are the **Kitemark**, used to show the product has passed a safety standard and the **CE mark**, used to show the product can be sold anywhere in the European Community.

C A food ingredients label

Activity

1 Collect some food packaging and note down what needs to be included as part of the label. Check what information is found on all the packages.

D A garment care clothes label

E A barcode

Activity

2 Look at the labels on some of your clothes and, using the internet, find out what all of the symbols mean.

Barcodes

All products now carry a barcode as part of a label or the packaging. These are used by the retailer in several ways: scanning at the point of sale automatically enters the name and price of the product on the receipt and also tells the retailer what items are selling and what they need to re-order. It also records what other products are being purchased with the item.

In addition to keeping the shelves stocked, the information gathered from barcodes can help some stores in targeting what to advertise to individual shoppers because it gives a guide to their shopping habits. This is especially the case when customers use a loyalty card.

F The Tesco clubcard is a loyalty card

AQA Examiner's tip

Ensure that you fully understand what is included on labels. What makes a good, easy to understand sign?

Summary

Signs give instructions or warnings.

Labels give information that applies to a product.

11.3 Corporate identity

▮ What is corporate identity?

As shown in Chapter 5 on page 40, **corporate identity** has become the main method of making an organisation identifiable using visual images that are easily remembered. Most companies need a lot of customers and therefore need to be remembered in a similar way to how you remember other people: by the way they act and their personal characteristics – their identity!

Logos

Organisations use a **logo** to help the public recognise them. These logos often give an impression of the company and the quality of the goods or services provided.

A corporate identity is usually based around a logo, but may also involve other elements of the organisational structure, such as company uniforms, advertising, public relations, information and the way that the company believes that it should behave, sometimes called its 'ethical position'.

Key terms

The word 'logo' is usually used to describe a combination of type (words) and symbols. However, there are several different types of logo:

- **Logograms** use the initial letters of an organisation, such as IBM.
- *Symbols* use a simplified image that helps to communicate the service or product, such as Apple.
- *Logotypes* use a different typeface to be distinctive, such as Virgin.
- *Background* images are used by some organisations to communicate information about the products or services they offer to customers, for example the glasses of milk being poured next to the Cadbury's logo.

A IBM is a good example of a logogram

B Apple uses a symbol as a logo

C Virgin's logotype

D Cadbury's uses a background image of glasses of milk

When working on a logo for an organisation, the designers must take many factors into consideration, for example:

- Is the logo clear and eye-catching? These elements can be achieved by using **contrasting** colours and simple shapes.

- Will it transfer to all types of material for use by the organisation? The logo will have to be applied to a variety of items and be produced in a variety of sizes – will it still be effective?

- Does it tell you enough information to become the trademark for the organisation? Many organisations will want just to put this logo on their products and not include their full name. Will it be suitable for this?

How is corporate identity used?

A corporate identity is about far more than just a logo. Once an organisation has agreed its corporate identity, it will want to ensure that it is widely adopted, and not be just an isolated logo on the door to head office. Corporate identity is about the way people look and behave in an organisation and the way they conduct their business. It should tell the customers a lot about what they are likely to expect from the company.

E How can you tell that this tennis player is wearing Adidas clothing?

Good examples of corporate identity are organisations such as Nike and Adidas who produce a vast range of different items but are still recognisable by the use of their identity. The identity will be on everything that the company is associated with, whether the products are sold to customers or not.

Activity

Produce a new corporate identity logo for your school or college.

Summary

The corporate identity of an organisation is more than just a logo.

Logos can be made of pictures, symbols and words.

AQA Examiner's tip

Make sure that you understand the elements that make an effective corporate identity.

11.4 Symbols, ideograms and pictograms

Symbols

Symbols are used to help communicate information that could be instructions or simply an aid to help people recognise something.

There are three types of symbols:

- Enactive or action symbols – these show something happening, such as the road sign for a pedestrian crossing showing people crossing the road.
- Iconic or pictorial symbols, which are often called pictograms – see opposite.
- Symbolic or abstract symbols – these are used to represent something that we can recognise from the concept they are portraying. A great example of this is the Olympic symbol which uses five interlocking rings that represent the five inhabited continents of the world.

Objectives

Be able to produce symbols, ideograms and pictograms.

Know what is the best type of symbol to use for different situations.

Pedestrian Crossing

A *A pedestrian crossing road sign is an action symbol*

B *The Olympic five rings is a symbolic symbol*

We use symbols either on their own (pictograms) or in combination with words as signs. Their main use is to provide information in a universal way so that everyone can understand it.

Ideograms

Ideograms are simplified pictures which relate a message to other people. People have used this type of communication since the Egyptians began to write hieroglyphics and cave dwellers began to paint on cave walls. Ideograms tell a story without using today's conventional methods of writing.

We still use ideograms today to convey messages to others without the use of words. For example, if we see a sign showing a series of trees we will assume that it means a forest or if there is a sign with a plate, knife and fork we assume that it is somewhere we can buy food.

C *Egyptian hieroglyphics used ideograms*

Pictograms

Pictograms are similar to ideograms but are usually more stylised (or simplified). They use block, contrasting colours and are wordless, therefore eliminating the need for people to be able to read a language in order to understand the information. Pictograms are used in public places and on packaging to convey information.

You will find pictograms in lots of locations all over the world. The most well known (and probably most used) are those you find on public toilets to show which are for men and which are for women.

D *Camping pictograms: what do you think they mean?*

On packaging, pictograms are used to describe what should be done with the package (such as keep it dry) or the product enclosed. They also explain the properties of the materials that have been used (such as the recycling symbol).

Activity

Look at the instructions on the side of a packet of washing powder and try to work out what each stage in the process is.

Summary

Symbols, ideograms and pictograms need to be simple and easy to understand.

AQA *Examiner's tip*

Designing symbols and pictograms to meet a purpose is a popular activity within the exam.

oadstone
Wallisdown Road
6b
26
University
Waterloo
Wallisdown
Winton
edown Avenue
39
3 4b

11.5 Flowcharts

■ Input → process → output and feedback

Everything that is made uses a linear way of working. A linear way is used in very complex production lines and in very small one-off situations, such as in the making of a single piece of furniture. To put it simply, all systems have **inputs** which are then processed into **outputs**.

You will need to be able to identify the linear stages in a variety of situations and show that you can recognise the elements that are part of each stage. As an example, if you were producing a card CD sleeve, the inputs are the card and the printing tools (inks and plates). The **process** involves applying the image, cutting the card, folding the card and gluing the sleeve together. The output is the finished sleeve.

Although this seems simple to understand, there needs to be some method of knowing if the process is working correctly. Is there enough ink in the press? Is there enough card? This is called giving **feedback**. This information will inform the process **operator** what needs to be done. On many production processes this feedback is given to the operator with the use of warning lights and dials.

A simple example of this is when someone inputs fuel into the family car. The engine processes this fuel and the output is the forward movement of the car. The feedback is given to the driver on the fuel gauge to tell the driver when more fuel needs to be added. This can be illustrated using a **flowchart**.

Activity

Work out the inputs, processes and outputs, including feedback for:

making a hot drink

playing a computer game or

recording a TV programme.

■ Creating a flowchart

A flowchart is a way of illustrating a sequence of **operations** that need to be undertaken when doing a task such as manufacturing a product or repairing a machine. In this way it can also be used to find a fault and how to repair it – sometimes called a diagnostic tool. Standardised symbols and arrows show the direction in which you should follow the chart. The most common symbols and their purposes are shown in Diagram **A**.

Diagram **B** shows a simple flowchart showing the process of printing a document from a computer. You simply follow the arrows to see what you have to do next. The chart is used to check that no stage is missed out and that the order of activities is correct. When a decision is made that will result in a yes or no answer, a loop is put into the system. This is called a **feedback loop**. Depending on the answer, the flow may either continue straight on or 'loop' back to a previous stage where

Objectives

Learn how to use a flowchart to help plan the manufacture of a product.

Understand the use of feedback loops.

Key terms

Inputs: what you add to a process (information or materials).

Outputs: the final outcomes of the process.

Process: what is done in the process, or the steps involved.

Feedback: information that informs the operator what is happening during the process.

Operator: the person who is controlling the process.

Flowchart: a diagram which explains the process, showing inputs, processes and outputs.

Operations: individual processes and functions.

Feedback loop: the part of a flowchart which shows the operator where to go back to if necessary.

AQA Examiner's tip

Systems and control procedures are evident in all processes. Be aware that you will need to identify the different elements.

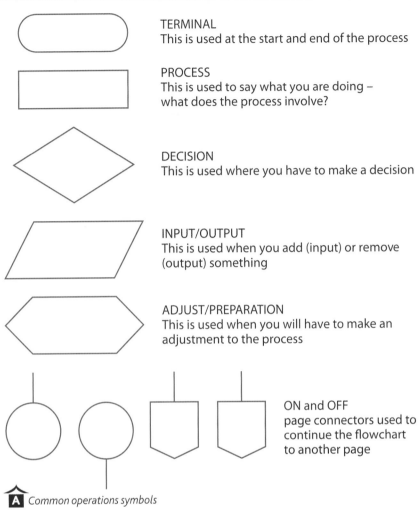

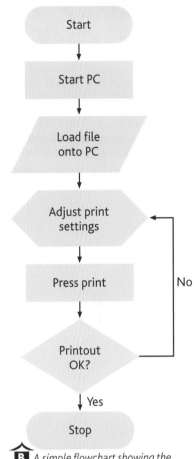

A Common operations symbols

B A simple flowchart showing the process of printing a document from a computer

some adjustments need to be made. You will see that the operator is asked to make a decision about the quality of the printout. If the quality is not correct the operator will go back and adjust the settings to print it again, just as you would at school.

Rules for creating flowcharts

- Always sketch out your flowchart first to check that it works and is logical, making sure that the layout is clear.
- A flowchart should be drawn downwards or from left to right.
- Always use arrows to indicate the direction of 'flow'.
- Try not to cross the lines, and keep all of the symbols a similar size.
- Remember you can produce flowcharts easily on a computer using word-processing packages such as Microsoft Word, which contain all flowchart shapes in the drawing area of the program.

Summary

Flowcharts are used to explain a process that needs to be followed.

Feedback loops are used to redirect the operator when a decision has been made.

AQA Examiner's tip

Make sure that you understand the use of each shape in a flowchart and that you can apply feedback loops in the correct place.

AQA Examiner's tip

Try to use flowcharts in the controlled assessment as this is a very good method of planning your making process. Flowcharts enable you to show all the relevant information, including decision-making. They are the best method of preparing a plan of making.

11.6 Sequential illustrations and schematic maps

Sequential illustrations

Sequential illustrations are simply a series of drawings showing the steps in a process of making something. They are used extensively by manufacturers of flat-packed furniture because the purchasers of the goods need to be shown how to put the parts together. Good examples of this are available from companies such as IKEA. They are also used by toy makers to show how you would put together a model aircraft or train kit.

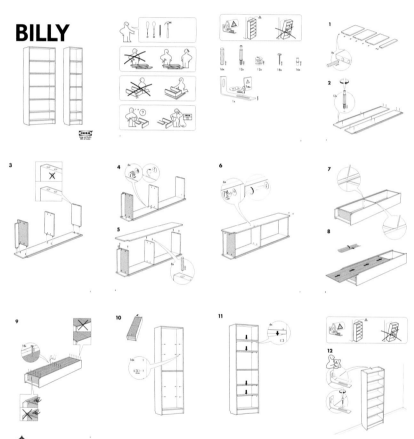

B *Sequential drawings in action - IKEA instructions.*

You may decide to use a series of sequential illustrations within your controlled assessment project. You will have to ensure that the diagrams you produce are easy to understand, and so very clear.

There are other points to bear in mind when you produce these drawings. Ensure that:

- you produce clear outline drawings which are not coloured or rendered
- you draw them in 3D and they are not too small
- the drawings are sequenced with numbers to help the reader follow your instructions

you keep written instructions to a minimum and use arrows to link the words with the drawing, thus making sure that you do not write all over the drawing.

Schematic maps

Schematic maps are produced to show the connection between places, but they do not try to represent the distances between the places or the accurate geographical location relative to each other. A great example of a schematic map is the one used by London Underground. It shows the tube lines in different colours, and are all linked together by straight lines (see Chapter 5 on page 36).

Schematic maps are commonly found in bus shelters, on leaflets advertising local attractions, in shopping malls, in brochures and in school or college prospectuses. All of these schematic maps show routes using major road intersections, roundabouts, stations or any easily recognisable place along the route. If you are asked by your friend to draw a map to explain how they would get to your house, you would produce a schematic map.

Activity

Produce a sequential diagram to show how to change the batteries in a torch.

AQA Examiner's tip

Remember to keep any schematic map simple, use straight lines and major 'staging points' along the route to explain directions.

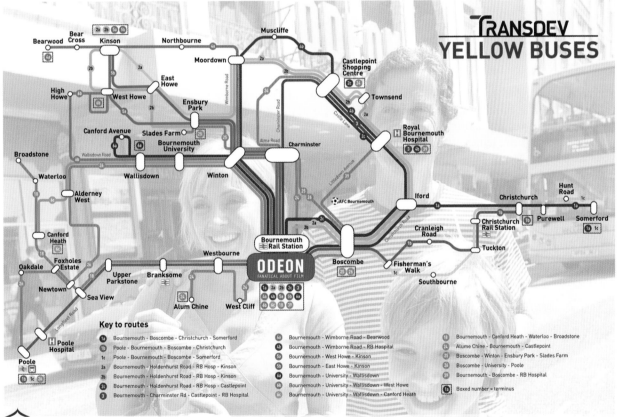

C Schematic maps of bus routes

Summary

Sequential diagrams are used to show a set of instructions graphically so that they are easy to follow. Look at the section on the designer Harry Beck to help you (Chapter 5, page 36).

Schematic maps use straight lines to simplify routes.

12.1 Pop-ups and card mechanisms

▌What are pop-ups?

Pop-ups are used in greetings cards and children's books. They are made with a mechanical action, and are designed to be dynamic and eye-catching. When you open a pop-up card or book something happens. It adds interest to the card or book.

Pop-ups are easy to make using paper and card. Many students have used this type of activity very successfully in a controlled assessment, producing a range of cards or pop-up books.

Creating a pop-up

To create a simple pop-up card you will need paper, ruler, scissors and a pencil. The instructions below are only the start of the process, but they will give you a basic understanding of the steps involved.

Start with a simple v-fold mechanism. Copy Diagram **B** onto a sheet of A4 paper. Look at the diagram and note that the angle of the fold can vary. The thin lines are fold lines and the bold are cut lines. Using a glue stick, attach the tabs to the coloured shape. Then open and close your card – you should have created movement.

Activity

1. Sketch or photocopy the net of a cube shown in Diagram **A** and try to make it. Can you write a set of instructions for somebody else to make it? Which are fold lines and which are cut lines?

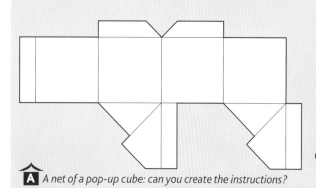
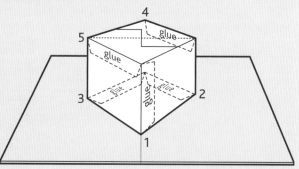

A *A net of a pop-up cube: can you create the instructions?*

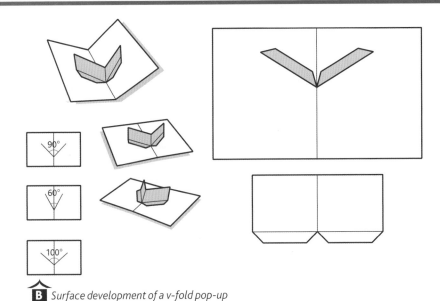

B *Surface development of a v-fold pop-up*

What are card mechanisms?

Card mechanisms are basic mechanisms that are used to create movement. Most types of mechanism involve the use of a **fixed pivot** and a **floating pivot**. A fixed pivot involves attaching the moving part to the base card, usually with a split pin. The moving part or **lever** will then pivot around the fixed location.

A floating pivot is a pivot that is allowed to move, and is usually attached to another lever, again with the use of a split pin. The type of movement created will depend on the type of mechanism.

These types of mechanisms are used effectively in the production of greetings cards, books, shop displays and posters.

Activity

2 Using any of the examples in Diagram **D** as a basis, try to produce a developed card mechanism. Add your own designs to the ends of the levers to create interest.

Summary

Pop-up cards are designed to create interest by the use of mechanical action.

There are a number of different methods used to do this.

Pop-ups can make a very successful controlled assessment project.

A card mechanism can create a variety of movements, including rotary, linear, reciprocating and oscillating.

The main elements of a card mechanism are fixed and floating pivots.

Levers are joined together to create the motion.

C *Types of mechanisms*

12.2 Bought-in components

Bought-in components

Graphic products are often combined with other materials and **components** to produce a product for a particular purpose. Components can be something you have made yourself or **bought in**. Examples of bought-in components are small light bulbs (**LEDs**), batteries and wire, which could be part of an electrical circuit to add to a point of sale to make it flash and attract attention.

Components can be combined with any other appropriate material. Anything added or combined should be used to enhance it or add structure. Products on the market today often use a mix of graphic product, materials and added components like **fastenings** to meet the design need. For example, children's mobiles often combine images on card with string, wire and various resistant materials. A jigsaw could be made from MDF with graphic images glued on. It could also have an irregular outer shape which is held in place by a vacuum formed **HDPE** insert. The outer box made of card would complete the product.

A *A jigsaw*

Using components and materials

In your own project you need to be realistic about how additional components or materials could improve appearance, function or both. Think about existing products that combine materials and incorporate other components. You should also consider the time available and whether there are the resources in school to help you complete the task accurately.

You cannot be given credit for the bought-in component itself, but you can be given credit for the **making skills** used in designing and fitting other materials or components to your graphic product. Making marks are awarded as appropriate to the level of skills used and to the overall finish and accuracy.

Imagine that a point-of-sale (POS) is needed for a new rock band. It is cut in the outline of a person in a new rock band.

There may be two reasons to add a component or combine it with another material:

- *To physically support the graphic product.* You may have designed your point of sale to be used at an event or convention. If this was the case, then the base or stand may not be strong or heavy enough to support it safely in a public place. You may use wood, metal, plastic or a combination of materials as a base or stand (see Diagram **B**).

- *To enhance the appearance and attract greater attention.* You may want to add some electrical components to make the eyes flash, or a linkage to make an arm move (see Diagram **C**). Or you could even add an electronically-controlled linkage if you want to take it even further!

B *A point-of-sale board with a stable base added component*

C *A simple lever mechanism for making arms move on a point of sale*

Activity

Working in small groups, name two other graphic products that combine materials or bought-in components. Discuss with your teacher how they are made and whether something similar could be made in school.

Summary

Think about existing products that combine materials and incorporate other components.

In your own project you need to be realistic about how additional components or materials could improve appearance, function or both.

Consider the time available and whether there are the resources in school to help you complete the task accurately.

AQA *Examiner's tip*

Using bought-in products like a CD case may add to the professional look of a graphic insert that you have designed. These are popular choices for a lot of candidates, but they do not require any higher-level skills to be used. For a higher-level outcome the bought-in item would need to be part of a range of 2D and 3D promotional products.

13.1 Ergonomics, anthropometrics and fitness for purpose

Ergonomics

Today, most products are made by machines. Sometimes designers can fall into the trap of designing a product which is too heavily influenced by how easily it can be made using the machines available. For example, examine a craft knife – it does not look uncomfortable to use, but it is not shaped very efficiently to fit your hand.

Ergonomics is the study of how efficient a product is when used by humans. Ergonomics deals with issues such as ease of use, comfort and safety. Designs *shaped and sized* to fit the body are ergonomic.

A *Office chairs are designed ergonomically, to support your back and to be height-adjustable*

B *Car baby seats are designed ergonomically to mould to the shape of the baby and provide maximum support and comfort*

Anthropometrics

In order to design products that work for as many people as possible, it's necessary to take measurements of the human body. **Anthropometrics** is the study of the varying sizes of all the parts of a human body. This data is used to help designers make an ergonomically good design, and often helps with sizing the product correctly.

Anthropometric study uses surveys to record a variety of measurements across a broad section of the population. If you measure a balanced sample of the population then you will find there are extremes. For example, if you are measuring height, there will be unusually tall people at one end of the scale and unusually short people at the other

end of the scale. The job of the designer is to design products that will fit the majority of the population, so they refer to the average sizes measured in an anthropometric study.

It's next to impossible to design a product that suits absolutely everybody – there is just too much variation in the human form. Because of this, anthropometric data often ignores the top 5 per cent and the bottom 5 per cent. The remaining data is known as 95 percentile anthropometric data. However, some products are targeted at specific groups and therefore a designer may design for above average people. For example, a designer who is developing a new shoe for basketball players may require more specific data for that particular target market.

Fitness for purpose

Humans have a range of basic needs. All humans need food, water, warmth and shelter to survive. If these four essential needs are not met humans feel a sense of deprivation. Beyond our basic needs, some individuals have special needs.

C *Basketball players are known for being very tall and having large feet!*

Activity

1 Can you think of a group of people with different needs to your own? How are these needs met? Discuss in small groups and feedback to the rest of the class.

When the four essential needs are met, humans begin to develop wants. A range of factors influences human wants. The opinions of our friends and family can affect what we aspire to, or where we work or choose to spend our recreation time. For example, if you are hungry you need food, but depending on your individual tastes, you may want a hamburger, while others may want a salad. You need clothing, and some people are satisfied with supermarket brand clothing while others want designer jeans. Your wants are shaped by those around you and by what you see in the media.

Products are designed for people to use. Most products are designed for a specific purpose, for example a pencil sharpener is designed for sharpening pencils. This is referred to as **fitness for purpose**. Every product has been designed to be used in a specific way and during the design process it has been tested on the target market. Fitness for purpose refers to the quality and the fulfilment of certain promises, in other words does the product do what the designer said it would do? For example, does the pencil sharpener sharpen the pencil effectively?

AQA Examiner's tip

You may be asked in an exam to give reasons why a product has been unsuccessful. If a product does not work as intended then you need to understand the possible reasons why. You need to consider reasons, such as the use of inappropriate materials or equipment.

Activity

2 What does 'fitness for purpose' mean? Work in small groups to discuss any products that are designed with a fitness for purpose. Can you think of any products that have not met their fitness for purpose? Can you justify your selection of choices with a list of reasons? Share your ideas with the class. Do you all agree?

Summary

Products that are designed for human use should be easy to use, comfortable and safe. A product that fulfils these criteria is often referred to as ergonomic.

Anthropometrics is the study of human measurements. Remember that not all people are the same.

Products should fulfil their intended purpose.

Product lifecycle

What is product lifecycle?

When a product goes on sale to the general public it goes through several stages. These stages are called the **product lifecycle**. It is important that manufacturers know where a product is in its lifecycle, so that they are ready to launch another product or develop another version of the same product. Products generally make more money in the early stages of the product lifecycle, so manufacturers need to keep relaunching products with newer versions or varieties.

The product lifecycle portrays distinct stages in the history of a product:

- **Introduction to market** – generally a period of slow sales as a new product is launched. Because of the high costs involved in developing and advertising a new product, profits are small at this stage.
- **Growth** – the popularity of the product increases and more people want to buy the product, which boosts profits.
- **Maturity** – eventually demand (and profit) hits a peak as most of those who are going to buy the product have done so. By now, competitors will also have launched their products and this too affects sales.
- **Decline** – a period when the sales of the product begin to slow down and profits reduce.

A A product lifecycle graph

The exact shape of a product lifecycle graph will vary, depending on the type of product. Consider the sports drink Lucozade, and ask yourself why it continues to be such a good seller in the UK for so many years. When first launched into the market, it was sold and promoted as an aid to help people who were recovering from an illness, and to give them an energy boost. Sold in a glass bottle wrapped in orange plastic film, it made many appearances at hospital bedsides. As sales began to slow, the product was rebranded and aimed at a completely different target market.

The design of the bottle changed. Instead of a large family-sized bottle, it was produced in a much smaller plastic bottle. It came in a range of

B *Lucozade is now targeted at sports people*

C *Video tape is already on the way out. How long until DVD's are yesterdays technology?*

different flavours and was promoted by some very famous people. It became known as 'Lucozade Sport' and professional sports people were seen to drink it after a race or a football match, or even at halftime. It then came in a tetra-pack with a re-sealable cap. Lucozade Sport is now sold in multipacks, in vending machines, and comes with sleeves to keep the product cold. It has associations with a number of professional sports. All this rebranding has kept the product in the public eye, and sales have soared.

Look at adverts on television or the internet for the latest mobile phone or trainers and ask yourself whether they are really that much better than the product you have now? Or is it a case of keeping up with the latest fashions and trends? Is it worth paying that much more? What do you do with your old phone or trainers?

Activity

Produce a timeline for the chocolate brand Kit Kat, from its introduction up to the present day. Find images of all the different types of bar, size, shape and packaging that have been used since its introduction. Think about who the designer had in mind as the target audience, and why. Think about typography, colour and other famous images or icons of the time. How was it advertised? Where was it advertised? Did they have the use of internet or mobile communications? Why do they still sell so many? Who buys them now? List possible locations where this product may be sold.

AQA *Examiner's tip*

In an exam situation always try to relate your answers to a product or products you are familiar with. It is very difficult to answer a question on a product you know nothing about.

Summary

Product lifecycle portrays distinct stages in the history of a product.

There are four distinct stages in a product's lifecycle: introduction, growth, maturity and decline.

14.1 Disassembly of products

Disassembly

A **disassembly** of a product is a vital part of your research. You need to analyse an existing product for both aesthetics and construction. You are not doing it just to copy or improve on a product. You are doing it to gain knowledge of processes that may help you in your own design work.

Let us consider a package for a perfume bottle for example. List any different materials involved and how they fit together. Carefully open up the net of the box. You are initially looking for information on construction. The perimeter has obviously been die cut, but there may be other cuts for more complicated internal construction reasons. A small bottle may have an internal card support inside a larger box and this may be included in the same net. You will then look for folds and/or scores. This will be where different knives or blades have been used within the body of the die cutter to make folding easy for final assembly. The final construction point may be the glue tabs or self-locking mechanisms. You should then note where they are located on the box.

You will then look at the graphic content. Look at the images and colours used to promote the product and attract the potential buyer. Consider the style of any text and how it fits into the overall design. Then you need to carefully note any other written information on the box. There will be product information and legal information. This will include size and basic ingredients for people who may have allergies

A *A perfume bottle package* **B** *Legal information on packaging*

to certain chemicals. It will also include barcodes or other pricing or stock methods. Your analysis of all these points and how thorough your annotations are will reflect in your marks.

Label the different construction methods and materials at the correct place. Label the text that has been included for all information and legal reasons. Label anything to do with corporate identity. Make your own personal comments about how well the graphics and colour are used to promote the product. Make some general overall comments about which of the construction methods and graphics have given you ideas for your own design.

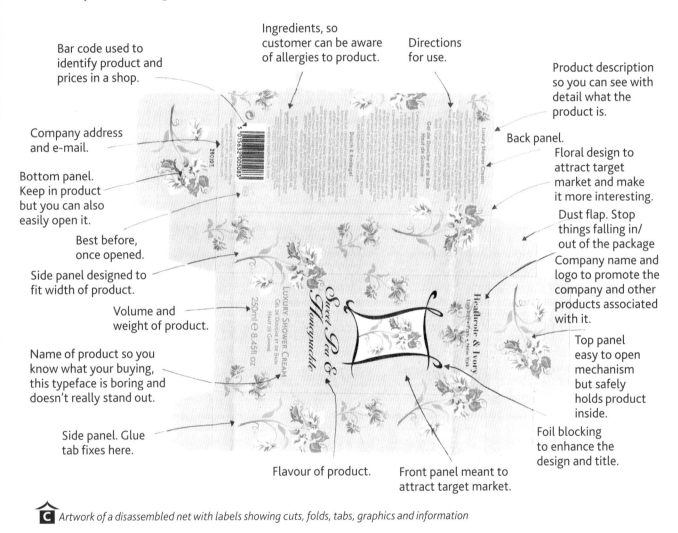

Ingredients, so customer can be aware of allergies to product.

Directions for use.

Bar code used to identify product and prices in a shop.

Product description so you can see with detail what the product is.

Company address and e-mail.

Back panel.

Floral design to attract target market and make it more interesting.

Bottom panel. Keep in product but you can also easily open it.

Dust flap. Stop things falling in/out of the package

Best before, once opened.

Company name and logo to promote the company and other products associated with it.

Side panel designed to fit width of product.

Volume and weight of product.

Top panel easy to open mechanism but safely holds product inside.

Name of product so you know what your buying, this typeface is boring and doesn't really stand out.

Foil blocking to enhance the design and title.

Side panel. Glue tab fixes here.

Flavour of product.

Front panel meant to attract target market.

C *Artwork of a disassembled net with labels showing cuts, folds, tabs, graphics and information*

Summary

Disassembly of products helps you learn techniques and processes.

You must be able to disassemble a product and show what you have learned from it.

Testing and evaluation

Testing and evaluation

Testing and evaluation are very closely linked. You should be doing some testing at appropriate stages throughout the folder. You test colours, test fonts and test materials. You may test mechanisms or construction methods. Whatever or wherever you test, you will naturally make comments and record these in your folder. These comments may lead to modifications or you may be happy with the results. Provided that you write down your comments and reasons for making changes, or not making changes, then this will be your ongoing evaluation.

Your research and analysis will hopefully lead to a comprehensive product specification and you will record all your specification points. Some of these specification points will be evaluated in your ongoing testing and others will be evaluated at the end when your final product is complete. Depending on the results of a test, some of the testing may lead you to update your specification. If for example a particular material from your specification does not take print very well, you may test this prior to producing any images. Another material may prove to be better and you would then update your specification. This would save a lot of wasted time and work.

- **Formative** evaluation is ongoing evaluation, which helps you to continually improve and modify your work during the design-and-make process. You do this by referring to your specification and checking how close you are to it. The results of some of the testing will help you with this and may lead to an update of certain aspects of your specification.

- **Summative** evaluation is, as the name suggests, testing that is carried out at the end of a design-and-make activity. This is when you check your final product against your original, or updated, design specification. You should also say where your product does not meet the specification and why. Summative evaluation checks whether your product suits the purpose for which it was intended, and it should also show how it could be improved.

Activity

You have designed a robust POS that will be used as a floor-standing POS in a public place. The base is made from MDF which will have a coating applied to it. The base is sectional and uses joints in its construction. The main body of the POS is made from a lightweight graphic board. Write a list of both formative and summative tests you would carry out and say why. Discuss the results with your teacher.

Commercial testing

Probably the best known formative test in industry is the use of a crash test dummy to test many safety aspects of a new car design. The *crumple zone* at the front is tested by crashing the chassis into a wall with the dummy inside. The car is also rolled over to test the internal roll bars and side panels. Individual components such as airbags are tested.

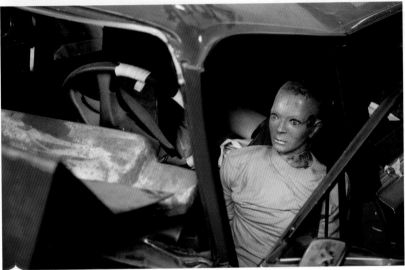

A *Crash test dummies*

Another test is to crash the finished car into a dummy to see the effects of hitting a pedestrian at different speeds. As this is done when the car is complete it would be considered as a summative test. Manufacturers usually have their own test tracks where they drive over rough roads for a set number of miles. These are also considered summative tests. Testing cars can lead to safety awards which the manufacturers often use to promote how safe their vehicles are. These are called the NCAP safety awards, where the higher numbers of stars denotes the higher safety level. Many potential customers will buy a vehicle based on how safe it is.

www.euroncap.com

B *The NCAP safety award logo*

Summary

Tests can help solve problems before you carry out too much work.

Ongoing evaluation shows that you are making decisions based on your tests.

Evaluation against your specification

Original specification

During a design-and-make activity you should produce a detailed list of what your graphic product needs to have. This detailed list is called the **design specification**. It should reflect all (or some) of the information you have found during your research. For instance, if you are designing an environmentally friendly product, your research will have told you that you should try to use only recycled materials.

When you write your initial product specification you should use the headings in Table A for guidance and say how you expect your product to look and function. It is useful to write these as bullet points with a simple sentence after each. This makes it easier to refer back to individual points at a later date. Always refer to each point in your final evaluation against specification. Has each been met? If not, then say why. If a point has, then say how well.

Objectives

Know what to include in your specification.

Understand the importance of carrying out an evaluation.

Key terms

Design specification: a detailed list of what your final design should include.

A *Headings for your initial specification*

Target market	Who is going to use your product? For example, an age specific toy or a CD promotion for a particular genre of music.
Function	Does it do the job? For example, a product designed to help children learn the time should do exactly that.
Finish	The level of accuracy. See Chapter 18 on page 122 on tolerance.
Size	The physical dimensions (this may be worked out from anthropometric data if for a particular age range). How long? How wide? How thick?
Weight	Will the product be carried or handled? Where will it be situated?
Product materials	Consider: its heavy or light use; whether it needs to take print; its tensile or compression strength; its water resistance; whether it is easy to cut or shape.
Aesthetics	Is it designed to attract and promote or is it merely functional?
Ergonomics	Does it need to be shaped to fit a hand?
Cost	Can the target market afford the finished product?
Health and safety	Are construction techniques used? Are bought-in components safe? Are there any toxic adhesives or coatings?
Environmental issues	Is it biodegradable? Can it be recycled or re-used? Is it made from any recycled materials? Do any of the manufacturing processes damage the environment? Sometimes it is not practical to consider all of these environmental issues.
Manufacture	What basic processes or production methods will you use? Do not go into a lot of detail as you will cover this in your plan of making. Will you add any other components?

Evaluating your product

Once you have completed your product, you should test it against your original specification. If you have met some of the criteria you listed, well done! Remember to evaluate the *product* and not the process you went through. Ideally, always try to get your client to test the product.

The evaluation section could include:

- product testing
- an evaluation against the specification
- modifications required
- changes needed for commercial production.

Changes for commercial production

Although you may only manufacture one final product from your design, it is important that you are aware of the various possible methods of production and how yours could be commercially produced. Standardised design involves designing products to be as similar as possible so that they can be easily mass-produced. Accessories and components can then be added to make them different. Templates, jigs and moulds enable the same process or multiple copies to be achieved.

Think about how your design would be manufactured on a commercial scale.

- Would they use the same materials as you have used for the prototype?
- Would the printing methods change for a commercially manufactured product?
- Would the construction methods be the same?
- Could design changes be made to reduce production costs?
- Could you reduce the number of parts or different components in the design?

B *Clients should test products too*

AQA Examiner's tip

Evaluate your product as you go through the design process rather than leaving it all to the end. You may not have met all the points in your specification and this is fine, as long as you give reasons.

Activity

You have designed and made a toy clock to help pre-school age children to learn the basics of time. You have done a final evaluation against all your specification points. Staff at a local nursery have agreed to test your product with a child under supervision. Write a questionnaire and then compare it with others in the class and discuss the results with your teacher.

Summary

An original specification is a detailed list of what your product needs to include. It is written following your research.

An evaluation against the original specification needs to be carried out after product manufacture.

Asking others for their opinions of your product shows how successful your product could be for the target market.

15.1 Moral, social and cultural issues

◼ Moral issues

Jigsaws are on sale for children and adults of all ages. They vary in complexity depending on who they are aimed at. The company obviously wants to sell as many as possible and, providing they are safe for use and comply with safety standards, they are sold in shops without restriction.

Jigsaws for younger children have simpler images and have larger pieces for ease of handling. Larger pieces are also more difficult to swallow and so less likely to choke a child. It is difficult to estimate exactly how big jigsaw pieces need to be for each age group and so manufacturers have a moral duty to print an age suitability warning on the box for the buyer. It may restrict the sales of a product slightly, but there are **moral issues** around child safety that should be considered by all responsible manufacturers and their designers.

A *An age suitability warning on a jigsaw*

Objectives

Understand why we need to consider moral, social and cultural issues when we create a design.

Look at examples of designs that take into account the above issues.

Key terms

Moral issues: points the designer has to make to decide if something could be dangerous or controversial. They are not covered by any law or design regulation, and are usually related to a specific target market.

Social issues: points to consider when the products being promoted for use or consumption may not be in the best interest of the consumers. They are usually related to the wider public in general.

Cultural issues: points that need advertising or product decisions; these issues are changeable and dependent on the actual target market.

◼ Social issues

Designers often work on campaigns to promote unhealthy fast food and high sugar sweets and drinks that damage teeth. They are not breaking the law, but they are actually encouraging children to damage their own health. This sort of advertising is part of the busy, hurried world that we live in today. It is a widespread problem and therefore a **social issue** that is often beyond the control of adults.

As children get a bit older and have the money and the time to make choices, they are influenced by promotions or trends. Some fast-food

outlets have a healthy range, but this is usually just a small selection from the mainly unhealthy range. If the designer has done a good job in promoting the general range, then it will still generate large profits from the sale of fast food and sweets to children.

Cultural issues

Certain animal products are offensive to some religions and their followers are not allowed to eat them. It is a similar **cultural issue** when we consider groups of people such as vegetarians. The legal requirements are that manufacturers have to display certain nutritional information. There is no guidance, however, on where this information is displayed and how big the text is that shows this information. Many responsible manufacturers have packaging designs showing a large green letter 'V' in a prominent place to show that a product contains no animal products.

Certain colours and numbers are lucky in some countries. In China, for example, red is considered a lucky colour and the number '6' is considered good in business. If you were going to design a product to be sold specifically in China, then this knowledge is useful. Also in China the number '13' is thought to be comforting and bring well-being. If you go to the USA however, you are unlikely to see a building with a floor number 13 or a street with a house number 13. The numbers on the lift or the houses will go from 12 to 14 with nothing in between. These are examples of where knowledge of culture can promote goods in some countries and would be a hindrance or even cause offence in others.

B *In China the colour red is considered lucky*

Activity

Carry out research from any available source and write down two more examples of each of the issues above. Swap some of these with others in the class and try to find memorable but simple examples.

Summary

Designers have moral and social responsibilities that may conflict with commercial interests.

When creating designs, designers should be aware of other people in the world and their beliefs and traditions.

AQA Examiner's tip

It is useful to know and remember simple examples of each of the above issues. You should be able to explain them in a couple of sentences.

Too much waste!

Part of our responsibility as designers is to be morally correct – and reducing the amount of waste we create falls under this heading. Hopefully, you are protective of our planet and are concerned about what you and industry could do to reduce the huge amount of waste that is created by us every day.

Did you know that the UK alone fills enough bins every year to reach the Moon and back? The richer countries are the worst offenders and it is our responsibility as designers to try to think of better ideas that are kinder to the environment.

Other parts of this chapter cover many of the global issues, but some specific graphical solutions can be covered under the following headings:

- Do we really need it?
- Are the material choices eco-friendly?

Do we really need it?

Did you know that 90 per cent of all plastic packaging ends up as landfill and can take over a hundred years to degrade? We need to look very carefully at all types of packaging to assess whether or not we really need them. The conclusion you will probably come to is that, yes, some packaging is necessary, but that it could be dramatically reduced. Did you also know that people in Mexico produce half as much waste per year each compared with people in the USA?

Material choice

When you make a product, you are probably going to be concerned with the environmental impact it will have. For example, you would try to use a paper-based package instead of a plastic-based package unless the plastic was biodegradable like the **bioplastics** discussed in Chapter 3 on page 24.

It is the designer's responsibility to choose materials that are recyclable and, if possible, totally biodegradable. **Recycling** saves on the Earth's natural resources. For example, producing metal uses vast quantities of energy such as electricity, whereas recycling waste metals uses relatively small amounts of energy. Recycling a material such as paper or card means that fewer trees need to be cut down to produce new paper and card. Manufacturing card and paper directly from trees uses more energy than the process of recycling old card and paper. Recycling materials also means there is less waste.

Good examples of how technology has helped create new biodegradable alternatives are water-based inks, coatings for paper made from vegetable matter and of course bioplastics. When designing a product that uses more than one material, it is important that you consider how these materials can be easily separated to make the recycling process easier.

Objectives

Understand how we can reduce waste in the world of graphics.

A *Is there too much packaging for this box of chocolates?*

Key terms

Bioplastics: plastics made from animal and vegetable matter, and are totally biodegradable.

Recycle: break down used material into a reusable state.

Renewable: materials that can be easily replaced, reproduced or grown.

B *d2w is a biodegradable plastic*

C *Recycling metals helps the environment*

A good example of a **renewable** material is wood. Forests can be replanted, so wood can be grown to replace the wood used by manufacturing industries. The Forest Stewardship Council (FSC) is a worldwide organisation responsible for the re-planting of many forests. Managed forests produce timber for use in many industries and the wood or products they produce are often stamped with the FSC logo.

An example of a non-renewable material is oil. Oil cannot be replaced because it takes millions of years for it to form below the surface of the Earth. Once it has been used it is gone forever.

D *The Forest Stewardship Council logo*

Activities

1. Find some specific examples of packages made from different materials that make them impossible to **recycle**. Try to download an image of one and say why it will have to end up as landfill.

2. In groups of four, split into pairs. One pair should discuss and write down the advantages of recycling, the other pair the disadvantages of recycling. After five minutes discuss your responses in your groups and then share your ideas with the rest of the class. You could then do the same thing for re-using.

AQA Examiner's tip

You are likely to be asked which materials you could make your designs from and their environmental impact. You should also refer to this in your coursework project.

Summary

We need to do what we can in our material choices as designers and consumers in order to look after our planet.

What can we do to help our environment?

Recently the world has begun to understand the damage caused to the environment through the production of energy. Hydroelectricity has been with us for many years. The final stage of the Aswan Dam in Egypt was completed in the early 1960s. It provided half of Egypt's electricity in the 1970s and, although this is now down to around 15 per cent, it is still a substantial amount of clean electricity.

As our world depends more and more on the use of technology in our everyday living, designers often ask the following questions:

- Can we use more environmentally friendly ways of producing energy, such as solar panels, wave power and wind turbines?
- Should industrialised countries be using their knowledge of technology to develop alternative energy sources?
- How can a product be friendlier to the environment?

The six Rs

Many consumers are thinking 'greener' when they buy things. Designers and manufacturers are required to reduce the environmental impact of products they create. There are six key words (known as the six 'Rs' because they all start with the letter 'R') that sum up what we need to do to reduce this impact. They are in order of importance:

1 Rethink

Designers and manufacturers could design packaging that can be made from a single material, which would make it easier to recycle. Designers and consumers should ask themselves whether packaging is needed and whether other solutions could be found. For example, can information be printed directly onto a product, or could more refill packs be used?

2 Refuse

As a consumer we have a choice as to whether we buy a product or not. When a product becomes outdated or old, we are encouraged to buy another 'new and improved' product, and throw the old one in the landfill site. Designers and manufacturers are increasingly thinking about how consumers will react to their products, and if they will accept or refuse them.

3 Reduce

Consumers should consider buying products that use less energy. For example, buying in bulk avoids the extra packaging in smaller amounts. This saves material and the energy used to create it. Manufacturers, on the other hand, are looking to design products that either use thinner grades of material or reduce the amount of packaging needed. Retailers can reduce carbon emissions by transporting goods from the manufacturing plant direct to the consumer, thus avoiding the need for so-called 'middle men'.

Activity

You are a designer and have been asked to design a new computer game console and packaging. List at least six things you would incorporate to take into account the six Rs. Share your ideas with others in the class.

4 Re-use

Supermarket customers are now encouraged to re-use their carrier bags, and some companies actually reward customers for re-using. Obvious examples of products that are re-used are glass milk bottles and printer cartridges. Can products be designed so that parts of them can be re-used?

A *Bulk-buying goods saves in packaging*

B *Glass milk bottles can be re-used*

5 Repair

Often it's cheaper to buy a new item than repair an old one. We need to repair more of the things we currently throw away. In the 1970s, it was common to have the same television for over ten years. Television engineers were skilled technicians and made a good living doing repairs. Nowadays, electrical goods are often made with components that are **designed to fail** after a few years. Manufacturers need to sell new products and new ranges of the latest gadgets to make more profit. This is called **built-in obsolescence**. Many old items finish up in landfills as the materials and components cannot be re-used or recycled.

Key terms

Designed to fail: designers and manufacturers plan the 'built-in obsolescence' at the design stage in order to generate future sales.

Built-in obsolescence: when a product is made with one or more components that are known to fail after a specific period.

6 Recycle

Recycling is a way of recovering materials such as metals, paper, cardboard and plastics, which can then be used to make new products. It can be extremely energy efficient if the waste is readily available. It is 20 times more efficient, in terms of energy usage, to recycle aluminium than to produce it from raw bauxite ore. It is often the collection and transportation of recyclable waste that makes the whole process expensive. Paper recycling is very common, but recycled paper has poorer colour quality and strength, and can actually be more expensive.

When we as consumers recycle our waste, we are conserving our non-renewable resources and the sites they are taken from. Recycling also reduces our dependence on imported raw materials. Many local councils now operate a coloured bin system, in which they will collect card and cardboard, steel and aluminium food cans, plastic bottles, and glass bottles and jars separately from normal domestic waste.

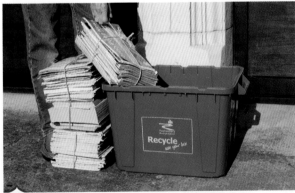

C *Recycling domestic waste makes a real difference*

Summary

Designers should consider the effect their designs have on the environment.

The 6 Rs are Rethink, Refuse, Reduce, Re-use, Repair and Recycle.

AQA *Examiner's tip*

Examples of the six Rs are useful to remember. Make your own notes of the best examples that have been shared during the activity.

16.1 Component parts of an ICT system

ICT systems

A computer system comprises hardware and software. **Hardware** includes any item that you can actually touch or move from one desk or room to another, such as the keyboard. **Software** is the computer programs, or the sets of instructions that tell the computer what to do. In organisations, such as schools, computers are usually connected to a central network, where you can save all your own work. Networks may or may not be wireless.

A special type of software, called the operating system, tells the computer how to use all the different **devices** it can be connected to, such as the printer. These devices are hardware.

Hardware

Input devices

An **input device** is any device that allows data to be entered into a computer, for example a scanner. A scanner is used to transfer images onto the computer from a 2D image. Other input devices include digital cameras, keyboards and graphics tablets. Digital cameras and graphics tablets are used in the following ways.

A digital camera stores digital images and videos, which can be downloaded onto a computer hard-drive. Once the images, or video footage, have been downloaded onto a computer, the user can save or modify them. These images would normally be saved on either a flash drive or the school computer network.

A graphics tablet is a flat, digitised pad used with a special pen to create images that can be copied or pasted onto the computer.

Objectives

Understand an ICT system.

Consider how you can incorporate ICT into your work.

Key terms

Hardware: machinery that supports the software.

Software: programs used by your computer, such as CorelDRAWand Microsoft Office.

Device: any type of hardware

Input device: any device that allows data to be entered into a computer.

Output device: any device that allows information to be downloaded in the form of a 'hard' copy.

A Input devices – a graphic tablet

Output devices

An **output device** is any device that allows information to be downloaded in the form of a 'hard' copy, for example a laser printer.

An example of an output device is a vinyl cutter machine. Vinyl cutter machines are used to cut letters or shapes onto coloured vinyl sheets. Vinyl cutter machines can be used to great effect in your coursework as you try to develop a name or a logo idea.

A laser cutter is also an output device. It is used to cut or engrave materials and fabrics except metals. A router is another output device which can machine in three dimensions (the x axis, y axis and z axis) on a variety of materials. A CNC (computer numerically controlled) milling machine is used for drilling, cutting and shaping thicker graphic materials.

Photographic evidence

Throughout the making process it is really useful to take lots of pictures. Why do you think that is?

- It enables you to justify any decisions made (including choice of materials, fixings and finishes).
- It can help to explain why certain decisions were made.
- It shows where your work was done and by whom.
- It can show the development of an idea.

Most students have a mobile phone with a camera. If this is allowed in your school, take photos and then print them off at a later date (wallet size photos are big enough).

> **AQA Examiner's tip**
>
> Use relevant and good quality ICT to enhance your presentation or your outcomes.

> **Activity**
>
> List all the different input and output devices that you know. Where have you used these in school? How did you use them, and what was the process?

> **AQA Examiner's tip**
>
> Try to be selective in the photographic evidence you put into your design folder. Do not take photos of every machine you use as the annotation should explain this.

B *Output devices – a vinyl cutter*

Summary

Input devices are used to enter data onto a computer. Output devices allow information to be reproduced in the form of a hard copy.

Input and output devices can enhance your work.

16.2 Advantages and disadvantages of CAD and CAM

Computer-aided design (CAD)

Computer-aided design, or CAD, is the process of producing designs using a computer. Once these designs have been finalised, complex orthographic drawings can be produced. There are many CAD software packages available to designers, including Pro/Desktop, Google SketchUp and AutoCAD. CorelDRAW, PowerPoint and even Microsoft Word have a basic drawing facility. These common, simple applications have electronic grid underlays with a snap facility, and can draw and colour. They also have 3D tools and word art.

Some software is standalone, but others, such as Pro/Desktop and AutoCAD can be linked to CNC manufacturing equipment. CAD packages are used extensively in a range of different industries, such as engineering, construction and electronics.

Objectives

Understand the application of CAD and CAM.

Know the advantages and disadvantages of using CAD and CAM.

Advantages

The main advantages of CAD are:

- It is fast once you are familiar with the layout and shortcuts available.
- It is easy to include variations, and designs can be altered without erasing and redrawing.
- Standard components can be combined to make new designs quickly.
- Designs can be seen in 3D, rotated on any axis or magnified using zoom features.
- Once a design has been finalised a standard orthographic drawing can be produced almost immediately.
- Presentation drawings can look almost like photographs.

Disadvantages

The main disadvantages of CAD are:

- Its initial expense can be very high for hardware and software.
- Staff need training and it is difficult to use well when you are not very familiar with it.

Computer-aided manufacture (CAM)

Once you have used CAD to design a component, you can use **computer-aided manufacturing**, or CAM, to make it. Computer-aided manufacture refers to the process of producing products and designs using computer-controlled technology.

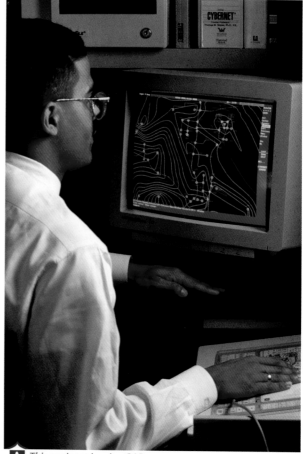
A *This engineer is using CAD*

Advantages

The main advantages of CAM are:

- Components are made exactly the same, time and time again.
- Machines can work non-stop, stopping only for scheduled maintenance.
- It provides flexible production as the machines can produce a range of products.

Disadvantages

The main disadvantages of CAM are:

- Repairs may be expensive, and specialist engineers may be required to come and fix the machines.
- If a machine breaks down it can stop all production.
- If your design is flawed then the components produced will be flawed.
- Without regular checks any mistakes will be repeated in large numbers and waste materials and money.

■ Computer numerically controlled (CNC)

Computer numerically controlled, or CNC, describes the machines that are controlled by a number system. They are a type of CAM. Some machines are driven using G- and M-codes. These codes are used to tell the machine, and in particular a specific tool, what to do and where to go in relation to a design.

Advantages

CNC has all the advantages of CAM. CNC machines can be continually updated by downloading new software updates, which control the device settings that power the tooling. CNC machines use modern design software, allowing the designer to simulate the manufacture of an idea. There is no need to make a prototype or a model. This saves time and money.

Training in the use of CNCs is available through the use of 'virtual software'. This means that less skilled or trained people can operate CNCs. CNC machine operators are generally paid less than skilled engineers. One person can supervise many CNC machines simultaneously. Once a CNC machine has been programmed it can usually be left to work by itself.

Disadvantages

CNC machines are more expensive than manually operated machines, so initial costs are high. In addition, if a CNC machine breaks down then production is halted and outside expertise may have to be sought if the breakdown problem is complex and cannot be fixed by an in-house engineer.

Key terms

Computer-aided design (CAD): producing a design using a computer.

Computer-aided manufacture (CAM): producing products and designs using computer-controlled technology.

Computer numerically controlled (CNC): describes machines that are controlled by a number system.

B *CNC machines working together*

Summary

Computer-aided design, or CAD, is the use of computer technology to design and develop ideas.

Computer-aided manufacturing, or CAM, is the use of computer technology to produce products.

There are a number of advantages and disadvantages in using CAD or CAM.

17.1 Using tools and equipment safely

Safety issues

Workshops and studios contain lots of tools, materials and equipment that can cause you a great deal of harm if they are not used correctly and you do not adhere to the appropriate **safety precautions**.

It is important that you use the appropriate materials and tools for the job you are doing and that the tools are correctly maintained and in good working order. However, it is also important that you are well prepared for the process you are undertaking by ensuring that you are fully protected by the correct **personal protective equipment** (PPE) and that you completely understand how to use the tools or equipment.

We all have a responsibility to 'manage the environment' in a safe way. This includes putting equipment away, cleaning up safely the spills that we have made and making people aware of dangerous spills and correct storage. It also includes using the correct containers for various chemicals and finishes. Some materials, such as adhesives and varnishes, are bought in large containers. These are tested and safe, and need to be stored according to the instructions. However, when we use them, we often transfer them to smaller containers for ease of use. It is our responsibility to use safe containers and to check with teachers before use.

Cutting tools

Even if you are only working in paper, card or board there are still potential hazards to be aware of. There are obvious dangers in using sharp tools such as a craft knife but you also need to be aware of the risks associated with the use of adhesives and paints in colour rendering the product. The workshop will also contain a variety of electrically powered tools that you will use, such as drills and fret saws. Before you use these tools, you must ensure you listen to your teacher carefully when they give all of the safety warnings and explain how to use them safely.

There are several basic rules to follow when using tools, materials and equipment:

- Protect yourself with personal protective equipment (for example goggles and aprons).
- Ensure that you know how to use the equipment correctly.
- Listen and act on advice given to you by your teacher.
- Do not get distracted by others (and do not distract someone using equipment).

Objectives

Be able to recognise and use appropriate tools, materials and equipment safely.

Know which tools and equipment are used to make products.

Key terms

Safety precautions: things you can do in advance to protect against possible dangers or accidents.

Personal protective equipment: safety clothing to protect you while you work, such as goggles or gloves.

A *How many hazards can you spot?*

- Ensure that the tools are well maintained and ready to use (for example, that the craft knife blade is sharp).
- Always read instructions for use on adhesives and other solvents such as spray paints.
- Use solvents in a well-ventilated area.

C (a) Scissors (b) scalpel (c) cutting mat (d) rotary cutter

B *Cutting tools found in a graphics room*

Tool/equipment	What is it used for?	Safety advice
Scissors	Cutting paper, thin card and thin plastic sheet	Ensure that the scissors are sharp and are strong enough to cut through the material. Keep fingers away from the blades.
Scalpel/craft knife	Cutting or scoring paper, card, thin plastic sheet, thin board	Use a safety ruler (one with a raised edge). Keep the blade against the edge of the ruler and cut away from yourself.
Cutting mats	To give a suitable cutting surface when using various types of craft knife	Make sure that the mat is on a flat surface.
Rotary cutter	Cutting paper, card, thin plastic sheet, thin board	Use a safety ruler (one with a raised edge). Keep the blade against the edge of the ruler and cut away from yourself.
Compass cutter	Cutting circles in paper, thin card, thin plastic sheet and thin board	Ensure that you use this on a cutting mat on a flat surface.
Safety rule	To help make straight line cuts with a craft knife	Hold the rule down firmly with one hand, making sure that your fingers are away from the knife edge

D (a) Fretsaw (b) coping saw

E *Cutting tools found in a workshop*

Tool/equipment	What is it used for?	Safety advice
Reciprocating saw or fretsaw ('Hegnar saw' is a brand name)	Cutting plastic sheet, thick board and wood; easy to cut intricate shapes	Ensure that you wear eye protection, the machine guard is positioned correctly and that you keep your fingers away from the blade.
Coping saw	Cutting plastic sheet, thick board and wood; easy to cut intricate shapes	Ensure that the material is firmly held and that you keep your fingers away from the blade.
Hot wire cutter	Cutting rigid foam	Make sure that this is used in a well-ventilated area and that you use a mask so as not to inhale the fumes.
Laser cutters	Cutting most materials with a laser gives outstanding accuracy and finish	Ensure that you follow all of the safety advice printed on the machine.
Vinyl cutter	Accurate cutting of card and sticky vinyl	Keep fingers away from the cutting blade.

Activity

Design a simple sketch, no larger than 30 mm, for each of the tools mentioned on this spread and then give a title to each one.

AQA Examiner's tip

You will often be shown a picture of a tool or piece of equipment in the exam and you will need to name them and describe their use.

Summary

Different cutting tools are required to cut different materials.

It is important to use cutting tools safely.

Hazards

A hazard is something that could possibly harm you if you pay no attention to the danger. This can be best demonstrated in crossing a road. If you simply walk straight into the road without looking then you are at great risk. However, if you stop at the edge of the pavement and carefully assess the traffic movements to find the best time to cross, then you are reducing the risk. If you use an identified crossing point, such as a zebra crossing, then you reduce the risk even more.

You have to accept that potential hazards exist everywhere but some places carry a higher risk than others. A classroom in which everyone is sitting and drawing or writing is a lot less risky than a classroom where you are all using knives to cut card!

Identifying risks

When any type of production takes place and involves hazardous situations, it is necessary to identify the possible risks and make every effort to reduce the risks to yourself and others.

In your school you will be required to abide by a set of safety rules that are given to you in order to ensure the safety of yourself and others around you. These are a series of outcomes from a risk assessment that the school has undertaken for working in that particular environment.

Every step of an industrial process will be identified as being a high-, medium- or low-risk operation and this is called a **risk assessment**. The most important part of this process is to ensure that everyone (employee and employer, or you and your teacher) then reduces the risk of any potential hazard as much as possible. This is called controlling the risk.

A cumulative risk is when a number of normally safe individual events may combine together and cause serious accidents. This can be best explained with these examples:

- A stationary car is not a risk unless the hand brake fails and it is on a slope.
- A phone is not a risk unless you cradle it between your ear and your shoulder for long periods.

Table **B** shows some common risks in your lessons and how you can reduce or control the risk.

Objectives

Know what is meant by risk assessment.

Know how to reduce the risk.

Key terms

Risk assessment: working out what the hazards are in a particular situation and deciding what you are going to do about them.

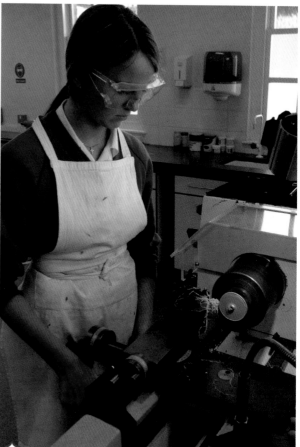

A Loose clothing should be protected or tucked away when using machinery

B *Common risks in the workroom*

Risk (hazard)	Reducing the risk
Bags or equipment on the floor	Make sure that these are put out of the way and ensure that all areas are clear of obstructions.
Using a craft knife	Make sure that the blade is sharp and use the correct safety rule with a cutting mat on a flat surface.
Eye strain from using a computer	Make sure that you take a break from the computer every 20 minutes.
Dust from a sanding machine, such as Linisher	Ensure that the dust extraction is on and the dust guard is correctly positioned.
Loose clothing while using a machine	Ensure that you are wearing the correct protective clothing and sleeves are rolled up.
Using spray adhesive	Ensure that you use this in a well-ventilated area or a spray booth.
Using a glue gun	Ensure that you do not touch the nozzle and that you rest the glue gun on a stand when not in use.
Using portable electric tools	Ensure that all cables are out of the way of people moving about – do not obstruct a walkway with the cables.
Carrying tools around the room	Make sure that you carry all tools in a safe manner and all retractable blades are fully retracted.

C *Do not look at a computer screen for too long without a break*

Activity

Think of six different hazards in your classroom or workshop at school and think of what you can do to reduce the risk. Display this in a table.

AQA *Examiner's tip*

Ensure you know what can be done in different situations to reduce the risk of accidents.

Summary

Risk assessment as a process means that you have looked at what the potential hazards are and provided solutions for how to reduce the risk of injury.

It is important that you consider all possible hazards in your practical work.

Safety and the law

Who is responsible for safety?

You are the main person who is responsible for *your* safety! This means that you need to work in such a way that you, and those around you are safe at all times. The school will ensure that all the tools and equipment are safe to use. It is your responsibility to use them in a safe manner, using the correct tool for the job you are carrying out. There will be workshop safety rules on display and they must be followed at all times.

However, there needs to be some regulations so that we can monitor environments and make sure that they are safe at all times. The government body that is responsible for this is the **Health and Safety Executive (HSE)**. This makes sure that all workplaces are safe places for people to work in, including schools, factories and offices. The HSE can inspect any workplace at any time and has the power to close anywhere down if it finds that the safety of workers is at risk.

While the HSE is responsible for ensuring that the environment is safe, employers must make sure that any possible hazard is identified and that workers are warned about it. This means that there must be a set of signs and symbols that are instantly recognised by people wherever they are placed. The design of these signs and symbols is the responsibility of the British Standards Institute (BSI), a body that produces a range of standards for almost every type of activity humans are involved in.

Signs and symbols

BSI symbols tell us that the products we buy are safe. These are usually recognisable from the product's packaging but they still form part of the safety signage that we look for to check the quality. Other signs and symbols are produced in accordance with European standards.

The signs that are used in the workplace are designed to make employees and visitors aware of the potential dangers. In the same way that signs on the road are grouped together into warning signs that are *triangular* and instruction signs that are *circular*, signs in the workplace also have a system of 'grouping'. This is usually done by using distinctive colours.

- High-risk danger signs and symbols tend to be bright yellow, usually with black lettering. Yellow and black are the most noticeable combination of colours. These are **warning signs**. Warning or caution signs are generally *triangular*. An example is the sign for electricity, which is a pictogram of a lightning bolt.

- Signs with *red circles* are mostly prohibitive. Diagonal lines are sometimes used to make it clear that this is something that must not be done. These are **do not signs**. An example is the sign for no smoking, which is a pictogram of a lit cigarette, crossed out.

- Signs with *blue* circles or rectangles are used to give positive instructions. These are **must do signs**. An example is the sign for switching off mobile phones, which is a sign of a mobile phone with 'switch off all mobile phones' written next to it.

- *Green* signs or symbols are often used to indicate where things are. These are **safety signs**. An example is the sign for first aid, which is a white cross on a green background.

A *A warning sign for electricity*

B *A 'do not' sign for no smoking*

C *A 'must do' sign for switching off mobile phones*

D *A safety sign for first aid*

Activity

Design a sign to tell people not to enter your bedroom.

Summary

You must stay safe while working with tools and equipment.

Signs and symbols are used to ensure people 'get the message'.

AQA Examiner's tip

The symbols that are used on signs are simple in shape and are in a single colour. Think about how they are used.

Joining materials

Adhesives

As a designer and maker you will always need to model your ideas, so you are likely to use a variety of materials, depending on what it is you are trying to make. You need to know the appropriate adhesives to use in joining different materials together. You need to be careful to use the correct adhesive as the wrong choice can either not work or leave unsightly marks. Table **A** will help you make the right choices.

> **Objectives**
>
> Know the correct adhesives to join different materials.
>
> Know how to apply these adhesives.

A *Adhesives*

Adhesive	What does it join?	What does it look like?	Advantages	Disadvantages
Glue stick	Paper Card	Solid white stick	Cheap Easy to use Safe	Not a strong bond
Polyvinyl acetate (PVA)	Card Wood	Thick white liquid	Strong bond Safe Sets within 2 hours and is colourless when dry	Can 'ripple' thin card if too much is applied
Spray adhesive	Paper Card	Clear spray	Quick Can reposition work easily	Not a strong bond Must wear a mask when spraying in a spray booth with an extractor Expensive
Balsa cement	Balsa wood	Clear and smelly	Quick-setting glue	Use in a well-ventilated area
Acrylic cement (Tensol is a brand name)	Acrylic	Water	Very quick and normally applied by a thin syringe	Use in a well-ventilated area Can leave marks where excess is applied
Epoxy resin (Araldite is a brand name)	Everything, but the glue always shows and will stain paper or card	Gloopy light brown	Very strong 2 hours to set Will join different materials to each other, e.g. acrylic to wood	Difficult to apply as it is so thick Use in a well-ventilated area
Hot glue gun	Most materials but not expanded polystyrene	Thick, clear, stringy	Very quick to set (10 seconds) Will join different materials to each other, e.g. acrylic to wood	Very difficult to use on fine model work as it is so quick to set Take care not to burn hands
Double-sided tape	Paper Card Foam board	Clear or white	Immediate strong join	Difficult to use as you cannot reposition work

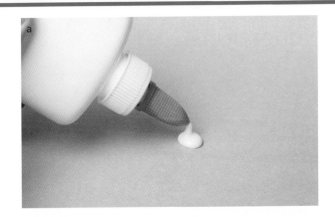

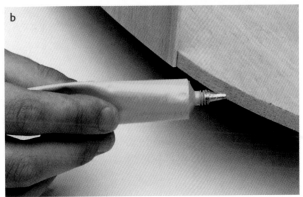

B *(a) PVA (b) balsa cement (c) epoxy resin (d) hot glue gun (e) double-sided tape*

Activity

Using Table **A**, choose the correct adhesive to join the following materials together. There may be more than one alternative. Justify your answer.

Materials: card to card, card to wood, acrylic to acrylic, acrylic to card, card to Styrofoam, card to balsa, wood to balsa, foam board to card, acrylic to wood.

AQA Examiner's tip

Make sure you refer to the adhesives you use in your controlled assessment.

Summary

Different adhesives are used for different joins and purposes on a variety of materials.

Before spending about 2 hours answering the following questions you will have to do some preliminary research into the packaging of 'fast' foods, for example burger and pizza boxes, and sandwich packets.

To complete these questions you will require some plain white paper, basic drawing equipment and colouring materials. You are reminded that quality of written communication is important, as well as neat sketches and drawings.

1 This question is about designers and their influence on the modern world. *(total 15 marks)*

Match these designers with their field of design. *(5 marks)*

 (a) Harry Beck (b) Alberto Alessi

 (c) Jock Kinnear and Margaret Calvert

 (d) Wally Olins (e) Robert Sabuda

with

 (i) typography (ii) paper engineering

 (iii) product design (iv) schematic drawing

 (v) corporate identity

 (b) Select two of the above designers and explain their influence on modern society. *(2 × 5 marks)*

2 (a) Produce a specimen questionnaire that you would use to identify a target market for a new MP4 player. (Use 5 questions.) *(5 marks)*

 (b) Explain why you have chosen each question. *(10 marks)*

3 This question is about communicating an idea to a client or customer. *(total 40 marks)*

A 3D sketch of a supermarket's clear plastic, sandwich container with its label panel is shown.

 (a) Draw a freehand isometric sketch of the container and include thick and thin lines to enhance the sketch. *(5 marks)*

 (b) Draw a freehand rectangle of 5 mm in from the perimeter of the label panel that can be used as a border to develop a letter style for part (d) and add the correct convention for a clear plastic material to the side panel. *(10 marks)*

 (c) (i) Draw an accurate half size drawing of the side panel. Include the dimensions to British Standard conventions and write down the correct scale. *(10 marks)*

 (ii) Render the side panel as though it was a coloured plastic. Use tonal control as though there was a light source shining on it from the left. *(5 marks)*

 (d) On a separate sheet, draw the label panel and develop letter styles for the product name 'QIK SNAX'. *(5 marks)*

 (e) Using your ideas from (d), draw a presentation drawing of the label panel. *(5 marks)*

4 This question is about graphical representation of data. *(total 15 marks)*

 (a) Name four different ways to graphically represent data. *(4 marks)*

 (b) A survey of 100 young people gave the following results for 'Favourite Snacks':

Baked potato = 10 people Fresh fruit = 15 people
Sandwich = 25 people Kebab = 20 people
Burger = 30 people

Draw a coloured pictograph showing the results of the survey. *(8 marks)*

(c) Explain the advantages of showing data graphically. *(3 marks)*

5 This question is about graphic symbols and signs. *(total 15 marks)*

(a) Study the four examples of labels and list four features that should be
present in a pictogram. *(4 marks)*

(b) A charger for a mobile phone is shown. The crank is turned to generate electricity.

Draw a pictogram, in the same style as 5(a), to show that the crank must be
turned to charge the phone. *(4 marks)*

(c) Ideograms convey ideas or instructions. What is the meaning of these? *(4 marks)*

(i) (ii) (iii) (iv)

(d) Draw a set of ideograms found in a car and briefly explain their meanings. *(4 marks)*

6 This question is about card engineering. *(total 20 marks)*

(a) A greetings card manufacturer has provided the following specification for a
'pop-up' card:

It must use layer pop-up mechanism (as shown).
The word 'HELLO' must appear when the card is opened.

(i) Sketch three different initial ideas for adding the word 'HELLO' to the
greetings card. *(6 marks)*

(ii) Design an envelope from sheet paper to take the greetings card. *(4 marks)*

(b) A children's publisher has provided a specification 'pop-up' book:
It must use a 'V-fold' mechanism (as shown).
The 'V fold' must form the mouth of an animal.

(i) Sketch ideas for a layout of this page in a children's book. *(4 marks)*

(ii) With sketches and notes explain how several different 'pop-up' pages can be assembled into the book, including the covers. *(6 marks)*

7 This question is about evaluation. *(total 10 marks)*

(a) How could a 'user group' contribute to an evaluation of your ideas for the greetings card or 'pop-up' book? *(3 marks)*

(b) Compare your best ideas with the specifications and complete the following sentences:

(i) My lettering in the greetings card is successful because … *(2 marks)*

(ii) The animal's mouth 'pop-up' is successful because … *(2 marks)*

(iii) If I were to change anything about my greetings card or book it would be …, because …? *(3 marks)*

8 This question is about the life cycle of a product. *(total 12 marks)*

A typical graph of sales against time for the life cycle of a product is shown.

Explain the stages lettered A, B, C and D in the history of a graphic product, for example a book or CD.

9 This question is about ergonomics and anthropometrics. *(total 6 marks)*

With reference to a craft knife or a mobile phone, explain the difference between 'ergonomics' and 'anthropometrics'.

10 This question is about social and environmental issues.

Many products are poorly packaged. Explain the following with reference to a graphic product and the environment.

(a) over packaging (b) deceptive packaging
(c) re-using (d) recycling
(e) biodegradable (f) sustainable resources

Always spend the right amount of time on each question. Use the marks as a guide – approximately 1 mark per minute.

Always answer the question asked – your response MUST satisfy the question. Do not rely on general knowledge.

Design and market influences

Introduction

This section is all about how a designer creates solutions to a problem and effectively communicates these to another person. It also looks at the role designers play in creating Graphic Products and some of the techniques commonly used to achieve this; including the use of CAD and CAM.

■ What will you study in this section?

This section will look at the way designers create and how the market can influence the direction a design takes. Explanations about the purpose of each stage with examples are provided, together with suggestions about how to carry out some of the different aspects of designing and making. The chapters will look at many different graphical techniques with helpful 'activities' suggested throughout. These should help you to understand the theme of each section and make it easier to use the information in the controlled assessment or written examination.

A range of relevant graphical techniques like card modelling or CAD and CAM will be looked at with the intention that you can use this information to explain how you can make your designs in quantity and commercially, always taking into account the environmental impact your design will have. This section also gives suggestions about the 'making' part of the design process and links to the sections on Materials and components and Processes and manufacture.

How will this unit help me?

In order to carry out your 'Designing and making practice' and to be able to answer questions in a written examination you need to have gained knowledge, understanding and skills. This unit provides you with understanding and knowledge about a wide range of techniques which are relevant to the controlled assessment but also will enable you to apply that knowledge and understanding when you have to answer examination questions. The skills you will have learned through explanations and examples in this section relate to both designing and making. This should enable you to apply these to the process of developing your own product and also to questions in the written examination.

18.1 Quality assurance and quality control

What is the difference?

The terms **quality assurance** (QA) and **quality control** (QC) are often confused. They are used together but the terminology needs to be applied correctly to get the best marks in your GCSE!

Quality assurance is built into the plans for a project so you will make the best choices during the design process, ensuring that the outcome is made to the best possible standard. It aims to create products that are safe, value for money, efficiently produced and economical for the intended user.

Quality control measures are what you put into place to check that the quality standards outlined in the plans are maintained. This will be checked at critical points throughout the production. To help with quality controlling products, manufacturers will use a variety of processes to ensure that the quality can be checked against the 'norm'.

Tolerance is the range of acceptability of accuracy. At the start of production, the tooling will be set to make the exact size. As production continues, there will be slight tool wear or tool movement. When sampling is carried out, as long as the finished sizes are within the tolerances then production continues. An example of a tolerance for the size of a birthday card can be 0.55 mm. This means that the card can be 0.5 mm bigger or smaller than the 'norm'. As soon as a sample falls outside the tolerance then production is stopped. Adjustments to the tooling are made when a sample is at the end of the tolerance range. This cuts down on waste and saves money on materials.

Using QA and QC

To help show you the difference between QA and QC, we are going to look at the production of musical greetings cards. These cards play a tune when they are opened. Table **B** shows the areas that need to be quality assured and the quality control checks that could take place to ensure the overall quality.

Objectives

Understand the terms quality assurance and quality control.

Apply quality assurance and quality control to a range of production methods.

Key terms

Quality assurance (QA): the process through which the designer actually states what quality he or she wants the product to have when it is finally made.

Quality control (QC): the measures that are put into place to ensure that the quality standards are met at critical points of the making process.

Tolerance: acceptable range of accuracy.

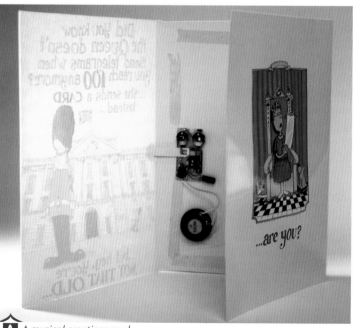

A *A musical greetings card*

B *QA and QC for producing musical greetings cards*

Quality assurance standards	Quality control checks
Appropriate quality card used	Check would be made on delivery – returned and replaced if incorrect or poor quality
Printing method is appropriate for type of card and quality of imagery/colour is high. Does the card match the colour specification for tone, density and hue?	'Proofs' or sample printouts would be printed using the intended printing technique. This would be visually checked using the registration marks to make sure that the printing plates are lined up. If it is correct, the registration mark will be black – if there are some misalignments there will be more coloured lines showing (see Photo C). The quality of the colour reproduction can be checked on the colour bar which is trimmed off but shows all of the print colours used on the page. This is usually visually checked but can be done using an electronic device called a densitometer.
Periodic sampling is needed throughout production	During batch or mass production the first card is checked for accuracy, etc. Sampling is then carried out where one card is tested per set number, that is 1 in 50 or 1 in 100. This is done to compensate for tooling wear or colour alignment failures. If testing shows a slight problem then adjustments can be made before it goes 'out of tolerance'.
Appropriate 'bought-in' modules (for example musical unit) are in working order	These will be supplied already assembled but there is a need to sample them initially to see if they play the correct tune (you do not want 'Happy birthday' to be played on a Christmas card!) and they work correctly. However, they will all need to be checked when the card is assembled.
Card is accurately cut and folded	The die cutting process will need to be checked for accuracy on a sample card and this will need to be tested to see if it fits into the envelope within the correct tolerance of space. A check will also be done to see if the images line up when the card is folded.
Components of the cards are assembled accurately	This will be checked for accuracy but so will any jigs or templates that are used to assemble the card. These tools can also be used to check the final accuracy after assembly.
Card fits envelope and packaging	Does the final card fit the specified size of envelope/ packaging? There must be a degree of tolerance to allow for easy packing.

C *Registration marks*

D *A page proof showing crop and registration marks*

Table **A** is not exhaustive and there will be differences depending on the actual assembly of the product. However, the main purpose of quality controlling a product is to make sure that the quality specification drawn up at the design stage is realised in the final product.

In the printing industry a lot of this can easily be seen when the proofs are printed for the publisher to check, immediately prior to doing the full print run. There will be several items on the sheets that will be used to undertake final checks for quality. These can be seen in Photo **D**.

Summary

Quality assurance makes sure the quality the designer wants is set out.

Quality control involves checks during manufacture to make sure this quality is achieved.

Industrial practices

Scaling-up production

It is important that you understand why most products you see outside school are made in some kind of quantity and why you tend to only make a 'one-off' in school, which means just one of any particular design. The approaches are different because of the scale of production.

The machinery required to make a single product from the raw material, such as blank card, to the finished product, such as an iPod box, is called a **production line**. A large factory that manufactures packaging may have several production lines making a number of different products at the same time.

Imagine you are making the packaging for an MP3 player. Now look at Table **B**, which shows the different steps you would take, compared to the ones used commercially.

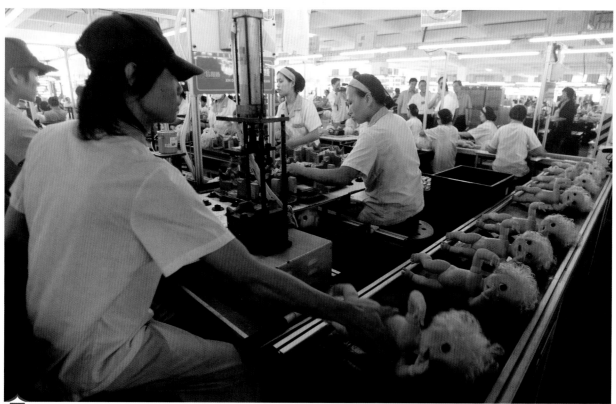

A *Factory production is very different from making a one-off in school*

B *The differences between one-off and industrial production*

Your method at school	Industrial method
Design images and text on paper (either by hand or CAD)	Receive specification from client
Design card net (either by hand or CAD)	Design graphics and text using graphics package on PC
Model card not by hand or using CAM	E-mail designs to client for approval
Transfer images and text to the net	Use pre-set net from a dedicated CNC software package
Use paper design, and spray mount onto card or print directly onto card	Electronic transfer of images and text to the net
Cut out net by hand or use CNC cutting equipment if available in school	Download settings to CNC die cutter
	Nets cut to exact settings
Glue and assemble by hand	Finished nets sent for automated assembly

> ### AQA Examiner's tip
> You may be asked to write how a product is modelled in the class or produced commercially using a step-by-step process.

Activities

1 Either working in a team of two or on your own, can you add any quality control checks to the processes in Table **B**? How about making a flowchart of the process, including QC checks, using the correct flowcharting conventions found on page 82?

2 Choose one of the following products and try to create your own guide on how you think it could be made in school, compared to industrially. Set it out in a similar style to Table **B**.

Products: a torch and its packaging, Easter egg package, perfume or aftershave bottle with packaging, set of computer speakers and packaging.

Summary

The way we make a 'one-off' product in school is usually very different to the method industry uses to make the same product in quantity.

There are also similarities in the way schools can use CAD/CAM compared to industry.

The four production processes

It may be hard to believe but industry goes through a similar design process as you; researching, designing and making models. The big difference is that a commercial company intends to try and put the design into production, in other words, to produce a large number of the product.

The way the product is made and the quantity required will determine the type of production level used. Generally, the greater the number of a product made, the cheaper the unit cost is (the cost of producing one individual item). Making only one of an item, or 'one-off' production, is quite rare as the cost is often so high, normally because of the labour costs.

Most of the designs you see are made in a batch, which means that more than one is made. **Batch production** normally involves a factory making the same item only for a few days or for up to a few months. This book is a good example of a batch produced item, with the printer taking about one week to produce many thousands.

If the demand for the product is huge, then it is likely that the item can be put into **mass production**, which means that millions will be made and the factory is likely to be making the same product for a year or more.

Sometimes the demand for a product is so high that the item can be made 24 hours a day and 7 days a week. This is known as **continuous production** and it is used commonly to make blank packaging products to be printed for different companies.

Manufacturers of soft drinks, perfumes, small electrical goods and computer games will mainly use standard-sized packaging such as the 33 cl aluminium can and the 25 cl tetrapak for drinks. It is very rare for the product manufacturer to actually make its own container or packaging. It is far more likely that a specialist independent manufacturer will supply these. The specialist factory will make one single basic size of product for several different companies.

The only difference for the factory that makes the basic size of tetrapak or can is in the printing. The printing machine is part of one production line and this line may run, for example, Fanta Orange for two days while another line may run Asda Cola for three days at the same time. Those particular lines will

Objectives

Know the four different types of production processes: one-off, batch, mass and continuous.

Be able to explain just-in-time production (JIT).

A *Sculpture is made as a one-off production*

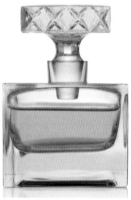

B *Perfume bottles are made using batch production*

C *Mass-produced cars*

stop for perhaps only a matter of minutes while the print rollers are cleaned and the design plates changed ready to run, for example, Pepsi for three days.

It is the same process for factories making standard-sized card packaging. It is usually a simple computerised process to increase or decrease the net size. A quick change of print plates from, for example Chanel perfume to a box for an iPod, and the process is continuous. The printed containers are then sent back to the product manufacturer where they are filled with the product and sealed. The cost of the product is added to the cost of the container or package and a final product price is established.

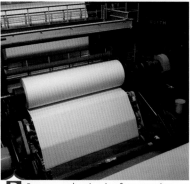
D *Paper production is often continuous*

E *Comparison of the different types of production processes*

Type of production method	Numbers made	Advantages	Disadvantages	Cost of setting up the production process	Cost of making individual item	Examples
One-off	1	Easy to set up, easy to change	Very high individual cost	Very low	Very high	Paintings, sculpture
Batch	1–10,000	Adaptable process of making so quite easy to change	Machines are expensive to buy and set up	Medium	Medium	Books, perfume bottles and their point of sales
Mass	10,000 +	Cost of individual item is low	Even more expensive than 'batch' to set up	High	Low	Cars
Continuous	Millions	Easy to make the same item cheaply to a very high standard	Cannot change if demand falls	Very high	Very low	Glass making, paper production, blank packaging products such as cans etc.

Activity

In pairs, see if you can think of more examples of products that use the four types of production processes discussed above.

Just-in-time (JIT)

Just-in-time is a specific method of controlling stock in which a company only buys in enough materials to cover its immediate needs. By ensuring that exactly the right amount of materials arrives at exactly the right time on the assembly line, companies can operate far more economically.

The three main advantages of JIT over normal production methods are:

- reduced storage costs
- production run can be more easily changed
- reduced over-stocking of product.

Summary

Industry nearly always makes products in quantity, normally batch- or mass-produced.

JIT is a more efficient production method.

Key terms

One-off production: used for high-value special items.

Batch production: used for limited runs such as books and magazines.

Mass production: used when making millions of the same item.

Continuous production: 24/7 production but with the possibility of changing printing plates.

AQA Examiner's tip

You are likely to be asked which production process would be suitable for different products.

19 Printing

19.1 How the printing process works

▦ The three stages of printing

There are three stages of printing which will be discussed over the next 12 pages.

1. **Pre-press** – the stages needed before actual printing takes place:
 - check **artwork**
 - colour separation
 - add quality control measures (page 130)
 - plate or screen production (page 134).
2. **Print** – the process of actually printing the design:
 - quality of paper/card
 - sheet of web feed paper/card
 - how many colours are needed.
3. **Finishing** – any additional processes required after the main four process colours (CMYK) are printed:
 - special effects (embossing, varnishing, laminating) (page 138)
 - die cutting (page 140)
 - binding a magazine/book.

Pre-press

Every process carried out before the actual printing happens is known as *pre-press*. There are four main stages.

Checking artwork

One of the printer's first jobs is to check that the artwork is suitable for the print process chosen. The printer will mainly check font types, colours and the quality of pictures.

Colour separation (page 134)

After the artwork is checked, the printer then goes through the process of **colour separation.** If you look very carefully at your television you will notice that the image is made up of dots using the three colours of red, green and blue. Our eyes merge these tiny dots together to create the whole spectrum of colours.

Printed images work on the same principle as when our eyes merge colours together, but instead of using three colours, they use four for higher clarity. Printed images use much smaller dots than a television and these four colours are known in the print industry as the **process colours.** They are cyan (C), magenta (M), yellow (Y) and black (K), commonly shortened by printers to CMYK. The letter K for black is used because the black is the 'key' colour, giving the overall image depth.

Objectives

Know the three stages of printing: pre-press, print and finishing.

Know how designers get their ideas printed.

Understand how and why the quality of the print can vary.

Key terms

Artwork: the name given to the hand drawn or CAD designs created by the designer.

Colour separation: the process through which the original image is separated into the four process colours by a computer program.

Process colours: cyan, magenta, yellow and black, commonly shortened by printers to CMYK.

Special colours: pre-mixed specific colours that can be used instead of the CMYK system.

A *The process colours: cyan, magenta, yellow and black*

The printer needs to separate the original artwork into CMYK so that those particular inks can be used on the actual printer. Each coloured ink is printed over each other in different densities to create the whole spectrum of colours you see in most images. To separate, or pull apart, the original image into the four colours of CMYK the printer uses a *colour separation* computer program. Sometimes **special colours** are used, where a specific colour is needed that cannot be made with the four process colours. Fluorescent (DayGlo) or metallic colours are good examples.

B *Images at high and low dpi*

Print quality

The printer knows that each of these process colours will be printed one on top of each other and that, as with the television, our eyes will merge these coloured dots together. The better the quality of the image, the smaller the dots are. Therefore an image with 800 dpi (dots per inch) is going to be much better quality than an image with 200 dpi, as there are fewer dots. Photo **B** shows the same image printed both on newsprint (which is at a low dpi, so you can see the dots if you look carefully) and on this book's paper (which is at a high dpi). You can see the marked difference in quality.

Activity

Try to find two or three examples of printed images that you think have different print qualities. Stick these in your exercise book and label with the quality you think they are, and whether they are a high or low dots per inch (dpi).

Summary

There are three stages to the printing process: pre-press, printing and finishing.

Most printing methods use tiny dots of the process colours CMYK, which are printed one on top of each other.

Printing quality control

Like you, the printer and customer are always concerned about maintaining the highest quality they can in their images. To achieve this quality control, the printer puts in special marks on the edge of the pages, just outside the printed area. These marks check different aspects of the quality of print and are called:

- registration marks
- colour bar
- crop marks.

Registration marks

You already know that the printer has to 'colour separate' the image into CMYK. Most print processes make a **printing plate** for each of these four colours (see page 133). These four printing plates have to align, or register, exactly with each other, otherwise the printed image can appear fuzzy or out of focus. To quality control this, the printer adds a **registration mark** to each plate in exactly the same position. The printer will then be able to regularly check the alignment of each plate by its colour. The registration mark should always be the colour of the last ink used on the printing machine. This is normally black.

Activity

2 Try to find a registration mark on a cereal packet that is 'out of register'. Cut it out and say which of the process colours, CMYK, are mis-aligned.

Colour bars

Not only do the printing plates have to register with each other to maintain the quality, but the printer also has to be certain that the colours are perfect. To do this a **colour bar** is added to the side of the image to show the density or **tints** (in percentages) of the individual colours. The printer looks at the colour bar with a tool called a **densitometer** and adjustments can be made if necessary.

Activity

3 Look at a cereal box and try to cut out all the printer's marks and any symbols used, such as recycling. Display these in your notes and label each. You should be able to find more than five items.

Key terms

Printing plate: normally made from a flexible material like aluminium for offset lithography or rubber for flexography.

Registration mark: a very clear mark about 10 mm across of a circle and lines, which is used to check whether the printing plates are aligned.

Colour bar: a small strip of the process colours (CMYK) printed outside the actual image. It is used to check the density of the four colours.

Tints: percentages of the process colours found in the colour bar.

Densitometer: measures the density of any colour.

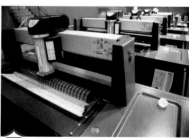

A Four colour printing

B Good and bad registration marks

C *Colour bar*

D *Checking image quality using a densitometer*

Crop marks

Another feature that the printer adds are **crop marks**, which are located at each of the four corners of the printed sheet. These show where the outline of the finished image should be and they thus guide the printer exactly where to cut, or **guillotine**, when trimming to the final size. If you look carefully, you will notice that the printed image is always larger than is necessary, to allow for a tolerance of error. It is normally 3 mm and this extra printed area is known as the **bleed area**.

E *Features added by the printer*

Activity

4 Answer these questions and stick them in your notes:

a Name two quality control measures a printer can make.

b Why should a registration mark be black?

c Draw the three marks a printer adds to the image and title each with a brief explanation.

d What tool is used to check the density of colour?

e Explain using a drawing what is meant by the 'bleed area'.

f Why is black ink shortened to the letter 'K' in CMYK?

Summary

Registration marks, crop marks and colour bars are used by the printer to ensure a quality product is achieved.

kerboodle!

Common print processes

Because there are so many variations in printing surfaces, the quantity of prints required, the quality of the print and the costs involved, a range of different print processes have been invented.

In the next few pages we will cover the most common print processes and you should become familiar with how each one works and be able to apply this knowledge of printing to products you see in everyday life. Each process is different, with laser as the cheapest and gravure having the most expensive set-up costs.

All the methods, apart from laser printing, use a similar process to print. It is important that you understand this, and then look at the individual methods to try to get to grips with why different print processes are used on different surfaces.

Objectives

Understand why different printing processes are used for different tasks.

Key terms

Set-up costs: the costs involved in setting up the printing machine, including making the printing plates and all the pre-press work.

A *The main qualities of each printing method*

Print process	Common use	Advantages	Disadvantages	Cost (10 = high)	Print quality (10 = high)
Offset lithography	Newspapers Magazines Books	Most common method High quality Fast Prints onto paper extremely well	Expensive set-up costs	5	9
Flexography	Packaging Corrugated boxes Shopping bags 3D surfaces like bottles	Very fast	Expensive set-up costs	6	8
Screen printing	Short print runs T-shirts Big posters	Good for short print runs Can print on absorbent surfaces	Not as good quality as the other processes Slow	4	6
Gravure	Expensive high-quality magazines Stamps	Best quality print process Very fast	Very expensive setup costs	8	10
Laser	One-off items	Immediate printing No set-up costs	Very expensive individual print	10	7

Activity

1 Write out Table **A** and cut up all the individual sections with scissors. Work in a team or two and reassemble the table exactly ... it's difficult!

AQA Examiner's tip

Try to understand that all the different print processes have their strengths and weaknesses. You are likely to be tested on what is the most suitable process for a product.

Summary of printing process

Pre-press

Stage 1
Artwork scanned into a computer and sent to printer via e-mail or CD

Stage 2
Printer colour separates image into CMYK

Stage 3
Printer adds registration marks and colour bar for quality control checks. Also adds crop marks to show where to guillotine the print

Stage 4
Printer makes four printing plates, one for each colour

Stage 5
Plates carefully aligned on machine, normally around a cylinder

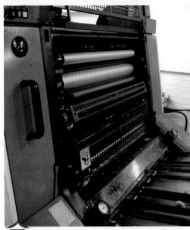

B *Pre-press*

Print

Stage 6
Job is printed with regular quality control checks on plate alignment and colour density, using the registration marks, colour bar and densitometer (see page 13).

C *Print*

Finishing

Stage 7
Any print special effects are now added, for example varnishing, laminating, embossing, heat foil blocking, die cutting, book binding. NB These are expensive!

Stage 8
Print is guillotined to size

Stage 9
Print is packed and sent to a distribution centre from where it will then go on to the shop to be sold.

D *Finishing*

Activity

2 There are nine main stages in the print process. Working in a team of two, read out one stage to your partner and your partner then has to tell you whether the stage is pre-press, print or finishing.

Summary

Printing methods vary enormously due to four things: cost, quantity, quality and the surface to be printed.

The most common print processes are offset lithography, flexography, screen printing, gravure, laser and inkjet.

Offset lithography: plates and paper

▮ How do they do it?

Did you know that **offset lithography** is used for about 70 per cent of all printing? It is nearly always used for printing onto paper and thin card. Once the machine is set up, it is a fast and high-quality process, only bettered by the more expensive printing process of gravure.

We already know that the image goes through the colour separation process, but did you know that the four printing plates (CMYK) of the artwork are made by shining an ultraviolet (UV) light through a photo for each colour onto separate plates? These four thin aluminium plates have a special green coating on the surface that reacts to the UV light. This reaction causes the printing ink to only be attracted to the area where the UV light has hit the plate. This process is known as **photomechanical transfer** or PMT.

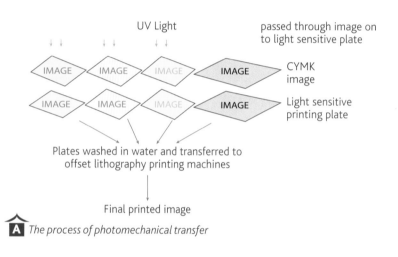

A *The process of photomechanical transfer*

The plates are made of aluminium because they are:

- flexible
- durable (last up to 30,000 prints).

But if the print run is very short, say up to 5,000 leaflets and letterheads, then these plates can now even be made from card.

How is the paper fed into the printer?

Paper and card can be supplied in two ways to the printer: **sheet fed** or **web fed**. Sheet fed, as the name implies, is when individual sheets of paper are fed into the printer, just like your printers at school. Although this type of feed is slower, it very common in small printers and makes it is easier to change the print job, which makes it preferable to web feeding for short print runs. Any size from A4 to A0 can be used.

Objectives

Understand the process of making printing plates for offset lithography.

Learn how paper is fed into the printer.

Know about the two types of inks.

Key terms

Offset lithography: a type of printing. The 'offset' means that the actual printing plate never touches the paper, because the image is first transferred, or 'offset', onto another cylinder.

Photomechanical transfer (PMT): this is the process used to transfer the image onto a printing plate.

Sheet fed: individual pre-cut pieces of paper are fed into the printer.

Web fed: paper is fed into the printer on huge rolls and the rolls are cut into pieces after printing.

AQA Examiner's tip

Make sure you know how printing plates are made and the difference between sheet- and web-fed paper.

Web fed is different in that the paper comes in what looks like a massive toilet roll that normally weighs about a ton, and has about a mile length of paper! It is a cheaper method of printing, as the paper has not had to be cut into individual sheets, and it is much faster. In fact, it is so much faster that you could sprint and still not keep up with the speed of the printer! Some presses can produce 60,000 prints per hour. It is normally used for long runs in excess of 20,000 prints.

Image offset

Once the printing plates have been made they are placed onto the offset lithography cylinders. The four ink colours (CMYK) are then applied to these plates by rollers. A very small quantity of water is used to help the ink stick to the image area and not the remaining part of the printing plate.

Each plate transfers, or 'offsets', the image onto the blanket plate, which in turn transfers the image onto the paper. When the paper has passed through all four plates, the full colour image has been created, unless a special print finish is required, in which case an additional process will be necessary (see Chapter 20).

Types of printing inks

There are two types of printing inks: oil-based and water-based.

- Oil-based inks. Traditionally, printing inks were oil based and not environmentally friendly. Recent advances in technology have created a different oil-based ink that now uses vegetable oils (like sunflower oil). This makes the inks far better for the environment as they are biodegradable and come from a renewable material.
- Water-based inks. These are even better for the environment, as they are based on water which makes them very easy to break down or degrade. They are now used by most printers.

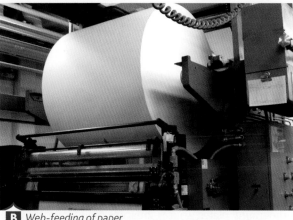

B Web-feeding of paper

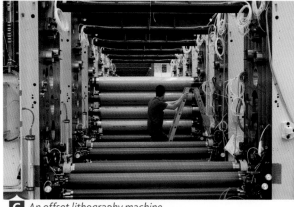

C An offset lithography machine

Summary

Offset lithography is a high-quality, volume print process that is great for paper and thin board.

Photomechanical transfer (PMT) is the process used to make the printing plates, which are mostly made from aluminium.

Paper is either sheet- or web-fed. Inks are either oil- or water-based.

Activity

If there were 100 pages in this book and 40,000 books were printed, what type of paper feed and print process do you think would be used?

Flexography

The basic principles of **flexography** are the same as lithography, using the four process colours, but as the name implies, the printing plate is made of flexible rubber. The image sticks out a little, unlike offset lithography where the image is totally flat. This makes it a really good process for printing onto flat or slightly uneven surfaces such as card, plastic or metal. Even cans can be printed in this way and the process is even faster than lithography. The printing plates last about twice as long as lithography plates, so it is great for really long, good quality runs.

Objectives

Understand the print processes of flexography, gravure and screen printing.

Key terms

Flexography: a high-speed, high-volume print process that can print onto nearly all surfaces, for example plastic and metal.

Gravure: the highest quality, but most expensive print process, used for the best detail image, for example stamps.

Screen printing: the lowest quality print process but able to print onto many different surfaces, including fabrics.

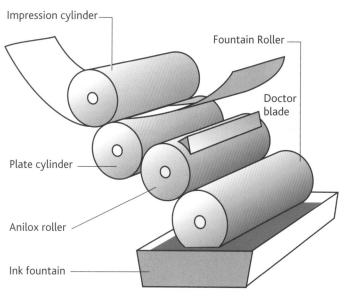

A *The flexographic process*

Digital printing

You will already be familiar with this method of printing as this is the type you will have used in the classroom. You are probably used to printing one or a very small batch of a design using inkjet and laser printers. These are examples of digital printing and industry also commonly uses this type of printing for short batches up to about 3000 copies. The major advantage of this method is that, although the image is printed using the four process colours of CMYK, printing plates do not have to be made and it is still possible to achieve a high quality print. Therefore there are no set up costs, except for the purchase of the printer. The disadvantage is that the unit cost of each print is relatively high compared to the other commercial print methods. An example of when digital printing could be used is for a local football team

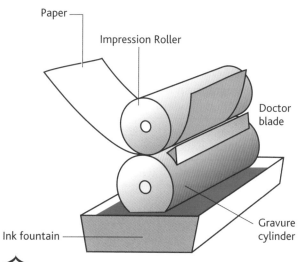

B *The gravure process*

wanting 1000 full colour A4 programmes printed. In this instance it would be more expensive to set up an offset lithography printer than to use a laser printer.

Gravure

Gravure is the most expensive but highest quality print process available. Like flexography, the image sticks out from the background but the plate is made from brass this time. It is used for full-colour magazines, stamps and special high-quality reproductions of photos.

It is mostly used for the longest print runs on paper of 1,000,000 or more as the plates are very expensive to make. Therefore gravure has the highest set-up costs of all the print processes.

Screen printing

The **screen printing** process is different to all the others we have looked at. It allows you the option of printing onto a vast number of surfaces, ranging from T-shirts to point-of-sale stands. It is useful for short print runs as it has a cheap set-up cost.

The way it works is that the image is made into a stencil through which the ink is forced onto

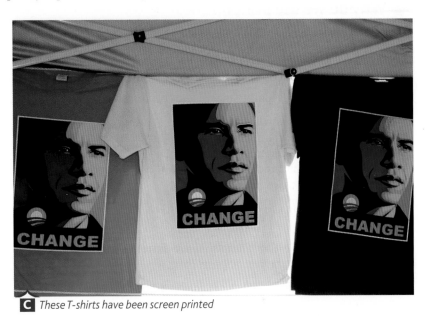

C *These T-shirts have been screen printed*

the product. This stencil is made in a similar way to the lithography printing plates, but it is put onto a screen, which is like a very fine gauze or mesh. The four process colours of CMYK are mostly used to create the image with the usual quality control marks added (registration marks and colour bar). Because of the screen size, it can only go to around 300 dpi (dots per inch), while lithography can go to 800 dpi; therefore screen printing cannot produce the best quality prints.

Although the quality is not as good as other methods of printing, screen printing does have some advantages. It is:

- simple and cheap to set up
- good for short runs
- can print onto nearly all surfaces.

Summary

Flexography is great for long print runs, especially on metals and plastics.

Gravure is expensive but the best quality print.

Screen printing is very good for short runs and it can print onto almost any material.

Activity

You may well have come across a screen printer in the art department at your school. Try to make a very simple stencil and use the squeegee to push one colour through the screen.

20.1 Varnishing, foil blocking and laminating

■ Why do we use print finishes?

You have probably looked quite carefully at a variety of printed items by now and noticed that not only does the quality vary, but that different 'special effects' or **print finishes** are used to help sell the product. They can enhance the image, but they are very expensive as most of them require a separate machine to produce the effect.

Imagine Christmas cards without metallic foil (rather boring!) or a book like this without a laminated layer of plastic on the cover (it wouldn't last long!). Look at a pop-up card. Die cutting is used to cut out those really complicated shapes. So as you can see, print finishes are very important for two main reasons:

1 aesthetics – making the product look better

2 protection – protecting the surface from wear and tear.

It is worth noting that although finishes are extremely useful effects, each one often *doubles* the actual print costs.

There are five main finishes, each of which will be described in this chapter:

- ■ varnishing/spot varnishing
- ■ foil blocking
- ■ laminating
- ■ embossing
- ■ die cutting.

Varnishing

You are probably familiar with the idea of adding a layer of varnish to wood to make it look better and add some protection. Exactly the same can happen to a printed surface. The varnishing process used to be a slow drying, but cheaper, oil-based varnish. Technology and speed have moved on so now most varnishing is ultraviolet (UV) sensitive. This means that the varnish is passed under a UV light and sets immediately, giving a very smooth and glossy finish. **Spot varnishing** is where only a certain part of the printed surface is highlighted by the varnish. You often see the title of a book spot varnished on the cover to add impact graphically.

There are three main finishes varnish can give: matt, satin and gloss.

Foil blocking

This is a great process for making a product look expensive! It works by stamping pre-glued metallic foil onto the printed surface by using heat and pressure. It is used a lot on cards and expensive packaging.

A Spot varnished book cover

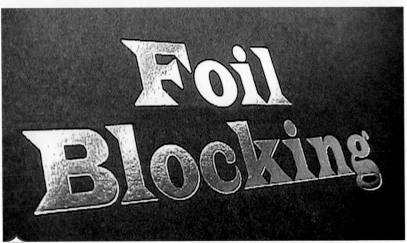

B *Foil blocking is used for Christmas cards*

Laminating

Some products need to be laminated, which provides greater protection than a simple layer of varnish. The lamination process involves heat-sealing a thin layer (normally on one side only) of a clear polymer, such as PET, to the printed surface, using heat and pressure from big steel rollers (see Photo **C**). Laminating also dramatically improves the strength of the page, improves appearance and produces a 'wipe-off surface'.

Activity

Collect an example of a product(s) that has used each of the five print finishes. Try to cut out a relevant section of each product and stick it in your notes with a title.

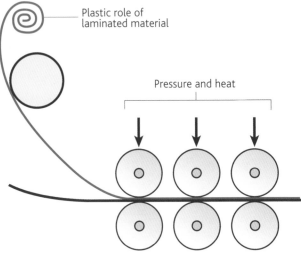

Plastic role of laminated material

Pressure and heat

C *Laminating process*

Summary

Varnishing and foil blocking are used to improve the aesthetics of the print.

Laminating not only improves the aesthetics, but also provides strength and protection.

Embossing

Without realising it you can almost certainly see something either in your classroom or at home in your bedroom that has been **die cut** or even **embossed**, although embossing is rarer. These are two expensive but effective finishes that can transform a graphic product.

The embossing process raises part of the surface by applying about five tonnes of pressure to a steel die or stamp onto the printed surface. This gives a really effective subtle visual and textural addition to the product, but it greatly increases the cost of printing because it is so expensive to set up.

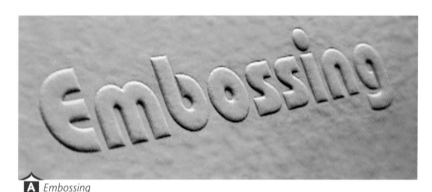

A Embossing

Objectives

Know about embossing and die cutting.

Consider how to use print techniques in your work.

Key terms

Die cutting: the process used to cut, score or crease shapes in card.

Embossing: a process that raises the surface of a material using a press or stamp. It is used to give a slightly 3D effect to the embossed area and therefore adds interest to the design.

Press forme: the actual tool that is used in the die cutting process.

Creasing: the paper or card is compressed to form a fold line.

Die cutting

There are a lot of graphic products out there that use all sorts of complicated curves and creases. Think about the shapes involved with the making of a pop-up card, or a net for a package – these shapes have to use the process of die cutting. Die cutting uses a system similar to that you would use in cutting pastry with a pastry cutter. The outline of an object to be cut out will be made by inserting sharp blades called press knives into a sheet of thick plywood (called a **press forme**). This is then placed on top of the card and it is pressed down to cut the shape out.

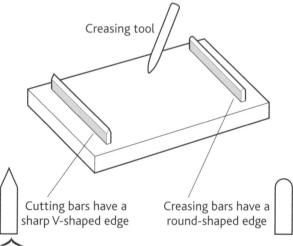

Creasing tool

Cutting bars have a sharp V-shaped edge

Creasing bars have a round-shaped edge

B A die cutter being used to 'stamp' a shape

Activity

1 Contact your local printer and ask them whether they have any spare formes that you could show other students in the class. Draw out the main parts found on a forme.

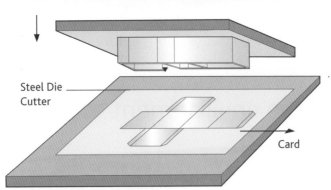

Steel Die
Cutter

Card

C *A die cutter*

> **Activity**
>
> **2** Draw a simple cross-section of the embossing technique.

Round-edge or serrated blades can also be included to either produce a crease line (**creasing** is used for the centre line in greetings cards) or a perforated edge (so that the product can be torn apart on that line, such as a sheet of postage stamps).

The press forme is made by cutting the slots into the plywood using a laser cutter. The cutting and creasing knives are then inserted into these slots in the plywood base, and finally rubber blocks are placed around the blades to push the product and the waste material away from the blades after it has been cut.

Although creasing is commercially done as part of the die-cutting process, it can also be achieved very easily in the classroom. Creases can be applied to card with the use of a safety rule and creasing tool. For this you simply mark where you want to crease and then use the tools to apply the crease using pressure.

> **Activity**
>
> **3** Unfold some card packaging that you find at home and identify the way that this has been die cut. Draw the net of the package and then show where the cutting blades and creasing bars would be for this net.

D *Die blades used in a press forme for die cutting*

Summary

Embossing is the raised surface used to improve the aesthetics of the printed image.

Die cutting uses a press forme to cut out and crease complex shapes. These shapes are then sometimes assembled into a 3D item, such as a package.

> **AQA** *Examiner's tip*
>
> Make sure you use all this knowledge and try to apply it to your ideas in your coursework. Use annotation to describe print processes and finishes. This will gain you a lot of marks and be useful revision for the exam.

21 Packaging

21.1 Packaging and the environment

Packaging problems

Today, packaging is a massive, lucrative multibillion pound industry. You have no doubt been persuaded to buy a product, at some time, based on the kind of fancy packaging we often see. The most common material used in packaging is plastic, which is based on the non-renewable resource of oil and it is often very difficult to recycle the packaging, therefore it ends up in a landfill site, making the whole process very un-environmentally friendly.

The top two functions of packaging are to protect and promote the product. **Primary packaging** is used to protect the product and provide information about storage and the contents. **Secondary packaging** actually contains the product. This is usually made of card or plastic with bright printed graphics giving detailed information to the consumer, such as legal requirements.

We all know that packaging does have its uses, but 70 per cent ends up in landfill sites and pollutes the environment with the potent methane gas released as the rubbish degrades. This methane is 21 times as potent as CO_2 as a greenhouse gas.

A Primary and secondary packaging

Our job as designers should be to try to minimise the impact on the environment with clever package design.

The main environmental questions to ask as a designer are:

- What material should I make the package from?
- What will happen to the package when it is finished with?
- Can it be easily recycled or re-used?
- Is the product over-packaged?

Objectives

Learn about the impact that packaging has on the environment.

Consider how we can be more environmentally friendly.

Key terms

Primary packaging: packaging that protects the product and gives key information.

Secondary packaging: packaging that contains the actual product and gives detailed information to the consumer.

Activity

1 Look at the example of primary and secondary packaging in Photo A. Can you collect one example of each from home and bring them into school and explain to your classmate why you chose these packages?

Eco-friendly solutions

Thankfully, many manufactures are now becoming more aware of the impact they can have on the fragile environment. Paper and card are always a better option than plastics, but sometimes products need different qualities in their packaging. To help solve this, two new totally biodegradable packaging materials have been created. Both are made from potato starch.

One is called PaperFoam. This is a recyclable and biodegradable alternative to the normal plastics we often see. The other is called Potatopak, which behaves very much like the polystyrene you tend to get fast food in, but is made entirely of potato and therefore easily degrades.

Activity

2 Go to www.paperfoam.com and look at the 5-minute video. It's really good! Also have a look at www.potatopak.org, www.thebodyshop.com and www.incpen.co.uk.

C *A PaperFoam CD case*

Waste hierarchy pyramid

The waste hierarchy pyramid can help us to become more aware of clever environmental packaging design by following this basic guide:

- Prevention is by far the best option, that is, do not package the item at all.
- Minimise the amount of packaging material used.
- Re-use existing packaging.
- Use recycled material to package the item.
- Use the waste packaging material to power a power station.
- By far the worst option and sadly the most common option is to just dump the packaging into a landfill site.

AQA Examiner's tip

You are likely to design some packaging during your GCSE course. Try to think about the function of the package and what environmental effect it will have.

Activities

3 Using the pyramid in Diagram **D**, think of one packaged product as an example for each of the six areas. For example, for *Energy Recovery* wax-coated orange juice cartons cannot be recycled easily, because of the wax, but can be incinerated to produce energy.

4 Collect five different examples of packaging, including some plastic and some paper-based. Now try to work out how environmentally friendly each one is, giving them a rating from 0 to 10. Explain your rating for each one.

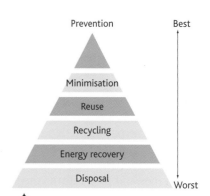

D *The waste hierarchy pyramid*

Summary

There are environmentally friendly alternative materials to plastics that can be used to package most products.

Some good examples are card, PaperFoam and Potatopak.

21.2 Why do we use packaging?

Main reasons for packaging

There are five main reasons for packaging. Try to remember them using the SIPPP acronym:

- Stacking and storage
- Information
- Protect
- Preserve
- Promote.

Stacking and storage

If you look in any supermarket you will notice that nearly every product is packaged in a way that it can be easily stored and stacked up on each other. The items are often secondary packaged, being put inside a separate rectangular corrugated cardboard box. This makes it easier to stack a quantity of the items.

Over packaging is where too much packaging is used. This could be a small product where a large package is used just for the purpose of advertising the product when it is on display in a shop. **Under packaging** is where too little packaging is used. This is usually where a product may be fragile, but is not protected properly by the package and therefore could get broken in transit. **Deceptive packaging** is where the package gives a false impression of the product. This may be similar to over packaging but for a different reason. It may not be to advertise, but could perhaps be done to make a product look larger than it actually is.

Barcodes

A barcode consists of a series of black strips of different widths with spaces between each strip. A laser beam scans the strips and line widths, converting these to numerical values which are recognised by a computer program.

Barcodes generally contain three items of information:

1 The first two numbers show the product's country of origin.
2 The next five numbers show the manufacturer's reference number.
3 The last five or six numbers show the specific product number.

RFID tags

An RFID tag is a microchip combined with an antenna in a compact package; the packaging is structured to allow the RFID tag to be attached to an object to be tracked. 'RFID' stands for Radio Frequency Identification. The tag's antenna picks up signals from an RFID reader or scanner and then returns the signal, usually with some additional data (like a unique serial number or other customised information).

RFID tags can store far more information than a barcode, making them more useful as they allow the retailer to store additional information.

Objectives

Know the five reasons why we need to use packaging.

Learn about barcodes and RFID tags.

AQA Examiner's tip

You need to be able to apply the SIPPP acronym to most packaging questions and to apply each of the five elements.

Activities

1 Can you find examples of over packaging, under packaging and deceptive packaging?

2 Use the internet to research RFID tags. Try to give one advantage and one disadvantage of these over traditional barcodes.

Key terms

Over packaging: where too much packaging is used.

Under packaging: where too little packaging is used.

Deceptive packaging: where the package gives a false impression of the product.

A A barcode

RFID tags can be very small - the size of a large rice grain. Originally invented as a security device to stop shoplifting, they have become increasingly popular as part of a sophisticated stock control method.

Information

It is now often a legal requirement to tell the consumer exactly what the product is and what it contains. This especially applies to packaged food.

Information can either be printed directly onto the package or in the form of labels. Consumers increasingly want to know more and more information about the product, such as:

- ingredients
- weights
- safety precautions
- best before dates
- how to use, etc.

B *An RFID tag*

Protect

It is extremely important that the product is protected so that the customer gets the product home in perfect condition. The main materials used for protective packing are:

- corrugated cardboard
- expanded polystyrene
- bubblewrap.
- Tamper-proof packaging is also necessary for some products.

C *Instructions are part of packaging – information*

Preserve

Most food products have to be packaged to keep them fresh and edible. The package often acts as a barrier against air, therefore an airtight seal has to be made.

Promote

Hopefully, the graphics on the package will be eye-catching to attract the customer. Brand names often have a specific colour and style that must be incorporated into the design.

D *Corrugated cardboard – protect*

Activity

2 Choose one package and try to use the SIPPP method to describe how that particular package answers each area. Write this up in your notes, perhaps with a photo of your package alongside.

Summary

Careful packaging design is an extremely important aspect of the final product. It can dramatically affect the saleability of a product due to its aesthetics (or looks).

Without good packaging a product will often fail to be a success for a variety of reasons, such as lack of protection resulting in the product getting damaged during transport.

E *Bacon in an airtight package – preserve*

21.3 Packaging materials

Main materials used for packaging

We know that designers have lots of options when considering the material they are going to use for packaging. All materials have advantages and disadvantages, and as a designer you need to weigh these up carefully when you make your packaging choices (see Table **A**).

A *The main materials used for packaging*

Material	Advantages	Disadvantages	Common use
Paper, card	Cheap Light Easy to print on	Not as strong as the other materials Not waterproof	Games Cereals
Thermoplastics, for example bubblewrap, expanded polystyrene	Waterproof Light Transparent Complex shapes easily made	This is the least environmentally friendly material in this table	Drinks Bags Insulation Protection
Metals such as steel and aluminium	Strong Waterproof	Expensive	Tin cans Fizzy drinks
Glass	Waterproof Transparent	Breaks Expensive	Drinks bottles
Softwoods, for example pine	Cheap, strong Can be re-used		Pallets
Engineering boards, for example plywood	Very strong	One-off use	Packing cases for transport of machinery

Symbols used in packaging

You have no doubt seen lots of different symbols on packaging and they should be easily understood. Table **B** shows some common pictorial symbols found and their meanings. These symbols remind those handling the package to take care of them in a particular way.

Activity

1 Find as many symbols as you can on different packages. Stick these in your book and explain what each one means.

In the same style as these symbols, design your own to represent one of the following:

■ electrical goods inside

■ contains liquids

■ sharp objects inside.

B *Some common symbols used in packaging*

Symbol	Meaning	Notes
	Keep out of the rain and do not store in damp conditions	Normally found on card packages that would be damaged if placed in contact with water
	Store package the right way up	Arrows point towards the top of the package
	Centre of gravity	Only normally used where the centre of gravity is not central
	Keep away from heat	Keep package under the coolest possible conditions and away from any heat, including sunlight
	Clamp as indicated	Also implies that the package should not be clamped anywhere else

C *Which symbols would be used on a box of chocolates?*

What industrial processes are used to make the package?

It is difficult to know which industrial process to use, as there are so many different types of packaging shapes and materials in the world. As a designer you need to go through the five reasons for packaging, mentioned earlier in this chapter and then decide on your material choice before you can make this decision.

D *Examples of common processes used*

Shape	Material	Industrial process to shape
Simple box	Board	Die cutting (see Chapter 20)
Bottle	Thermoplastic, glass	Blow moulding (see Chapter 3)
Bottle lid	Thermoplastic	Injection moulding (see Chapter 3)
Blister packing	Thermoplastic	Vacuum forming (see Chapter 3)

Spiral wound tubes

These are a useful method that can provide structurally strong tubular support. You will have seen these used in products like 'Pringles' containers or the centre of toilet rolls.

Summary

The four main materials used to package an item are board, plastic, metal and glass.

The four main processes used to make the packaging are die cutting, blow moulding, injection moulding and vacuum forming.

AQA **Examiner's tip**

Remember SIPPP: Stacking, Information, Protect, Preserve, Promote.

AQA **Examiner's tip**

- Try to make sure you are familiar with why a specific material is used for packaging and the industrial processes associated with that material.
- Make sure you are familiar with symbols found on packaging.

Activity

2 Find one example of packaging for each of the four main industrial processes. Sketch each one and label with the process and material.

22.1 Patents and copyright

Patents

As soon as a designer creates a new design there is a risk that someone else might try to copy it and then claim it is theirs. **Patents** are there to prevent this. A patent is a legal protection granted by the country to the designer or inventor, giving that person exclusive rights on his or her design so no other person can copy it. To achieve a patent, a product must be new, inventive, able to be industrially made and be a physical item. A UK patent costs £200 and are recorded on the product, normally with a long number and lasts for 20 years.

Patent holders, however, must allow their designs to be made public, with the idea that this will encourage further invention in design and so benefit everyone in the long run.

The UK patent office has four criteria that a design has to have, before one will be granted. They are:

1. It must be new.
2. It must be inventive.
3. It must be able to be industrially made.
4. It must be a physical product or process.

Once a patent has been granted, the designer officially owns it and they can do various things with it:

- Continue to make it themselves.
- Sell the patent.
- Sell the right to make it to individual companies. Often the designer will receive a royalty for every product sold. This is normally a small amount of money for each product.

Copyright

A **copyright** is similar to a patent but is used to protect text, music, films, computer-generated works or drawings from being copied. When a copyright is granted the symbol © is printed on the text, which indicates that the author or designer has the right to be recognised for their work. For example, if you look on the first few pages of this book, you will see that the authors are covered by copyright and no one can copy the contents or appearance without their permission. The copyright normally lasts the lifetime of the author plus 70 years.

Objectives

Know what a patent is, why designers need a patent and how it is granted.

Know what copyright is.

Know what a registered design is.

Know what a trademark is.

Key terms

Patent: a legal protection the designer has for their design to prevent it from being copied for up to 20 years.

Copyright: protects original authored works from being copied for the lifetime of the creator, plus 70 years.

A *A detail of a patent on a product*

Registered design

This is different to patents and copyrights in that a **registered design** protects the design's shape, pattern or colour. In other words, the aesthetic of a design is protected.

The design rights can be a powerful method of protecting your design from being copied and they can be used instead of, or together with, a patent. For example, if you create a new package design for a board game, you can stop people copying that design. It is straightforward to register your new design with the UK Intellectual Property Office and costs £60. This will give the designer rights for up to 25 years. The registered design is represented by a number, for example Registered Design 1234567.

Trademarks

Trademarks are distinctive symbols or logos that contain the company name or slogan and cannot be copied. A 'TM' mark is normally placed alongside the symbol to show that it has been registered. The symbol must be unique and it costs £200 to have it registered. HMV, Apple computers and Sony are good examples of companies that have distinctive trademarks.

Activity

Try to find four different products: one with a patent number, one with a registered trademark, one with a registered design and one with a copyright. Copy or cut the appropriate symbols out and stick them in your notes with a title.

B *Examples of registered designs*

Summary

Patents, copyrights and registered designs are all used to protect the designer from others copying their creations. Each design must be original if it is to be awarded any of these three marks.

Trademarks are symbols that show the consumer that the product is protected by law.

C *The 'Walkman' trademark. 'Walkman' is a registered trademark of Sony Corporation*

Before spending about 1½ hours answering the following questions you will have to do some preliminary research into board games and activity packs.

To complete these questions you will require some plain white paper, basic drawing equipment and colouring materials. You are reminded that quality of written communication is important as well as neat sketches and drawings.

1 This question is about quality assurance (QA) and quality control (QC). *(total 25 marks)*

Quality assurance and quality control should be applied to all products.

(a) Explain quality assurance with reference to the designing and making of a board game. *(3 marks)*

(b) Explain what part the following play in controlling quality during commercial printing. *(12 marks)*

(c) To achieve QA and QC, jigs and templates are often used. From your experiences in design technology, use annotated sketches to explain a jig or a template you have used. *(5 marks)*

(d) You are required to produce a batch of identical 'pop-up' greetings cards. Explain with sketches and notes how you would ensure that all the cards are the same. *(5 marks)*

2 This question is about systems and processes. *(total 24 marks)*

(a) Name the three basic components of any system. *(3 marks)*

(b) Computers can be considered a system. To which components of a system do the following belong? *(4 marks)*

(i) mouse (ii) printer (iii) digital camera (iv) operating chip
(v) CAM machine (vi) CPU (vii) scanner (viii) memory stick

(c) A 'flow chart' is an applied system for ensuring quality control and project planning.

Name the following flow chart symbols. *(4 marks)*

(i)

(ii)

(iii)

(iv)

(d) Draw a flow chart using the symbols in (c) for hand-sharpening a pencil. *(13 marks)*

The stages are:
Start,
place pencil in sharpener,
rotate pencil,
remove from sharpener,
check if sharp,
if still blunt repeat until sharp,
remove,
and stop.

 Remember to include feedback.

3 This question is about commercial printing and scales of production. *(total 13 marks)*
 (a) Name the four processing colours in the order they are usually printed. *(4 marks)*
 (b) (i) Name five methods of commercial printing. *(3 marks)*
 (ii) Which method is usually associated with printing the following.
 plastic bags
 stamps
 fabrics
 newspapers
 bottles
 high-quality one-off items. *(6 marks)*

4 This question is about print finishes. *(total 21 marks)*
 (a) Describe each of the following and explain how it can enhance a product. *(15 marks)*
 (i) UV varnishing
 (ii) embossing
 (iii) foil blocking
 (iv) laminating
 (v) spot varnishing.
 (b) Using annotated sketches, explain 'die cutting' and illustrate how the following are done on thin board when making a surface development (net) of a chocolate box.
 (i) Outlines are cut
 (ii) Creases made
 (iii) Perforations are added. *(6 marks)*

5 This question is about the responsibilities of a designer. *(total 27 marks)*
 (a) As a graphics designer you have been asked to produce ideas for the graphics for a new brand of cigarettes.
 Explain (i) why you would not take on this work, or (ii) why you should submit your ideas. *(6 marks)*
 (b) Explain why the graphics for a product should reflect multiculturalism. *(3 marks)*
 (c) Designers should be aware of the 6 Rs when producing new ideas for graphic products.

Study each of the following and briefly explain its meaning.

(i) Reduce

(ii) Rethink

(iii) Re-use

(iv) Recycle

(v) Refuse

(vi) Repair *(6 marks)*

(d) Match the following products to the design considerations above and explain why they best fit that design point.

(i) inkjet printer cartridges

(ii) chocolate eggs

(iii) plastic bottles

(iv) drink cans

(v) plastic sandwich packets

(vi) computer equipment *(12 marks)*

6 This question is about waste reduction. *(total 18 marks)*

(a) Give an advantage of waste reduction to:

(i) the environment

(ii) the manufacturer

(iii) the customer. *(6 marks)*

(b) Below is the layout for a chocolate container. Each square is 10 mm.

(i) Draw this surface development (net) full size on a 10 mm grid. *(4 marks)*

(ii) Using your surface development (net) as an 'underlay', draw as many complete layouts as possible on one piece of A4 paper without overlapping them. *(6 marks)*

(iii) Explain the term 'tessellation' with reference to the above example. *(2 marks)*

7 This question is about packaging. *(total 24 marks)*

(a) Explain, in full, the meaning of the letters in the SIPPP acronym. *(3 marks)*

(b) Using annotated sketches, apply SIPPP to the packaging of either a product you have made in school or a commercially bought item. *(10 marks)*

(c) Use annotated sketches to explain (i) bubble wrap and (ii) blister pack. Illustrate each with a practical example. *(6 marks)*

(d) The outer packaging used in transporting products can have many different signs and symbols.

(i) Explain why signs and symbols and not words are used. *(2 marks)*

(ii) Study the following, which appear on some packaging, and give the exact
 meaning. *(3 marks)*

8 This question is about the legal protection of products. *(total 9 marks)*

Sketch the symbol and explain the meaning of the following:

(a) copyright *(3 marks)*

(b) trademark *(3 marks)*

(c) patent *(3 marks)*

Read the questions carefully and answer only what is asked for.

■ Do not add colour unless it is wanted – it uses time that could be spent on other
questions.

■ Know the difference between sketches and drawings – do what is asked.

■ Give your answers in context to the question.

■ If you are asked to 'develop an idea' show the steady improvement of your design and
give reasons for the changes you have made.

Remember: some questions carry quality of written communication (qwc) marks.

GCSE

Introduction

This unit is broken down into four spreads. Each spread directly relates to the assessment criteria for the project, making it much easier for you to understand how you can get the most out of the Controlled Assessment.

The five assessment criteria are:

- Investigating the design opportunity
- Development of design proposals
- Making
- Testing and evaluation
- Communication.

You will be required to hand in a *design* and *make* project that has been selected from a list of tasks provided by the examination board, AQA. Your teacher will give you the list of set tasks. It is very important to discuss any decisions to do with your brief with your teacher so that he or she can steer you in the right direction.

You will be expected to spend about 45 hours on the whole project, including the modelling and making, so you will need to plan your time in class carefully in order to achieve the top grades. The project should consist of approximately 20 pages of A3 paper, with each page carefully thought through so that the project flows and is easy for another person (especially the examiner!) to follow.

Communication

Throughout your graphics project you will be assessed on your communication skills. This means that AQA are looking for concise, focused and relevant information that is closely related to your brief.

If you present your work clearly and use appropriate technical language, you will be rewarded in the marks you gain, so always think about how clear and logical your project looks.

Quality of written communication

There are also some marks specifically dedicated to your spelling, punctuation and grammar. So you need to try to make sure everything you write is legible, accurate and you use specialist graphics words when they are relevant. For example, if you were writing about the paper or card you propose to make your pop-up mechanism from, you could write about the thickness of the card in microns (see Chapter 2 on page 19).

AQA Examiner's tip

- Try to get the information across quickly. You could use bullet points, as these often make you focus on facts.

■ Frequently asked questions (FAQs)

How long should the Controlled Assessment be?

The design folder should be approximately 20 sides of A3 paper or ICT equivalent. Each page should be carefully laid out and the supporting writing should be concise and accurate.

How much time should be spent on the project?

You should take approximately 45 hours on the design and make task. This time does NOT include any additional teaching and learning of techniques and processes.

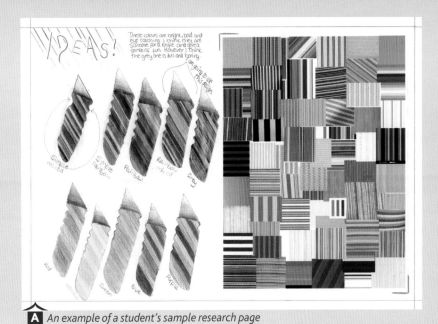

A *An example of a student's sample research page*

Can I complete the work at home?

Planning and preparatory work may be carried out at home but all the writing, designing and the presentation of this work must be done under your teacher's supervision in the classroom.

Can I write my own design brief?

No. You must use a brief that has been set by the Examination Board AQA and given to you by your teacher. You may be given a range of suitable specific briefs that answer the more generalised AQA brief.

What research do I need to do?

You should carefully plan what research is relevant to your brief. All of this does not necessarily need to be completed at the beginning of a project. In fact, it is more likely that you will undertake some extra research as you start to get to grips with the way your ideas are developing.

As a guide, you should try to include: how similar, existing graphic products have been designed and made; relevant industrial processes used in their manufacturing; material choices; environmental issues; sustainability of the design; social and moral issues; and aesthetic (how they look) decisions. Try to be concise.

What does 'target market' mean?

The target market is the specific group of people you intend to aim your product at, that is the consumer/user. You need to justify and define this group, giving for example their age, sex and social factors, including cost of the product, current fashion and disabilities. An example of a product and target market is a textural book for blind, ethnic groups.

How detailed should my specification be?

You should try to justify every specification point you have concluded, which should be based on your research and analysis. You may find this changes as the project develops, which is fine as long as you record your reasons.

You may also want to divide the specification into a design specification and a product specification. The product specification should include specific details on how the actual final design will be manufactured and, as a guide, this could include details on materials, printing processes, costs, sizes and joining methods.

How should I sketch my design ideas?

You should start with a range of initial sketches that try to answer your brief and specification. You can use a range of media to do this, including hand-drawn sketches or computer-aided images. Always try to annotate each design, referring back to your specification as much as you can.

Try to show a range of design techniques and add details of material choices, dimensions, colour variations, typography and industrial techniques that may be suitable for commercial manufacturing.

How many ideas should I create?

There is no exact number, but try to show innovation and creativity in your solutions. Try to design ideas that have not been thought of before. Originality will be highly rewarded.

How many ideas should I develop?

It is likely that you will develop lots of different aspects of your ideas, including typography, shape, sizes and colour to name a few, but ultimately you will only need to develop one idea through to a final detailed design. If you use CAD to help with this process, make sure you show how you have arrived at your final solution by printing lots of the stages you went through with small, annotated screen dumps.

Should I include any models?

Yes.

Try to show a wide variety of techniques, including CAD/CAM where appropriate. You may want to take photos of your models and annotate these showing how they have helped you solve the brief. If you do not record your modelling in your project you cannot gain any marks for this element.

How do I achieve high marks in the making?

You must produce one or more related graphic products that demonstrate a range of skills to a high level. The complexity/demand of the product, along with the accuracy and finish, should all be of a high level. Try to show originality and innovation in your final design, using your models and development to help you decide on the best way to achieve the appropriate solution.

Take care to select the right tools, techniques and materials and use CAM correctly if you have the facilities.

Make sure you record any quality-control methods that you have completed in order to create a high-quality outcome.

Do I have to use CAD/CAM?

No, but you should refer to these processes in your folder as alternative methods of producing your designs.

Do I need to produce a finished outcome?

Yes, you do if you want to gain any of the top grades.

Do I need to evaluate anything?

Yes you should always evaluate all your coursework, taking into account your specification and especially the client/user.

Do I need to test my product?

You should try to get a user or a representative of your target market to test your product against the specification. Record their views and try to suggest ways of modifying the design to improve it and how it can be made suitable for commercial production. Try, if you can, to take a picture of the product being used appropriately and insert this into your folder.

Do I get marks for good presentation of the folder?

Part of this course is about how you communicate your solution in your folder. You should always try to present your work to the highest standards possible and make the coursework flow in a logical order so that it is easy for another person to follow.

Does my spelling matter?

There are specific marks awarded for accurate spelling and grammar, along with the use of appropriate technical language. So if you are writing about the printing of your product, try to say exactly what type of process you would use, for example offset lithography and die cutting a complex pop-up mechanism out of 300 micron white card.

Who will mark my work?

Your teacher will assess everything you have done, which includes all the design folder and all the modelling and making. This assessment will then be checked by a moderator from AQA.

23.1 Investigating the design opportunity

How do you get started?

It can be quite a worry starting your real GCSE project, but do not get yourself into a state – just try to follow some of these simple guidelines. You will probably find them really useful and they should help your project 'flow' and will become easy to follow.

Before rushing into your project, ensure you discuss things carefully with your teacher. Be honest about your own skills and ask your teacher if there are the resources in school to make your product to a good standard. You need to choose carefully if you want to gain higher marks. If you decide to make a CD cover and do a fantastic job, it is still only a CD cover and can be made very quickly without a varied range of making skills. If your CD cover is part of a range of 2D and 3D outcomes, then this increases the range of skills used and therefore your potential for higher grades. You may even decide to make one quite complex 3D outcome, such as a new board game that has a number of components. Again, this gives you the potential to reach higher grades.

Ask your teacher to explain each of the marking criteria, and then consider how long you have for both the 'design' and 'make' elements. Work out a rough time plan (not part of your portfolio) and try to allocate an amount of time to cover each of the criteria as thoroughly as possible. It is easy to get carried away on one section and neglect another. Stick to your schedule. Once you have considered your own skills and the resources available, you can look at the time available and make a final decision about how varied and how complex your outcome or outcomes will be.

Design context

You will be given a list of tasks provided by AQA and you will have to choose to base your project from this list.

You are likely to discuss your choice either in pairs or with your teacher which should lead nicely onto the first page of your project. You want to try to analyse the design context in as much detail as you can. The analysis helps to sort out what is relevant and what you need to research into. It also helps to develop a specification. This should allow you to then write a design brief.

Objectives

Get you started.

Give you guidance on 'Investigating your design opportunity'.

A *This student has created a range of logos based on relevant research*

Research

Always try to break the design problem down into the sections you think you need to research.

You will probably need to cover the following areas, but you may come up with your own:

- detailed analysis of existing products
- analysis of relevant systems or processes.

A good way to start solving a problem is by looking at how other designers have tried to solve a similar problem. It is often very helpful if you try to graphically 'pull apart' a similar product to see how it has been made. This can lead you into early sketches of ideas or simple models to help you try to understand the problem.

You may also need to look into relevant processes that are directly related to your design problem. This may mean that you need to decide what would be the most suitable printing method for your ideas, or perhaps you need to look into how a product has been constructed. Only relevant research should be included in the design folder and this should be as concise as possible. Try to go into detail but don't waffle! If you are using the internet then you must write the information in your own words and *not* simply copy. You may find that you need to do some extra research later in the project, for which you will still gain marks.

B *Using research images*

The cap is black to represent an oil that can be used for garden tools as Aspen make a range of oils for different engines. I feel this should be changed to a green. It is made using the injection moulding process.

The main 'aspen' name is bold and in a lower case sans serif type in orange. I intend on changing this.

Black border is simple and provides a visual boundary. I think this should be green to go with the environment theme.

The red main bottle is probably blow moulded from a thermoplastic like PET. I will look into different colour options.

The current 'Aspen' logo is green to represent an environmentally friendly company. I feel I could improve this design. perhaps changing the size and its dominance.

The barcode is scanned using a laser beam to help the garage know the sale price and also how many have been sold.

Symbols used to show what the oil can be used for. A pictogram of a strimmer, chainsaw and hedge cutter are shown.

There is information about the oil in the middle of the design using a brown typeface. I think I could improve this.

The whole sticker is probably printed using offset lithography as this is high quality commercial and economic print process. It is printed onto a matt white paper of about 100 gsm and then die cut into the special shape.

 C *Product disassembly*

Summary

Remember: only do research that is relevant to your design brief.

Try to be succinct in how you present the information.

After you have completed all your analysed research, you need to try to write a clear and concise list that your designs should follow. This is called the *specification* and it should bring together all the information you have learnt from your research. You should be able to complete this succinctly on one A3 sheet.

This is an important part of the design process and it should get you to think carefully about what it is you are going to design. You should find it really helps you and gives you a direction in your future design work. It will also help you tremendously when you evaluate your designs as they progress, and also help you in a final summative evaluation when you will have specified particular areas that your designs should answer.

What follows is only a guide and you may well think of more areas that are relevant to your design problem. The first section is really a minimum that should be covered, but the titles can easily be remembered by the acronym, ACCEESSFMM, with each letter standing for a sub-heading. Try always to justify each of the specification points and refer to your research. You may find that you need to research a little more to help you understand your product after writing this. This is fine, but make sure the research is relevant.

A = Aesthetics

What will the product look like? How will colour, shape, tone, texture and layout affect the style of the design? Will the design be based on a theme?

C = Customer

Who are you aiming the product at (this is also known as the target market)? Are you aiming at a retailer, in which case you may need to make a point of sale, or are you aiming at a particular group of people? What is their age, sex, social type (for example, student, teenager, child, professional, elderly or disabled)? Are they the intended user?

C = Cost

What do you intend to sell the product for? Try to give an amount based on the research you have found on similar products, or give a reason why you feel your product will sell for more or less. What is the estimated manufacturing cost? This should lead you to the estimated selling cost.

E = Ergonomics

How do you think your design needs to take account of how a human will use it? Do they need to pick it up? Will it be too heavy? How will you ensure it is comfortable and easy to use? What anthropometrical data do you need to include (for example, sizes of hands or fingers)?

E = Environmental issues

What environmental impact could your design have? How can you minimise this? Can you use recycled material? Can the final product be recycled or re-used? Can the product have a secondary use? For example, if it is a package, can it then be used as a money box or a game?

S = Safety

Is your product safe to use? Should it pass a recognised safety standard, CE mark or BSI mark?

S = Size

What dimensions do you think the product should have?

F = Function

What is the intended product supposed to do? For example, is it supposed to protect, promote or be easier to use? Where will it be used?

M = Materials

What materials do you think the product will use and why? This can be closely related to the environmental impact and the manufacturing method chosen. The materials you choose should be based on your research.

M = Manufacturing

What methods of manufacturing do you think you may use? Try to think about both the commercial methods, like printing or vacuum forming, as well as how you might make the product in the classroom. Will it be batch or mass produced?

Other areas you might want to consider are:

Social/ moral issues. Is the product good for society to use? Will it make life easier for people or perhaps improve an existing product environmentally? Will the product offend anyone because of the graphical imagery?

Quality. Is the product designed to last a certain time? What quality control measures will you put into place to ensure all the products reach a certain standard? How will the product be protected until the customer buys it?

Deadline for making. When do you have to complete the product by?

Summary

ACCEESSFMM is a really good way of remembering the main sub-headings.

Try to use bullet points for each sub-heading and then justify each one.

A word processor is an excellent tool for this activity using 12 or 14 point size.

How do you develop your designs?

From carrying out a majority of your analysed research, you have probably drawn a few initial sketches of what you consider are good examples of existing ideas. This has probably helped you write your specification and given you a very clear direction of where you want your designs to go. Now is the time you need to start using your creativity to answer your initial brief, with your specification to guide you. Here are some guidelines that you should try to follow, and your teacher will lead you through them.

Initial ideas

Start by sketching as many original thoughts as you can. You will probably want to initially design small pencil sketches, some of which you might want to draw in more detail and use colour to help get your idea across. To gain high marks, your ideas must show a range of different design solutions. If ideas are too similar then they are merely developments of one idea, so try to create a wide range of at least six original solutions to the problem.

You will be graded on the range, inventiveness, presentation and originality of your designs, so take pride in your work.

Always annotate your ideas, stating how you think they could be made and what materials you could use. Keep looking back at your specification as this will be an excellent reference page to help with the annotation.

You may decide to sub-divide your ideas into sections, such as logo design, typeface, package, point of sale, graphical theme and product. You should find that as the ideas develop, you become more confident with your choice of design – it should naturally improve the more you draw.

Objectives

Give you some guidance on how to generate ideas with creativity and flair.

Help you develop your design proposals through experimentation of techniques and modelling into a final design.

AQA Examiner's tip

Try to be really creative and show flair and imagination. Try to use a variety of hand-drawn techniques as well as using CAD if you feel it will help.

Hint

Printing a similar image on to different papers can give an interesting 'feel'. The student eventually chose to print the image on to brown wrapping paper.

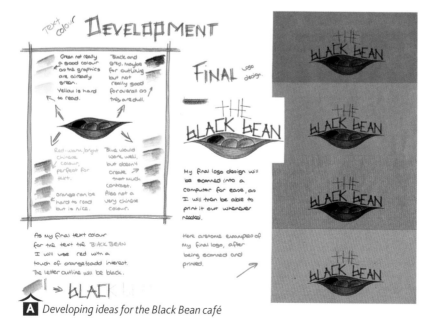

A Developing ideas for the Black Bean café

Development of your ideas

You should now have a range of ideas that are ready for developing in fine detail. You will want to show your ability to solve the initial brief and answer your specification with clever justified design. Here are some tips:

- Try to use colour carefully.
- Your designs should be clearly laid out so that it is easy to follow your progress.
- Try to experiment with a wide variety of techniques and modelling and use photos and screen dumps when helpful.
- You should annotate all your designs to explain what you are intending to do. Try, if you can, to use the correct technical language when carrying this out.
- You should try to think about environmental factors, sustainability, and social and moral issues so that your final design is a responsible solution to your problem. Look back to Chapter 15 on page 100 to remind yourself.

The final detailed design should give all the technical data for construction. You can use a number of pictorial and/or orthographic techniques, but may need to include extra drawings showing cross-sections of the details. A good design solution (the working drawing) could be given to another person and they should be able to make the product just from the data given. CAD packages like 2D Design are excellent for this task.

All added or bought-in components need to be drawn and included in the technical data.

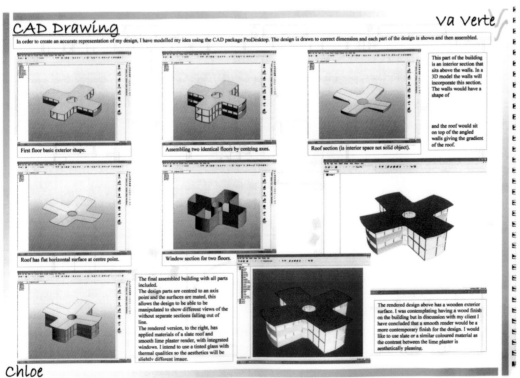

B *More development work using CAD can quickly but effectively change the colour scheme*

kerboodle!

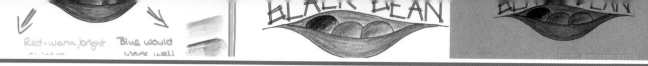
Modelling

Always try to model your ideas before you go into your final, accurate, detailed model or prototype. You can use all sorts of materials to help you find the best solution, such as papers, boards, Styrofoam, plastics and fabrics. Record your models in your folder, either by using a digital camera or by keeping these 3D pieces and handing them in alongside your final making piece.

C 3D modelling:
Stage 1 Basic 3D shape cut out using a hot wire cutter.
Stage 2 Rounding edges using a file or rasp.
Stage 3 Detail of the main shape of the camper added using files.
Stage 4 Layer of Plaster of Paris added to fill any dents or imperfections in the surface. This is allowed to dry and then sanded down to a smooth surface.
Stage 5 Surface is finally painted using acrylic paints with great care.

Planning

You need to show that you have clearly planned how you intend to make the final solution. This is a vital part of the design process and it should show each process you plan to carry out, quality control checks, estimated times for each process, equipment, any health and safety factors and, most importantly, what and when decisions will be made. Also remember that it is a *plan of making* and *not a diary of making*. Retrospective work is not planning and should be recorded as modification work in the evaluation.

Planning of Making

Activity Process	How they will be achieved	Tools used	Safety Precaution Necessary	Predicted Time	Quality Control
Mark out on thick grey card measurements for pages of my book	Measuring and Marking	⇒30cm ruler ⇒Pencil	NONE	10 min.	Make sure the measurements are accurate.
Cut out card with a Stanley knife. ⇒2xFront cover ⇒4xInner page. ⇒1xSpine	Cutting	⇒Safety ruler ⇒Stanley knife ⇒Cutting board	⇒Safety ruler with grip. ⇒Cutting board.	30 min.	Accurately cut

D A planning sheet

The best ways of presenting this plan is by using a table or a **flow chart**, or both (see Chapter 11 on page 83 for details on flow charts). The advantage of using a flow chart is that it is easy to structure and include a lot of relevant information by using just a few flowcharting conventions.

If you intend to make more than one product, it will be necessary to produce a separate plan for each, so you may choose to present one process as a table and the other as a flow chart. Try to set realistic deadlines, but be aware that they may change due to unforeseen circumstances. If they do change, then make sure you record why and how you tried to solve any such manufacturing problems.

Product/manufacturing specification

You will have already written an outline specification, but now you should try to consider exactly how the product could be made commercially. This is a good stage for using specialist vocabulary and it can gain you extra marks.

Try to present the information in bullet points, as you probably did for your original specification. This specification is likely to be much shorter and should only concentrate on facts relating to the *actual product* being made. You are likely to consider some or all of the following areas.

- **Specific materials**, for example Styrofoam for the model with a thermoplastic like PVC for the actual object. You are likely to need to specify any qualities of paper or board you intend to use. Try to use grams per square metre (gsm) for paper and microns for board, and mention any surface finish you think would be appropriate, for example a white gloss finish.

- **Industrial method of manufacture,** for example vacuum forming, injection moulding or die cutting.

- **Printing process used,** for example offset lithography if the product will use the four process colours (CMYK) and many thousands will be printed to a high standard.

- **Printing effects** that you might consider would enhance the product, such as foil blocking, embossing or laminating.

- **Exact sizes** of the product in millimetres (mm).

- **Predicted costs** of the manufacturing. This is a very difficult area to answer accurately without actually obtaining a quote from a real company, so try to show that you have at least considered the cost implications of your design. For example, if you have chosen to add a printing effect, this will probably double the print costs.

Summary

Remember to annotate all your designs, giving reasons for any decisions made.

Make sure your final design is easily understood. You will need to do an accurate scaled third-angle orthographic projection with accurate sizes.

Make sure your planning is clear and in a logical order.

Key terms

Flow chart: a chart using symbols to show the sequence of a process

E *The finished example of a bottle, point of sale and packaging for a perfume. In order to give a softer effect, the student has used tracing paper to overlay clear acetate on which she has printed a tree image. The perfume bottle is shaped and polished acrylic. The base is carefully painted Styrofoam.*

AQA Examiner's tip

Always try to model your ideas before you make a final decision on the chosen design. If you have time, it is useful to get an opinion of your ideas from your target market.

23.4 Making, testing and evaluation

◼ Making

By now you should have created a good range of ideas, some of which you have developed in detail and possibly modelled a few. You have then chosen one and presented this as a technical drawing, probably using orthographic projection, which should have information of sizes in millimetres and the materials you intend using.

You should also have planned how long you propose this making process to take (if possible include **quality control** measures to ensure accuracy as you progress) and the tools you intend to use, including any CAD/CAM that could be useful.

Creating the final piece

When you come to make your final piece, think about the different ways you can go about it. Here is some advice to help you:

- ◼ The complexity of your design(s) will dictate the level of skill needed in the making. The greater the range of skills, the higher the marks.
- ◼ Use the correct tools and techniques and use them safely.
- ◼ Ensure that any joints, folds, scores and edges are accurate, neat and safe.
- ◼ The quality of the finish gives the first impression. Only use an additional finish if it can be applied to enhance and/or protect.

Here are some examples of practical outcomes. You may find it helpful to consider the examples of practical outcomes in Photo **A**. If in doubt, ask your teacher for advice on how you could solve your design proposal.

◼ Testing

You should always try to test your final outcome to see if it is effective. This testing must take account of the views of the client or user. Try to write down all their views and comment on how they could help you improve your design.

Always try to get a real client to test your product, as you are likely to get a far more valid test this way. If possible, take a photo of the product actually being used. Does it function and perform as you intended? Is it easy to use? Is it better than other similar products on the market?

Try to include sketches of how you think it could have been improved, based on the comments that you have recorded from your client(s).

Objectives

Give you some guidance on how to achieve a high quality outcome.

Learn how and why you need to test and evaluate your product.

Key terms

Quality control: all the systems you need to put into place in order to check the quality of product during the making process, for example visual checks of colour.

A *Examples of practical outcomes*

Evaluation

As you go through your project, you will almost certainly want to evaluate any of the major decisions you make to do with the design, but *not* the process. This means that, for example, if you chose to change a colour scheme due to your client's preference, then this *is* evaluating. If you chose to alter your material choice because your initial choice was too weak, then this is a relevant point, too.

You need to try to think very carefully about the evaluation and remember that it does not have to be at the end of a project, but can and should be throughout it. You may wish to highlight any evaluation points in another colour, for example use a red pen, as you progress through your project.

You should have written a design specification early on in your project and then a product/manufacturing specification later on (usually nearing the end of the development stage). You must now evaluate your final product against each point, trying always to say how the product could be improved in some way. It is almost impossible to create the perfect design, so after all this evaluation and testing, it is almost certain that you would be able to change your design in some way to improve it. Try to think in particular about how the outcome could be improved if it were to be commercially made in volume. Annotated sketches can be a very easy way of showing any changes. Alternatively, you could create a table similar to Table **B**.

B *Sample evaluation table*

Specification point (ACCEESSFMM)	How my final outcome meets this and how it could be improved.
A = Aesthetics	My client felt that my product was aesthetically pleasing and used colour really well to create a hi-tech image, which is what I intended to do.
	An improvement could have been to make the logo stand out more from the background and use a darker outline on the typeface.
Design change	The shape of the lid on the package did not shut as well as my client wanted. Here is a sketch of how I could change this.
Colour change	The background colour was too dark for the typography to stand out, therefore I could lighten it to this tone.
Size change	The size of my travel game package was fine but my client found some of the playing pieces too small to use easily. I could increase their size by 5 mm and still be able to fit them in the existing package.
Material change	I used 700 micron thick board for the point-of-sale display but my client felt this was a little too weak so I would increase this to 1,000 microns if I made it again.

AQA Examiner's tip

Try to use a real client or a person from your target market to test your product as this is more true to life than using your own views.

Summary

Always try to make your product to the absolute best of your ability with a high-quality finish.

Use a variety of materials and techniques including CAD/CAM if appropriate.

The purpose of evaluation and testing is to try to find ways of improving your design.

Glossary

2-dimensional: a sketch or drawing which shows only two dimensions, e.g. length and width.

3-dimensional: a sketch or drawing which shows all three dimensions, e.g. length, width and thickness.

A

Analysed: examining information by looking at separate parts of it.

Annotated: brief notes which help explain design sketches and drawings.

Anthropometrics: the study of the varying sizes of all the parts of a human body.

Artwork: is the name given to the hand drawn or CAD designs created by the designer.

B

Batch production: used for limited runs such as books and magazines.

Biodegradable plastics: are plastics that can be totally broken down by micro organisms into harmless waste.

Biodegradable: this is a material, normally based on animal or vegetable matter, that can be broken down by other living organisms into harmless waste.

Bioplastics: are made from animal and vegetable matter and are totally biodegradable.

Bleed area: the 3mm extra area at the edge of a printed image. This allows for slight misalignment by the printer when cropping the image.

Blow moulding: a process of making hollow plastic forms by blowing air into a heated thermoplastic.

Bought in: components you haven't made but have bought in for your project.

Branding: a logo or image associated by the public with a product.

Brightness: the level of optical whiteness.

Built-in obsolescence: where a product is made with one or more components that are known to fail after a specific period.

C

CAD: the process of developing an idea using a computer.

CE mark: a safety standard that allows the product to be sold within the European Union.

Centre line: the line that defines the centre of a circle or an arc.

Collated: collecting and putting numbers or letters into an order.

Colour bar: a small strip of the process colours (CMYK) printed outside the actual image. It is used to check the density of the four colours.

Colour separation: the process where the original image is separated into the four process colours by a computer program.

Complementary: colours that are opposite each other on the colour wheel. These colours provide the greatest contrast to each other.

Component: an individual piece of a product that is connected to another during assembly to make the final product.

Computer numerically controlled (CNC): machines which are controlled by a number system.

Computer-aided design (CAD): producing a design using a computer.

Computer-aided manufacture (CAM): producing products and designs using computer controlled technology.

Continuous production: 24/7 but with the possibility of changing printing plates.

Copyright: protects original authored works from being copied for the lifetime of the creator, plus 70 years.

Corporate identity: the qualities and values an organisation wishes to be associated with and recognised by – its signage, products and public appearances.

Creasing: the paper or card is compressed to form a fold line.

Creativity: new designs, new ideas, new interpretations of older ideas and products.

Crop marks: found at the four corners of a page. They tell the printer where to crop or guillotine the printed image.

Cultural issues: advertising or product decisions that are changeable dependent on the actual target market.

D

Deceptive packaging: where the package gives a false impression of the product.

Densitometer: measures the density of any colour.

Design specification: a detailed list of what your final design should include.

Designed to fail: designers and manufacturers plan the 'built-in obsolescence' at the design stage in order to generate future sales.

Desktop publishing: using a computer program that combines text and images.

Device: type of hardware.

Die cutting: an industrial process used to produce large quantities of the same surface development.

Dimensions: sizes, usually in mm.

Disassembly: means to take apart a product in order to gain information.

Do not signs: signs that tell you not to do something.

E

Embossing: a process that raises the surface of a material using a press or stamp. It is used to give a slightly 3D effect to embossed area and therefore adds interest to the design.

Encapsulation: the inclusion of a printed item within a transparent outer casing, for example a thin layer of plastic bonded over a printed surface.

End/side view: a view looking at the side or end of your product.

Ergonomics: the study of how products can be shaped and sized to work well with the human body.

Evaluation: the process of enquiring how well the product or ideas meet the specification.

Exploded drawings: the production of a 3D drawing showing construction methods and components, all drawn separately but in relation to one another.

Eyecatching: so that it is noticeable and easy to understand.

F

Fastenings: things like brass paper fasteners to produce a linkage or simple mechanism.

Feedback: information that informs the operator what is happening during the process.

Feedback loop: the part of a flow chart which shows the operator where to go back to if needed.

Finish: adding a property to a board.

Fitness for purpose: quality in terms of fulfilling a customer's requirements, needs or desires.

Fixed pivot: the point at which a lever can rotate. It is normally attached to the base card with a split pin.

Flexography: High speed, high volume print process that can print onto nearly all surfaces e.g. plastic and metal.

Floating pivot: a point at which two or more levers are joined together, usually with a split pin.

Floor plan: a scaled down drawing to represent how the floor space in a building is to be laid out.

Flowchart: a diagram which explains the process showing inputs, processes and outputs.

Font: a specific letter type consisting of upper and lower case letters. You can change the style of typeface by using different fonts., For example, Times New Roman can be used in regular, italic, bold and bold italic fonts. These are four different fonts, but only one typeface.

Formative: Ongoing testing on materials, construction, components, safety, colours, images and systems.

Front view: a view looking towards the front of your product.

G

Grades of pencil leads: H, HB and B.

Gravure: highest quality, but most expensive print process used for the best detail image e.g. stamps.

Grid: a boxed framework to help drawing shapes.

Group/ungroup: selecting a line or part of a design then grouping it together and then being able to apply constraints to the 'grouped' items.

Gsm (grams per square meter): paper thickness is measured in gsm which is the weight in grams of a whole square meter of paper.

Guillotine: very large and powerful blade used for the final cut to the printed sheet. This blade normally follows the crop marks.

H

Hardware: machinery that supports the software.

Hatching: equally spaced lines usually drawn at 45 degrees which represent where an object has been sectioned.

Health and Safety Executive: government body responsible for ensuring workplaces comply with health and safety at work laws.

Hidden detail: lines which you know exist but you can't see them.

Horizon: the horizontal line on which the vanishing point sits.

Hue: a particular gradation of colour.

I

Ideogram: pictorial symbol used to communicate a message.

Import: bringing an image from one application into another application.

Injection moulding: process in which hot liquid plastic is injected by force into a mould.

Input: what you add to a process (information or materials).

Input device: any device which allows data to be entered into a computer.

Instructions: explain to others how to do something.

Isometric: pictorial drawing without horizontal lines, which shows objects in 3 dimensions. Lines are vertical or at 30 degrees to the horizontal.

J

Jigs and formers: These are used to accurately locate, bend or aid in the construction of a product. They often save time and make it possible to make each item identical.

K

Kitemark: a product that displays a Kitemark has been tested to ensure that it complies with relevant safety standards.

L

Leader line: the line that defines the outer limits of an object to

be measured. It does not touch the object and extends past the arrow head.

LED: a light-emitting diode.

Lever: a piece of card that can be attached in a number of ways to other levers or the base board.

Line bending: a process used to bend straight lines in a heated thermoplastic.

Linear movement: is movement in a straight line.

Logo: an image that is associated with an organisation.

M

Making Skills: How bought in components or other materials are attached to the graphic components of a product.

Manipulation: reducing or enlarging a design, it can be done to shrink or enlarge an image whilst keeping its dimensions relative.

Mass production: used when making millions of the same item.

Mechanical books: books which have movement and actions built into them.

Microns (μm): card thickness is measured in microns. A micron is 1/1000th of a millimetre.

Mirror image: selecting an axis in which to produce a mirror image of a line/shape/design of a picture. This can save time in the long run.

Mock-up: a model, often full size, of a design to allow for evaluation, a working model of a product built for study or testing or display.

Model: a graphic representation of the item you are designing. It is often a scaled down (smaller) version of the design.

Modelling materials: the range of materials used to produce quality 3D models.

Modern material: a material invented within the last 50 years.

Moral Issues: These are where the designer has to make a decision about something that may be dangerous or controversial, but it is not covered by any law or design regulation. Usually related to a specific target market.

Must do signs: signs that tell you that you must do something.

N

Non-biodegradable: waste that cannot be broken down by living organisms.

Non-geographical map: not related to the actual landscape or topography.

O

Oscillating movement: is movement backwards and forwards in a circular motion.

Offset lithography: the 'offset' means that the actual printing plate never touches the paper, because the image is first transferred, or 'offset', onto another cylinder.

One point perspective: a drawing created with only one vanishing point.

One-off production: used for high-value special items.

Operations: individual processes and functions.

Operator: the person who is controlling the process.

Outline: the outside line of an object.

Output device: device which allows information to be downloaded in the form of a 'hard' copy.

Output: the final outcome of the process.

Over packaging: where too much packaging is used.

P

Paper engineering: precise, accurate mechanisms made from paper and designed to enable the desired actions to take place.

Paper/Card engineering: the design and manufacture of 'pop-up' type products.

Patent: a legal protection the designer and their design to prevent it from being from being copied for up to 20 years.

Personal protective equipment: safety clothing to protect you while you work, such as goggles or gloves.

Photomechanical transfer (PMT): this is the process used to transfer the image onto a printing plate.

Pictogram: simple ideogram without language and used in public places.

Pictorial drawing: a 3D drawing.

Plan view: a view looking down at the top of your product.

Pop up: cut out sections appear when the page is turned.

Press forme: the actual tool that is used in the die cutting process.

Primary packaging: packaging which protects the product and gives key information.

Print finishes: these are effects that are usually added after the main print process has been carried out.

Printing plate: normally made from a flexible material like aluminium for offset lithography or rubber for flexography.

Process: what is done in the process.

Process colours: Cyan, Magenta, Yellow and Black, commonly shortened by printers to CMYK.

Production line: a set of machinery required to make a product from start to finish.

Prototype: a life-size (scale 1:1) working model of your design used for testing, development and evaluation.

Q

Quality Assurance (QA): the process through which the designer actually states what quality he/she wants the

product to have when it is finally made.

Quality Control (QC): the measures that are put into place to ensure that the quality standards are met at critical points of the making process.

R

Reciprocating movement: is movement backwards and forwards in a straight line.

Recycling: a method used to break the used material back down into a reusable state.

Registered design: protects the aesthetics or look of the design from being copied.

Registration mark: a very clear mark about 10mm across using a circle and lines, which is used to check whether the printing plates are aligned.

Renewable: materials that can be easily replaced, reproduced or grown.

Risk assessment: working out what the hazards are in a particular situation and deciding what you are going to do about them.

Rotary movement: is movement in a circular motion.

S

Safety precautions: things you can do in advance to protect against possible dangers or accidents.

Safety signs: signs that advise you how to be safe.

Scale: the ratio between the drawing and the object.

Schematic drawings: a drawing of an electrical or mechanical system.

Scoring: done on a fold line to help reduce the risk of the paper or card cracking.

Screen printing: lowest quality print process but able to print onto many different surfaces including fabrics.

Secondary packaging: packaging that contains the actual product and gives detailed information to the consumer.

Sectional drawing: a drawing produced by cutting through an object.

Self assembly: to construct independently from a kit using instructions supplied.

Sequential illustration: series of drawings to show the steps in a process of making something.

Set up costs: costs involved with setting up the printing machine, including making the printing plates and all the 'pre-press' work.

Sheet fed: individual pre-cut pieces of paper are fed into the printer.

Site plan: a drawing showing a piece of land from above with existing and/or new buildings and features.

Sketch: a quick, informal image sufficient to communicate important features to others.

Smart material: a material that responds to a stimulus like heat, and then returns to its original state when the stimulus is removed.

Social Issues: where the products being promoted for use/consumption, may not be in the best interest of the consumers. Usually related to the wider public in general.

Software: programs used by your computer, Corel draw, MS Office.

Special colours: pre-mixed specific colours that can be used instead of the CMYK system.

Spot varnishing: a particular part of a printed surface is highlighted by the varnish.

Strength: the resistance of a board to bending or lateral pressure.

Summative: any tests on a completed product.

Surface development: 2D version of an item that will eventually be assembled into a 3D object.

Symbol: visual device used to communicate.

T

Target market: the group of people your design is aimed at.

Tessellation: the arrangement of a surface development that reduces waste to an absolute minimum.

Testing: a process of checking that occurs a regular stages throughout the design process.

The product lifecycle: portrays distinct stages in the history of a product.

Thermoplastic: a plastic that can be re-shaped many times when it is heated.

Third angle orthographic projection: a standard technique for producing detail and working drawings that everyone can understand.

Tints: percentages of the process colours found in the colour bar.

Tolerance: acceptable range of accuracy.

Tone: a colour or shade of colour created by adding amounts of white or black.

Trademark: a unique mark that helps you to identify a product or range of goods by the same producer.

Two point perspective: a drawing created using two vanishing points.

Typeface: is the style of text you can use e.g. Times New Roman or Comic Sans. They are sometimes given their name based on the designer who created them.

Typography: is the art form of letter style and design.

U

Under packaging: where too little packaging is used.

Underlay: a ruled pattern that assists when drawing 3D shapes.

V

Vacuum forming: a process in which simple hollow shapes are created by sucking air from underneath a heated thermoplastic plastic sheet draped over a mould.

Vanishing point: the point or points at which all lines in a perspective drawing appear to meet.

Virgin paper: paper is that is just made from wood pulp with no recycled paper added.

W

Warning signs: signs that tell you about a possible danger.

Web fed: paper is fed into the printer on huge rolls and it cut into pieces after printing.

Index

Note: key terms are in bold